SOURCES AND DOCUMENTS IN THE
HISTORY OF ART SERIES

H. W. JANSON, *Editor*

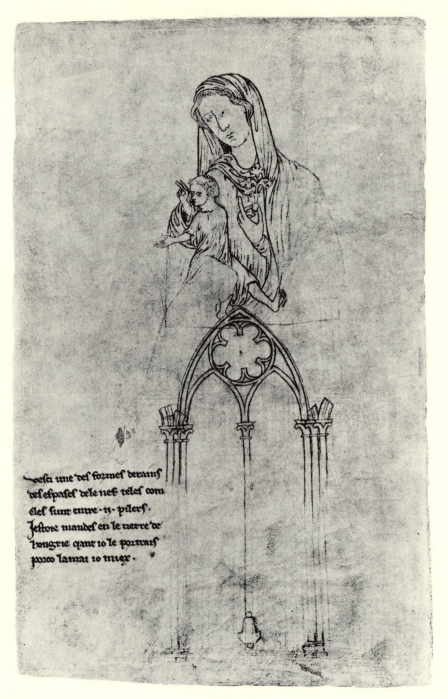

Reprint of plate XX of Villard de Honnecourt: *Kritische Gesamtausgabe des Baühuttenbuches MS. fr. 19093 der Pariser Nationalbibliothek*, ed. Hans R. Hahnloser (Vienna: Verlag von Buch-und Kunstverlag Anton Schroll & Co., 1953); reproduced with the kind permission of the publishers.

Gothic Art

1140–c. 1450

SOURCES and DOCUMENTS

Teresa G. Frisch

Professor of Art, Emerita
Wellesley College

PRENTICE-HALL, INC.
Englewood Cliffs, New Jersey

Library of Congress Catalog Card Number: 77–135403

Printed in the United States of America 13–360545–0

Current Printing (Last Digit)

10 9 8 7 6 5 4 3 2 1

PRENTICE-HALL INTERNATIONAL, INC., *London*
PRENTICE-HALL OF AUSTRALIA, PTY. LTD., *Sydney*
PRENTICE-HALL OF CANADA, LTD., *Toronto*
PRENTICE-HALL OF INDIA (PRIVATE) LIMITED, *New Delhi*
PRENTICE-HALL OF JAPAN, INC., *Tokyo*

Preface

To look at gothic art from the vantage point of the period's own documents and literary sources offers—apart from the study of the object itself—the only assurance of a direct connection with a civilization so far removed in time from our own. Otherwise, impatient as we are with what we do not readily comprehend, and eager to accept brief summaries for the whole, we are apt to add to the distance in time, with its own leveling effect on our vision, our blindness to the effect of even short variations in time and to different geographic, social, economic and human conditions; and—most serious of all—we fail to recognize the complexity of human motivation by not being able to distinguish between the explicit, symbolic gesture and the implicit motivation for the creation of an artwork, or vice versa, and separate entities become fused into an inarticulate lump.

In contrast to other epochs, medieval man did not theorize on art and artists until shortly before the end of the gothic period. Yet in what follows the reader will be given the opportunity to decide for himself whether the absence of such literature inevitably proves medieval man's inability to apply a systematic critical approach to questions of taste, as has been said so many times. Often only the lodge book and the craftsman's handbook, dealing with the practices in the medieval workshops, have been considered the true art literature of the period.

Discussions of beauty and harmony in the writing of scholastic philosophers have been left out of this book. Gothic philosophical systems, like earlier Christian ones, treat of beauty of any kind as being in the service of God, helping to lead man beyond himself in an anagogical way toward the divine and serving, in a moral sense, as a reflection of that incomparable beauty which is God. Looked at from this point of view, all debate is meaningless. But modern critics have also said that the chief motivation of the medieval artist—architect, sculptor, painter —was to serve God and to achieve beauty solely in his service. Perhaps this more than anything else that has been said with regard to medieval art shows how far the historian and critic have removed the period from living reality. The truth is that most documents of the gothic centuries give evidence of a healthy, alert, objective weighing and appraisal of technical and aesthetic problems on the part of both client and artist. Neither, it would appear, felt any need for theorizing until the time came when, *in reaction to gothic art,* the Italian apologists in Tuscany devel-

v

oped the fourteenth-century commentary, critique and anecdote directed against it, thereby resuming an art-critical literature which had existed before the Christian era.

The documents which have been selected for this book come from a variety of sources. Whenever possible, personal observations of professional men and the observations of contemporaries have been used, but these are rare, and so, for the most part, impersonal records such as legal contracts, agreements, inscriptions, inventories and excerpts from expense accounts have had to make do instead, illuminating only obliquely changing times and attitudes. These documents were dictated or written by clerks and laymen, by churchmen and lawyers, and eventually by city magistrats and the guilds: by men whose interest in what they recorded varied, so that the texts also vary in formulation and usefulness to the art historian.

In arranging the texts, a chronological sequence seemed the most logical approach, because it promised to show up differences in milieu, in customs and temporary needs, in resources, and in psychology during different periods; and the chronological sequence frequently also coincided with a topographical order. The most interesting available texts for the twelfth and the first half of the thirteenth century came from within the frontiers of modern France and England. From the mid-thirteenth to the mid-fourteenth century they came from France, England and above all from Italy. From the mid-fourteenth to the mid-fifteenth century they belong to a widening geographical range, though here too the documents which pointed in new directions converged on limited parts of Europe, above all on France, England, Burgundy, Flanders, and, once more, Italy. The volume, *Northern Renaissance Art, 1400–1600,* in this series, includes the records concerning late gothic painters and sculptors of Flanders and Germany.

To the patrons through the centuries, most of what seemed worth preserving were records of business transactions or legal papers such as ordinances, rulings and contracts. The very limited number of records of the twelfth and thirteenth centuries is, with notable exceptions, terse and factual. Unknown numbers of records of the planning and construction of the great cathedrals perished through fire or neglect during the ensuing centuries. Nor must it be forgotten that during this early phase of the gothic period historians and chroniclers were preoccupied with the recording of historical events of grave consequence, of military expeditions and dynastic strife, of crusades and voyages to distant lands and the discovery of strange men and customs. There seemed no reason —or no more than in Homeric times—to dwell on the familiar sight of the indigenous house of God, or on the treasures accumulated in this house in honor of Christ, the Virgin and the saints.

Gradually the situation changed: more documents were kept and they assumed greater variety. This is particularly true of the thirteenth- and fourteenth-century records preserved from the Tuscan city-states; it seems that there the traditional sense of the value of historical recording was joined with the sound procedure of businessmen and above all with deep civic pride, to leave behind a relatively full documentation of various building enterprises and other artistic commissions. From the end of the fourteenth century on there is full and explicit evidence in most documents of strong critical faculties and a taste and eagerness for progress, two qualities which, while present in substance in the earlier documents, frequently needed to be painstakingly extracted from the whole text. There was, in sum, no time during the entire age when the individual artist did not distinguish his own world from that which went before or when he shied away from experimenting with the new.

In closing I wish to express my gratitude for the opportunity to write this book to the editor of the series, Professor H. W. Janson, and for his patience, which has been exceptional and exceedingly generous. I wish also to thank the Radcliffe Institute, and in particular its dean, Dr. Constance E. Smith, for a fellowship for the years 1966 and 1967 which made it possible for me to prepare the book in complete pecuniary freedom among a group of friends and congenial scholars. It is impossible to convey the depth of my gratitude for the gift of those happy years. In connection with my Institute grants I was able to make full use of the Harvard University libraries, and so I cannot close without mentioning my deep appreciation of the existence of that great institution, the Widener Library. Its staff, and the staffs of the Fogg Museum and of the library of the Harvard Graduate School of Design in Robinson Hall, were infinitely kind and helpful at all times. I wish to thank for her help Professor Margaret Taylor of Wellesley College, who entered the intricacies of medieval Latin to make translations of all the Latin texts used in this book (all other translations having been done by me); and Professor Agnes A. Abbot of Wellesley College who, as many times before, briefed and guided me in all technical questions concerning medieval painting and sculpture. Above all, I thank my young friend and former student Blair McElroy for her selfless and patient assistance through all stages of the preparation of the manuscript and the final typing and ordering of the text and notes. Lastly, but not least, I want to thank my family and all my friends for their forbearance during the years I lived so entirely between the twelfth and fifteenth centuries.

Teresa G. Frisch

Contents

I

Early and High Gothic
(1140 to c. 1270)

The period between 1140 and c. 1270 covers, broadly speaking, the first and most creative epoch in the history of gothic architecture and of the arts related to it. This is not to say that 1140 designates the beginning of the experimental stage of the characteristic new style, the roots of which go back to the eleventh century; it was specifically the moment when the perfected new architecture was unequivocally set forth for the first time in the abbey church of Saint-Denis and the event was fully recorded by its abbot. The date of about 1270 is selected as the terminal date for the high gothic period because many of the historical, ideological and artistic conditions which characterized the period between 1140 and 1270 had come to an end. In 1270 Louis IX of France, who had wielded moral supremacy in the Europe of his day, and in 1272 Henry III of England, Louis' brother-in-law, died. These two most powerful European princes had, during their respective long and relatively stable reigns, supported the arts with a prodigious benevolence. About 1270 also the great scholastic philosophers passed away one by one and their theology had begun to be superseded by new ideas; Vincent of Beauvais died in 1264; Saint Thomas Aquinas and Saint Bonaventura in 1274. In architecture a saturation point had been reached, the period of large cathedral building was over in France and the last of the monumental cathedral façades, decorated with sculpture that depicted in comprehensive cycles church history and Christian dogma, were in the process of being completed. The heretofore uninterrupted flow of evolving new art forms seemed at a standstill, the momentum of an almost inexhaustible creative energy exhausted.

During this epoch France was the center of gothic architecture even though English experiments in architectural forms and techniques during the early twelfth century contributed vastly to the gothic experience. The Church was the chief patron of the arts, particularly of architecture, both for ecclesiastical and private structures. While it should be understood that kings and nobles built castles, palaces and manor houses, existing records regarding them speak more of safety and defensive concerns than of demands for comfort and beauty, as did those of a century later. Finally, it is architecture rather than any of the other arts which is the chief subject of this chapter, because it was in its architecture that this period expressed itself most eloquently, and it was architecture which led the other arts and carried them beyond the borders of France.

Very little of the original fund of contemporary information for this first gothic period has survived. What there is is mostly restricted to brief, usually spotty annotations in the records of individual religious houses concerning gifts, expenses or dedications; this information has been used and is available in every scholarly monograph concerned with the construction of individual buildings. Here a few chance surviving documents of a more descriptive character have been assembled, containing a micro-

scopic cross section of opinions, facts, conditions and situations existing at the time with regard to art; at best they are but a patchy sampler of various attitudes toward gothic art in its first phase.

ABBOT SUGER OF SAINT-DENIS: THE PATRON
OF THE ARTS

The man who commissioned and personally directed the building of the first completely gothic structure was Suger, abbot of Saint-Denis, churchman, diplomat and trusted adviser to two kings of France (1081– 1151). His passionate interest in every phase of the reconstruction of the old abbey church, his rare intelligence and his intuitive ability to evaluate the artistic experiments of his time made him a great patron of the arts. Fortunately, he was moved by circumstances and temperament to commit to writing the account of the reconstruction and embellishment of his church. He wrote it in his own and his fellow brethren's name, as he said, "in honor of the Abbey and to the Glory of God and the Holy Martyrs." Suger's account is an undisguised encomium on the beauty of the new lofty structure and the infinite variety of precious objects contained in his church.[1]

The abbey of Saint-Denis was situated in the town of Saint-Denis just to the north of Paris. Founded by King Dagobert (629–639) in memory of Saint-Denis, traditionally considered apostle of the Gauls, the monastery had enjoyed uninterrupted royal patronage. The abbey church housed the tombs of the French kings and guarded the royal coronation insignia and the abbey school was responsible for the education of many princes of the blood. At this school, as children, the later King Louis VI and Suger formed a lifelong friendship.

When Suger was ordained abbot of Saint-Denis in 1122, the abbey

[1] *Abbot Suger on the Abbey Church of Saint-Denis and Its Art Treasures,* trans. and ed. Erwin Panofsky (Princeton: Princeton University Press, copyright 1946). Passages reprinted by permission of Princeton University Press. The reader is advised to turn to this monograph for the full Latin text, the English translation and commentaries and identification of objects mentioned in the text. Minor corrections of the Latin text, which were later published by Professor Panofsky, are incorporated here; see Erwin Panofsky, "Postlogium Sugerianum," *The Art Bulletin,* XXIX/2 and 4 (1947), 19–21, 287. The history of the abbey church and its successive structural changes are exhaustively treated in the monography by Sumner McKnight Crosby, *L'Abbaye royale de Saint-Denis* (Paris: Paul Hartmann, 1953). For a more recent critical interpretation of Suger's text see Paul Frankl, *The Gothic: Literary Sources and Interpretations through Eight Centuries* (Princeton: Princeton University Press, 1960), pp. 3–24.

had been in poor condition for years. Its immense wealth in land, privileges, treasures and buildings had been dissipated. Within a few years of Suger's administration, the abbey was reorganized and reformed, its landholdings and finances had been brought back under firm control and Suger was free to give the old Carolingian church a spacious new narthex, dedicated in 1140, and a new choir, greatly enlarged, dedicated in 1144.

So strong was Suger's preoccupation with the reconstruction of his church that he discussed it in three separate treatises written between 1140 and 1148–49. The Scriptum consecrationis, *written between 1144 and 1146–47, is entirely dedicated to the account of the construction and consecration of the new narthex and chevet. His account of his administration, entitled by its first editor* Liber de rebus in administratione sua gestis, *written between 1144 and 1148–49, contains an account of the improvement of the abbey's economic condition and the story of the remodeling and embellishment of the interior of the church. The* Ordinationes, *Suger's collection of his newly formulated regulations for the monastery, written between 1140 and 1141, also contains a statute which deals with the construction and consecration of the narthex and the laying of the foundation for the new choir.*

I. DE ADMINISTRATIONE.

In the twenty-third year of our administration, when we sat on a certain day in the general chapter, conferring with our brethren about matters both common and private, these very beloved brethren and sons began strenuously to beseech me *in charity* that I might not allow the fruits of our so great labors to be passed over in silence; and rather to save for the memory of posterity, in pen and ink, those increments which the generous munificence of Almighty God had bestowed upon this church, in the time of our prelacy, in the acquisition of new assets as well as in the recovery of lost ones, in the multiplication of improved possessions, in the construction of buildings, and in the accumulation of gold, silver, most precious gems and very good textiles. For this one thing they promised us two in return: by such a record we would deserve the continual fervor of all succeeding brethren in their prayers for the salvation of our soul; and we would rouse, through this example, their zealous solicitude for the good care of the church of God. We thus devoutly complied with their devoted and reasonable requests, not with any desire for empty glory nor with any claim to the reward of human praise and transitory compensation....

XXIV. OF THE CHURCH'S DECORATION.

... The first work on this church which we began under the inspiration of God [was this]: because of the age of the old walls and their

impending ruin in some places, we summoned the best painters I could find from different regions, and reverently caused these [walls] to be repaired and becomingly painted with gold and precious colors. I completed this all the more gladly because I had wished to do it, if ever I should have an opportunity, even while I was a pupil in school.

XXV. OF THE FIRST ADDITION TO THE CHURCH.

However, even while this was being completed at great expense, I found myself, under the inspiration of the Divine Will and because of that inadequacy which we often saw and felt on feast days, namely the Feast of the blessed Denis, the Fair, and very many others (for the narrowness of the place forced the women to run toward the altar upon the heads of the men as upon a pavement with much anguish and noisy confusion), encouraged by the counsel of wise men and by the prayers of many monks (lest it displease God and the Holy Martyrs) to enlarge and amplify the noble church consecrated by the Hand Divine; and I set out at once to begin this very thing. In our chapter as well as in church I implored Divine mercy that He Who is the One, *the beginning and the ending, Alpha and Omega*, might join a good end to a good beginning by a safe middle; that He might not repel from the building of the temple *a bloody man* who desired this very thing, with his whole heart, more than to obtain the treasures of Constantinople. Thus we began work at the former entrance with the doors. We tore down a certain addition asserted to have been made by Charlemagne on a very honorable occasion ... and we set our hand to this part. As is evident we exerted ourselves incessantly with the enlargement of the body of the church as well as with the trebling of the entrance and the doors, and with the erection of high and noble towers. . . .

XXVII. OF THE CAST AND GILDED DOORS.

Bronze casters having been summoned and sculptors chosen,[2] we set up the main doors on which are represented the Passion of the Saviour and His Resurrection, or rather Ascension, with great cost and much expenditure for their gilding as was fitting for the noble porch. Also [we set up] others, new ones on the right side and the old ones on the left

[2] Suger's distinction between bronze *casters* and bronze *sculptors* implies a division of work between the casters, who were called in from the outside for the highly specialized job of casting, and the sculptors, who were artists who probably came from among a crew already in the employment of the monastery. It was they who made the models for the door reliefs and later chased and polished the cast door leaves; Panofsky, *Suger*, p. 159 n. 146. As will be seen in Chapter II of this book, a similar arrangement was made 190 years later, when the first doors for the Florentine baptistry were cast.

beneath the mosaic which, though contrary to modern custom,[3] we ordered to be executed there and to be affixed to the tympanum of the portal. We also committed ourselves richly to elaborate the tower[s] and the upper crenelations of the front, both for the beauty of the church and, should circumstances require it, for practical purposes. Further we ordered the year of the consecration, lest it be forgotten, to be inscribed in copper-gilt letters in the following manner:

> "For the splendor of the church that has fostered and exalted him,
> Suger has labored for the splendor of the church.
> Giving thee a share of what is thine, O Martyr Denis,
> He prays to thee to pray that he may obtain a share of Paradise.
> The year was the One Thousand, One Hundred, and Fortieth
> Year of the Word when [this structure] was consecrated."

The verses on the door, further, are these:

> "Whoever thou art, if thou seekest to extol the glory of these doors,
> Marvel not at the gold and the expense but at the craftsmanship of
> the work.
> Bright is the noble work; but, being nobly bright, the work
> Should brighten the minds, so that they may travel, through the true
> lights,
> To the True Light where Christ is the true door.
> In what manner it be inherent in this world the golden door defines:
> The dull mind rises in truth through that which is material
> And, in seeing this light, is resurrected from its former submersion."

And on the lintel:

> "Receive, O stern Judge, the prayers of Thy Suger;
> Grant that I be mercifully numbered among Thy own sheep."

XXVIII. OF THE ENLARGEMENT OF THE UPPER CHOIR.

In the same year, cheered by so holy and so auspicious a work, we hurried to begin the chamber of divine atonement in the upper choir where the continual and frequent Victim of our redemption should be sacrificed in secret without disturbance by the crowds. And, as is found in

3 Both Panofsky, *Suger*, pp. 161–63, and Frankl, *The Gothic*, pp. 17–18, attribute Suger's choice of a mosaic for the old northern portal of the west façade instead of relief sculpture, which would have been more in accordance with the rest of his new façade, to his love for shiny and glittering things. This interpretation seems to oversimplify the facts, for it seems highly improbable that Suger should not have "comprehended" that mosaic had become old-fashioned, as Professor Frankl implies; the wording of this passage is explicitly apologetic; Suger's remark on the subject sounds as if the mosaic had been forced upon him by others—possibly for reasons of tradition. Whatever the reason, Suger clearly wished to make sure that posterity would be aware that he knew what he was doing when he selected the old-fashioned over the new in this particular instance.

[our] treatise about the consecration of this upper structure, we were mercifully deemed worthy—God helping and prospering us and our concerns—to bring so holy, so glorious, and so famous a structure to a good end, together with our brethren and fellow servants. . . . How much the Hand Divine Which operates in such matters has protected this glorious work is also surely proven by the fact that It allowed that whole magnificent building [to be completed] in three years and three months, from the crypt below to the summit of the vaults above, elaborated with the variety of so many arches and columns, including even the consummation of the roof. Therefore the inscription of the earlier consecration also defines, with only one word eliminated, the year of completion of this one, thus:

> "The year was the One Thousand, One Hundred, Forty and
> Fourth of the Word when [this structure] was consecrated."

To these verses of the inscription we choose the following ones to be added:

> "Once the new rear part is joined to the part in front,
> The church shines with its middle part brightened.
> For bright is that which is brightly coupled with the bright,
> And bright is the noble edifice which is pervaded by the new light;
> Which stands enlarged in our time,
> I, who was Suger, being the leader while it was being accomplished."

Eager to press on my success, since I wished nothing more under heaven than to seek the honor of my mother church which with maternal affection had suckled me as a child . . . we devoted ourselves to the completion of the work and strove to raise and to enlarge the transept wings of the church [so as to correspond] to the form of the earlier and later work that had to be joined [by them]. . . .

XXXI. Of the Golden Altar Frontal in the Upper Choir.

Into this panel, which stands in front of his most sacred body, we have put, according to our estimate, about forty-two marks of gold; [further] a multifarious wealth of precious gems, hyacinths, rubies, sapphires, emeralds, and topazes, and also an array of different large pearls—[a wealth] as great as we had never anticipated to find. You could see how kings, princes, and many outstanding men, following our example, took the rings off the fingers of their hands and ordered, out of love for the Holy Martyrs, that the gold, stones, and precious pearls of the rings be put into that panel. Similarly archbishops and bishops deposited there the very rings of their investiture as though in a place of safety, and offered them devoutly to God and His Saints. And such a crowd of dealers in precious gems flocked in on us from diverse dominions and regions that we did not wish to buy any more than they hastened to sell, with everyone contributing donations. . . .

Since it seemed proper to place the most sacred bodies of our Patron Saints in the upper vault as nobly as we could, and since one of the side-tablets of their most sacred sarcophagus had been torn off on some unknown occasion, we put back fifteen marks of gold and took pains to have gilded its rear side and its superstructure throughout, both below and above, with about forty ounces. Further we caused the actual receptacles of the holy bodies to be enclosed with gilded panels of cast copper and with polished stones, fixed close to the inner stone vaults, and also with continuous gates to hold off disturbances by crowds; in such a manner, however, that reverend persons, as was fitting, might be able to see them with great devotion and a flood of tears. . . .

XXXIII.

We hastened to adorn the Main Altar of the blessed Denis where there was only one beautiful and precious frontal panel from Charles the Bald, the third Emperor; for at this [altar] we had been offered to the monastic life. We had it all encased, putting up golden panels on either side and adding a fourth, even more precious one; so that the whole altar would appear golden all the way round. On either side, we installed there the two candlesticks of King Louis, son of Philip, of twenty marks of gold, lest they might be stolen on some occasion; we added hyacinths, emeralds, and sundry precious gems; and we gave orders carefully to look out for others to be added further. . . .

But the rear panel, of marvelous workmanship and lavish sumptuousness (for the barbarian artists were even more lavish than ours), we ennobled with chased relief work equally admirable for its form as for its material, so that certain people might be able to say: *The workmanship surpassed the material.* . . .

Often we contemplate, out of sheer affection for the church our mother, these different ornaments both new and old. . . . Thus, when—out of my delight in the beauty of the house of God—the loveliness of the many-colored gems has called me away from external cares, and worthy meditation has induced me to reflect, transferring that which is material to that which is immaterial, on the diversity of the sacred virtues: then it seems to me that I see myself dwelling, as it were, in some strange region of the universe which neither exists entirely in the slime of the earth nor entirely in the purity of Heaven; and that, by the grace of God, I can be transported from this inferior to that higher world in an anagogical manner. I used to converse with travelers from Jerusalem and, to my great delight, to learn from those to whom the treasures of Constantinople and the ornaments of Hagia Sophia had been accessible, whether the things here could claim some value in comparison with those there. When they acknowledged that these here were the more important ones, it occurred to us that those marvels of which we had heard before might have been

put away, as a matter of precaution, for fear of the Franks, lest through the rash rapacity of a stupid few the partisans of the Greeks and Latins, called upon the scene, might suddenly be moved to sedition and warlike hostilities;[4] for wariness is preeminently characteristic of the Greeks. Thus it could happen that the treasures which are visible here, deposited in safety, amount to more than those which had been visible there, left [on view] under conditions unsafe on account of disorders. From very many truthful men, even from Bishop Hugues of Laon, we had heard wonderful and almost incredible reports about the superiority of Hagia Sophia's and other churches' ornaments for the celebration of Mass. If this is so— or rather because we believe it to be so, by their testimony—then such inestimable and incomparable treasures should be exposed to the judgment of the many....

XXXIV.

We also changed to its present form, sympathizing with their discomfort, the choir of the brethren, which had been detrimental to health for a long time on account of the coldness of the marble and the copper and had caused great hardship to those who constantly attended service in church; and because of the increase in our community (with the help of God), we endeavored to enlarge it.

We also caused the ancient pulpit, which—admirable for the most delicate and nowadays irreplaceable sculpture of its ivory tablets—surpassed human evaluation also by the depiction of antique subjects, to be repaired after we had reassembled those tablets which were moldering all too long in, and even under, the repository of the money chests; on the right side we restored to their places the animals of copper lest so much and admirable material perish, and had [the whole] set up so that the reading of Holy Gospels might be performed in a more elevated place. In the beginning of our abbacy we had already put out of the way a certain obstruction which cut as a dark wall through the central nave of the church, lest the beauty of the church's magnitude be obscured by such barriers....

Moreover, we caused to be painted, by the exquisite hands of many masters from different regions, a splendid variety of new windows, both below and above; from that first one which begins [the series] with the *Tree of Jesse* in the chevet of the church to that which is installed above the principal door in the church's entrance....

4 There is a curiously prophetic note in these words, and one may perhaps venture to think that Suger, the astute diplomat and interpreter of human emotions, was aware, as early as his own time, of the covetous desires among his countrymen and others for the accumulated treasures of the Byzantine Empire, appetites which sixty years later were to lead to the sack of Constantinople in the fourth crusade in 1204.

Now, because [these windows] are very valuable on account of their wonderful execution and the profuse expenditure of painted glass and sapphire glass, we appointed an official master craftsman for their protection and repair, and also a goldsmith skilled in gold and silver ornament, who would receive their allowances and what was adjudged to them in addition, viz., coins from the altar and flour from the common storehouse of the brethren, and who could never neglect their duty to look after these [works of art].

We further caused to be composed seven candlesticks of enamelled and excellently gilded [metal] work, because those which Emperor Charles had offered to the blessed Denis appeared to be ruined by age.

XXXIV A.

... We also offered to the blessed Denis, together with some flowers from the crown of the Empress, another most precious vessel of prase, carved into the form of a boat, which King Louis, son of Philip, had left in pawn for nearly ten years; we had purchased it with the King's permission for sixty marks of silver when it had been offered to us for inspection. It is an established fact that this vessel, admirable for the quality of the precious stone as well as for the latter's unimpaired quantity, is adorned with "verroterie cloisonnée" work by St. Eloy which is held to be most precious in the judgment of all goldsmiths. . . .

We also procured for the services at the aforesaid altar a precious chalice out of one solid sardonyx,[5] which [word] derives from "sardius" and "onyx"; in which one [stone] the sard's red hue, by varying its property, so strongly contrasts with the blackness of the onyx that one property seems to be bent on trespassing upon the other. . . .

SCRIPTUM CONSECRATIONIS II.

... Through a fortunate circumstance attending this singular smallness [of the existing church]—the number of the faithful growing and frequently gathering to seek the intercession of the Saints—the aforesaid basilica had come to suffer grave inconveniences. Often on feast days, completely filled, it disgorged through all its doors the excess of the crowds as they moved in opposite directions, and the outward pressure of the fore-

5 This chalice of sardonyx (agate), gold, silver gilt, gems and pearls was in the treasury of the abbey of Saint-Denis until the French Revolution. Its history during the following century and a half is filled with intrigue, mystery and, eventually, good luck, for it was rediscovered unharmed in 1923 after it had been acquired for the Widener Collection in Philadelphia in 1922. With the rest of this collection it entered the National Gallery in Washington, D.C., in 1940; Panofsky, *Suger*, p. 205, and William D. Wixom, *Treasures from Medieval France*, Exhibition Catalogue, Cleveland Museum of Art (Cleveland, Ohio: 1967), pp. 70, 353, with an excellent photograph facing p. 70.

most ones not only prevented those attempting to enter from entering but also expelled those who had already entered. At times you could see, a marvel to behold, that the crowded multitude offered so much resistance to those who strove to flock in to worship and kiss the holy relics, the Nail and Crown of the Lord, that no one among the countless thousands of people because of their very density could move a foot; that no one, because of their very congestion, could [do] anything but stand like a marble statue, stay benumbed or, as a last resort, scream. . . .

Since in the front part, toward the north, at the main entrance with the main doors, the narrow hall was squeezed in on either side by twin towers neither high nor very sturdy but threatening ruin, we began, with the help of God, stenuously to work on this part, having laid very strong material foundations for a straight nave and twin towers, and most strong spiritual ones of which it is said: *For other foundation can no man lay than that is laid, which is Jesus Christ.* Leaning upon God's inestimable counsel and irrefragable aid, we proceeded with this so great and so sumptuous work to such an extent that, while at first, expending little, we lacked much, afterwards, expending much, we lacked nothing at all and even confessed in our abundance: *Our sufficiency is of God.* Through a gift of God a new quarry, yielding very strong stone, was discovered such as in quality and quantity had never been found in these regions. There arrived a skillful crowd of masons, stonecutters, sculptors and other workmen, so that—thus and otherwise—Divinity relieved us of our fears and favored us with Its goodwill by comforting us and by providing us with unexpected [resources]. . . .

In carrying out such plans my first thought was for the concordance and harmony of the ancient and the new work. By reflection, by inquiry, and by investigation through different regions of remote districts, we endeavored to learn where we might obtain marble columns or columns the equivalent thereof. Since we found none, only one thing was left to us, distressed in mind and spirit: we might obtain them from Rome (for in Rome we had often seen wonderful ones in the Palace of Diocletian and other Baths) by safe ships through the Mediterranean, thence through the English Sea and the tortuous windings of the River Seine, at great expense to our friends and even requiring payment of passage money to our enemies, the near-by Saracens. For many years, for a long time, we were perplexed, thinking and making inquiries—when suddenly the generous munificence of the Almighty, condescending to our labors, revealed to the astonishment of all and through the merit of the Holy Martyrs, what one would never have thought or imagined: very fine and excellent [columns]. Therefore, the greater acts of grace, contrary to hope and human expectation, Divine mercy had deigned to bestow by [providing] a suitable place where it could not be more agreeable to us, the

greater [acts of gratitude] we thought it worth our effort to offer in return for the remedy of so great an anguish. For near Pontoise, a town adjacent to the confines of our territory, there [was found] a wonderful quarry [which] from ancient times had offered a deep chasm (hollowed out, not by nature but by industry) to cutters of millstones for their livelihood. Having produced nothing remarkable thus far, it reserved, we thought, the beginning of so great a usefulness for so great and divine a building— as a first offering, as it were, to God and the Holy Martyrs. Whenever the columns were hauled from the bottom of the slope with knotted ropes, both our own people and the pious neighbors, nobles and common folk alike, would tie their arms, chests, and shoulders to the ropes and, acting as draft animals, drew the columns up; and on the declivity in the middle of the town the diverse craftsmen laid aside the tools of their trade and came out to meet them, offering their own strength against the difficulty of the road, doing homage as much as they could to God and the Holy Martyrs. There occurred a wonderful miracle worthy of telling which we, having heard it ourselves from those present, have decided to set down with pen and ink for the praise of the Almighty and His Saints.

III.

On a certain day when, with a downpour of rain, a dark opacity had covered the turbid air, those accustomed to assist in the work while the carts were coming down to the quarry went off because of the violence of the rain. The ox-drivers complained and protested that they had nothing to do and that the laborers were standing around and losing time. Clamoring, they grew so insistent that some weak and disabled persons together with a few boys—seventeen in number and, if I am not mistaken, with a priest present—hastened to the quarry, picked up one of the ropes, fastened it to a column and abandoned another shaft which was lying on the ground; for there was nobody who would undertake to haul this one. Thus, animated by pious zeal, the little flock prayed: "O Saint Denis, if it pleaseth thee, help us by dealing for thyself with this abandoned shaft, for thou canst not blame us if we are unable to do it." Then, bearing on it heavily, they dragged out what a hundred and forty or at least one hundred men had been accustomed to haul from the bottom of the chasm with difficulty—not alone by themselves, for that would have been impossible, but through the will of God and the assistance of the Saints whom they invoked; and they conveyed it to the site of the church on a cart. Thus it was made known throughout the neighborhood that this work pleased Almighty God exceedingly, since for the praise and glory of His name He had chosen to give His help to those who performed it by this and similar signs. . . .

GERVASE OF CANTERBURY: THE NEW ARCHITECTURE

Less than half a century after Suger, another twelfth-century histo-rian, Gervase of Canterbury, recorded the history of the rebuilding of the choir of his church.[6] Gervaise, like Suger, was an acute observer and an able writer and chronicler. He, however, represents a younger generation's more factual attitude toward the world around him, and this, as well as his relatively uncommitted position within the monastery, enabled him to write a more objective account than Suger's. As he followed the recon-struction of the romanesque choir of the cathedral of Canterbury in the new style, he realized, to an extraordinary degree, that he was witness to a historically important event and he took pains to explain the new forms in adequate new terms.[7] His grasp of the subtleties of gothic architecture rank him among the great art critics of all time.

Little is known about Gervase's personal life except what appears in his writing. It is assumed that he was born about 1141 in the county of Kent. He was a monk at the cathedral of Canterbury from 1163 to 1210. He was at Canterbury in the years of strife between Henry II and Thomas à Becket, years of conflict which ended with the murder of the archbishop in the cathedral in 1170. In 1193 Gervase became sacristan of the monastery and died there in 1210.

The tract Of the Burning and Repair of the Church of Canterbury *is brief and to the point. Gervase follows the description of the fire of 1174 and its damage to the church as he had known it with a graphic and concise year-by-year account of the reconstruction of the choir and cross-ing. He mentions the mode of procuring an architect, the time consumed in erecting each new part of the structure, the way in which old portions were adapted and worked up and, above all, the way in which new pro-portions, new forms, new spatial concepts and new tactile volumes were*

[6] The English translation of the Latin tract *Gervasii Cantuariensis tracta-tus de combustione et reparatione Cantuariensis ecclesiae* is taken from Robert Willis, *The Architectural History of Canterbury Cathedral* (London: Longman and Co., W. Pickering, and G. Bell, 1845), pp. 32–62. Willis breaks the original text into sections. Also from Willis comes the background information on the earlier history of the church. Wherever Willis' translation of the Latin uses antiquated or insufficient technical terms, his terminology has been replaced with the one used by Frankl, *The Gothic*, pp. 24–35; special mention is made wherever Frankl's wording replaces Willis'. Passages reprinted by permission of Princeton University Press. Copyright, 1960. Geoffrey Webb, *Architecture in Britain: The Middle Ages*, The Pelican History of Art, ed. Nikolaus Pevsner, 2nd ed. (London: Penguin Books, Ltd., 1965), pp. 72–74; figs. 44, 45, pls. 64–66, should be consulted for illustrations. For the Latin text see Julius von Schlosser, *Quellenbuch zur Kunstgeschichte des abendländischen Mittelalters*, N.F., VII (Vienna: Carl Graeser, 1896), 252–65.

[7] Frankl, *The Gothic*, p. 34.

achieved. It took exactly ten building seasons to construct the new choir. Gervase's description comes to an end in 1184 with a brief summation of its completion.

1. *The Conflagration.* In the year of grace one thousand one hundred and seventy-four, by the just but occult judgment of God, the church of Christ at Canterbury was consumed by fire, in the forty-fourth year from its dedication [1130], that glorious choir, to wit, which had been so magnificently completed by the care and industry of Prior Conrad.

Now the manner of the burning and repair was as follows. In the aforesaid year, on the nones of September [September 5, between 3:00 and 4:00 p.m.], at about the ninth hour, and during an extraordinarily violent south wind, a fire broke out before the gate of the church, and outside the walls of the monastery, by which three cottages were half destroyed. From thence, while the citizens were assembling and subduing the fire, cinders and sparks carried aloft by the high wind, were deposited upon the church, and being driven by the fury of the wind between the joints of the lead, remained there amongst the half rotten planks, and shortly glowing with increasing heat, set fire to the rotten rafters; from these the fire was communicated to the larger beams and their braces, no one yet perceiving or helping. For the well-painted ceiling below, and the sheet-lead covering above, concealed between them the fire that had arisen within.

Meantime the three cottages, whence the mischief had arisen, being destroyed, and the popular excitement having subsided, everybody went home again, while the neglected church was consuming with internal fire unknown to all. But beams and braces burning, the flames rose to the slopes of the roof; and the sheets of lead yielded to the increasing heat and began to melt. Thus the raging wind, finding a freer entrance, increased the fury of the fire; and the flames beginning to shew themselves, a cry arose in the church-yard: "See! see! the church is on fire."

Then the people and the monks assemble in haste, they draw water, they brandish their hatchets, they run up the stairs, full of eagerness to save the church, already, alas! beyond their help. But when they reach the roof and perceive the black smoke and scorching flames that pervade it throughout, they abandon the attempt in despair, and thinking only of their own safety, make all haste to descend.

And now that the fire had loosened the beams from the pegs that bound them together, the half-burnt timbers fell into the choir below upon the seats of the monks; the seats, consisting of a great mass of woodwork, caught fire, and thus the mischief grew worse and worse. And it was marvellous, though sad, to behold how that glorious choir itself fed and assisted the fire that was destroying it. For the flames multiplied by this mass of timber, and extending upwards full fifteen cubits [about 25 feet], scorched and burnt the walls, and more especially injured the columns of the church.

And now the people ran to the ornaments of the church, and began to tear down the pallia and curtains, some that they might save, but some to steal them. The reliquary chests were thrown down from the high beam and thus broken, and their contents scattered; but the monks collected them and carefully preserved them from the fire. Some there were, who, inflamed with a wicked and diabolical cupidity, feared not to appropriate to themselves the things of the church, which they had saved from the fire.

In this manner the house of God, hitherto delightful as a paradise of pleasures, was now made a despicable heap of ashes, reduced to a dreary wilderness, and laid open to all the injuries of the weather.

The people were astonished that the Almighty should suffer such things, and maddened with excess of grief and perplexity, they tore their hair and beat the walls and pavement of the church with their heads and hands, blaspheming the Lord and His saints, the patrons of the church; and many, both of laity and monks, would rather have laid down their lives than that the church should have so miserably perished.

For not only was the choir consumed in the fire, but also the infirmary, with the chapel of St. Mary, and several other offices in the court; moreover many ornaments and goods of the church were reduced to ashes.

2. The Operations of the First Year. Bethink thee now what mighty grief oppressed the hearts of the sons of the Church under this great tribulation: I verily believe the afflictions of Canterbury were no less than those of Jerusalem of old, and their wailings were as the lamentations of Jeremiah; neither can mind conceive, or words express, or writing teach, their grief and anguish. Truly that they might alleviate their miseries with a little consolation, they put together as well as they could, an altar and station in the nave of the church, where they might wail and howl, rather than sing, the diurnal and nocturnal services. Meanwhile the patron saints of the church, St. Dunstan and St. Elfege, had their resting-place in that wilderness. Lest, therefore, they should suffer even the slightest injury from the rains and storms, the monks, weeping and lamenting with incredible grief and anguish, opened the tombs of the saints and extricated them in their coffins from the choir, but with the greatest difficulty and labour, as if the saints themselves resisted the change.

They disposed them as decently as they could at the altar of the Holy Cross in the nave. Thus, like as the children of Israel were ejected from the land of promise, yea, even from a paradise of delight, that it might be like people, like priest, and that the stones of the sanctuary might be poured out at the corners of the streets; so the brethren remained in grief and sorrow for five years in the nave of the church, separated from the people only by a low wall.

Meantime the brotherhood sought counsel as to how and in what

manner the burnt church might be repaired, but without success; for the columns of the church, commonly termed the *pillars* [piers], were exceedingly weakened by the heat of the fire, and were scaling in pieces and hardly able to stand, so that they frightened even the wisest out of their wits.

French and English artificers were therefore summoned, but even these differed in opinion. On the one hand, some undertook to repair the aforesaid columns without mischief to the walls above. On the other hand, there were some who asserted that the whole church must be pulled down if the monks wished to exist in safety. This opinion, true as it was, excruciated the monks with grief, and no wonder, for how could they hope that so great a work should be completed in their days by any human ingenuity.

However, amongst the other workmen there had come a certain William of Sens,[8] a man active and ready, and as a workman most skillful both in wood and stone. Him, therefore, they retained, on account of his lively genius and good reputation, and dismissed the others. And to him, and to the providence of God was the execution of the work committed.

And he, residing many days with the monks and carefully surveying the burnt walls in their upper and lower parts, within and without, did yet for some time conceal what he found necessary to be done, lest the truth should kill them in their present state of pusillanimity.

But he went on preparing all things that were needful for the work, either of himself or by the agency of others. And when he found that the monks began to be somewhat comforted, he ventured to confess that the pillars [piers] rent with the fire and all that they supported must be destroyed if the monks wished to have a safe and excellent building. At length they agreed, being convinced by reason and wishing to have the work as good as he promised, and above all things to live in security; thus they consented patiently, if not willingly, to the destruction of the choir.

And now he addressed himself to the procuring of stone from beyond sea. He constructed ingenious machines for loading and unloading ships, and for drawing cement and stones. He delivered molds for shaping the stones to the sculptors who were assembled, and diligently prepared other things of the same kind. The choir thus condemned to destruction was pulled down, and nothing else was done in this year. . . .[9]

8 Sens is a sizable town of France in the district of Champagne, 84 miles southeast of Paris. The nave of the cathedral, which was completed about 1168, has several peculiarities in common with the work of Canterbury; Willis, *Architectural History*, p. 35; n.e.

9 At this point Gervase inserts the early history of the church, extracted from older chronicles. He follows this with the description of the church as he knew it before the fire. The nave, from the main crossing tower toward the west, was still the one built by Archbishop Lanfranc between 1070 and 1077, after another fire in the earlier Saxon church. Lanfranc's nave was to remain standing

5. *Operations of the First Five Years.* The master began, as I stated long ago, to prepare all things necessary for the new work, and to destroy the old. In this way the first year was taken up. In the following year, that is, after the feast of Saint Bertin (Sept. 5, 1175) before the winter, he erected four pillars [piers], that is, two on each side, and after the winter two more were placed, so that on each side were three in order.[10] Above these and above the outside wall of the aisles he erected appropriate arches and vaulting, namely, three vaulted compartments . . . on each side. I use the word keystone . . . for the whole quadripartite vault . . . because the keystone, placed in the middle, locks and unites the parts coming from each side. The second year of building ended with these works [1176].

In the third year he set two piers on each side, adorning the two outermost ones [farthest to the east] with engaged columns of marble and making them main piers, since in them crossing . . . and arms of the transept were to meet. After he had set upon these the quadripartite vaults . . . with the [complete] vaulting, he supplied the lower triforium from the principal tower [the old tower over the crossing in Lanfranc's edifice] to the above mentioned piers of the crossing, that is, to the [new western] transept, with many marble columns. Over this triforium he placed another triforium of different material, and the upper windows. Furthermore [he built] the three ribbed vaults of the great vault [of the nave of the choir], namely, from the [old] tower over the crossing to the [new eastern] transept. All of this seemed to us and to all who saw it incomparable and worthy of the highest praise. Joyful, therefore, at this glorious beginning and hopeful of its future completion, we were solicitous to hasten the accomplishment of the work, our hearts full of fervent longing. With that the third year was ended and the fourth begun.

In that summer [1178] he erected ten piers, starting from the transept . . . five on a side. The first two of these he decorated with marble engaged columns and constituted piers of the crossing like the two other

until the second half of the fourteenth century. Coming from Normandy, where he had grown up and was abbot of the Abbaye-aux-Hommes at Caen until his departure for Canterbury, Lanfranc rebuilt his new church after such Norman models as the abbey church of Jumièges, which was completed in 1067 shortly before his departure for England. Lanfranc's choir, however, had been rebuilt within one generation between 1100 and 1126 in the fully developed Romanesque style, and it was this choir whose destruction Gervase witnessed in 1174.

10 In the annals of these operations the "years" of which Gervase speaks begin with the 6th of September, the day following St. Bertin's Day, on which the fire occurred. At the end of the first year's operations Gervase says: "In the following year, that is, after the feast of St. Bertin," such and such works were done before the winter, and such and such works after the winter; only in summing up his enumeration of the works of the third year does he mention specifically the work done during the remaining months of the calendar year between September 5, 1177, and the period when the winter put a stop to the works; Willis, *Architectural History,* pp. 49–50; n.g.

[western] ones. Above these he set ten arches and the vaults. But after the two triforia and the upper windows on both sides were completed and he had prepared the machines . . . for vaulting the great vault,[11] suddenly the beams broke under his feet, and he fell to the ground, stones and timbers accompanying his fall, from the height of the capitals of the upper vault, that is to say, of fifty feet. Thus sorely bruised by the blows from the beams and stones he was rendered helpless alike to himself and for the work, but no other person than himself was in the least injured. Against the master only was this vengeance of God or spite of the devil directed.

The master, thus hurt, remained in his bed for some time under medical care in expectation of recovering, but was deceived in this hope, for his health amended not. Nevertheless, as the winter approached, and it was necessary to finish the upper vault, he gave charge of the work to a certain ingenious and industrious monk, who was the overseer of the masons; an appointment whence much envy and malice arose, because it made this young man appear more skillful than richer and more power-ful ones. But the master reclining in bed commanded all things that should be done in order. Thus the vault between the four main piers was completed; in the keystone of this quadripartite ribbed vault . . . the choir and the arms of the transept seem, as it were, to convene. . . . Two quadri-partite ribbed vaults were also constructed on each side before winter [1178]. Heavy continuous rains did not permit of more work. With that the fourth year was concluded and the fifth begun [September 6, 1178]. In the same year, the fourth [1178], there occurred an eclipse of the sun [September 13, 1178] at the sixth hour before the master's fall.[12]

And the master, perceiving that he derived no benefit from the physicians, gave up the work, and crossing the sea, returned to his home in France. And another succeeded him in the charge of the works; William by name, English by nation, small in body, but in workmanship of many kinds acute and honest. He in the summer of the fifth year [1179] finished the cross [transept] on each side, that is, the south and the north, and turned the ciborium [put the vault] over the great Altar, which the rains of the previous year had hindered, although all was prepared. Moreover, he laid the foundation for the enlargement of the church at

11 The text between note 10 and this point is from Frankl, *The Gothic,* pp. 27–28.

12 This is, of course, the autumn of the fourth calendar year since the fire. The partial eclipse of the sun of September 13, 1178, was visible in Canterbury between approximately ten and twelve o'clock, and Gervase gives a detailed ac-count of all its phases. The fall of master William occurred about five o'clock in the afternoon of the same day. We notice that the master had prepared the machines (scaffoldings?) for vaulting the great vault by September 1178. After the accident the master's substitute completed the vault of the eastern transept; then work was interrupted by rain; Frankl, *The Gothic,* pp. 28–29 and n. 12; Willis, *Architectural History,* pp. 49–50, n.g. Frankl's version of the text, pp. 28–29, is used starting with "Thus the vault between . . ."

the eastern part, because a chapel of St. Thomas [Becket] was to be built there.

For this was the place assigned to him; namely, the chapel of the Holy Trinity, where he celebrated his first mass, where he was wont to prostrate himself with tears and prayers, under whose crypt for so many years he was buried, where God for his merits had performed so many miracles, where poor and rich, kings and princes, had worshipped him, and whence the sound of his praises had gone forth into all lands.

The master William began, on account of these foundations, to dig in the cemetery of the monks, from whence he was compelled to disturb the bones of many holy monks. These were carefully collected and deposited in a large trench, in that corner which is between the chapel and the south side of the infirmary house. Having, therefore, formed a most substantial foundation for the exterior wall with stone and cement, he erected the wall of the crypt as high as the bases of the windows.

Thus was the fifth year employed and the beginning of the sixth [autumn 1179].

6. The Entry into the New Choir. In the beginning of the sixth year from the fire, and at the time when the works were resumed [1180], the monks were seized with a violent longing to prepare the choir, so that they might enter it at the coming Easter. And the master, perceiving their desires, set himself manfully to work, to satisfy the wishes of the convent. He constructed, with all diligence, the wall which encloses the choir and presbytery. He erected the three altars of the presbytery. He carefully prepared a resting-place for St. Dunstan and St. Elfege. A wooden wall to keep out the weather [from the east] was set up transversely between the penultimate pillars [piers] at the eastern part, and had three glass windows in it.

The choir, thus hardly completed even with the greatest labour and diligence, the monks were resolved to enter on Easter Eve with the new fire.[13] . . .

7. Remaining Operations of the Sixth Year. . . . Moreover, in the same summer, that is of the sixth year, the outer wall round the chapel of St. Thomas, begun before the winter, was elevated as far as the turning [springing] of the vault. But the master had begun a tower at the eastern part outside the circuit of the wall at it were, the lower vault of which was completed before the winter.

The chapel of the Holy Trinity above mentioned was then levelled to the ground; this had hitherto remained untouched out of reverence to St. Thomas, who was buried in the crypt. But the saints who reposed in the upper part of the chapel were translated elsewhere, and lest the

13 *Cum novo igne,* that is, the lighting of the paschal candle, which took place on Easter Eve. The candle was left burning until Ascension Day; Willis, *Architectural History,* pp. 53–54; n.k,m.

memory of what was then done should be lost, I will record somewhat thereof. . . .

The translation of these Fathers having thus been effected, the chapel, together with its crypt, was destroyed to the very ground; only that the translation of St. Thomas was reserved until the completion of his chapel. For it was fitting and manifest that such a translation should be most solemn and public.[14] In the mean time, therefore, a wooden chapel, sufficiently decent for the place and occasion, was prepared around and above his tomb. Outside of this a foundation was laid of stones and cement, upon which eight pillars [piers] of the new crypt, with their capitals, were completed. The master also carefully opened an entrance from the old to the new crypt. And thus the sixth year was employed, and part of the seventh. But before I follow the works of this seventh year, it may not be amiss to recapitulate some of the previous ones which have either been omitted from negligence or purposely for the sake of brevity.

8. Explanations.[15] It was said above, that after the fire practically all the old parts of the choir were torn down and transformed into a new edifice of noble form. . . . But now it must be stated in what the difference of the two works consists. The form of the old and new piers is the same and also their thickness is the same, but their length is different. That is to say, the new piers were increased in their length by about twelve feet. In the old capitals the work was plane; in the new ones the chisel work is subtle. There, twenty-two piers stood in the passage around the choir; here, on the other hand, are twenty-eight. There, the arches and every-

14 The solemn translation of the body of Saint Thomas from the tomb in the crypt to the shrine in the chapel of the Holy Trinity behind the new choir did not take place until July 7, 1220, the fiftieth anniversary of his martyrdom. Yet the cult of the saint assumed, almost at once, a remarkable growth. The funds for the construction seem to have been at least partially supplied from the oblations at the tomb; Willis, *Architectural History*, p. 62n. We have the account of an Italian visitor to the shrine in 1496: "The magnificence of the tomb of Saint Thomas the Martyr, Archbishop of Canterbury, surpasses all belief. This, withstanding its great size, is entirely covered over with plates of pure gold; but the gold is scarcely visible from the variety of precious stones with which it is studded, such as sapphires, diamonds, rubies, and emeralds; and on every side that the eye turns, something more beautiful than the other appears. And these beauties of nature are enhanced by human skill, for the gold is carved and engraved in beautiful designs, both large and small, and agates, jaspers, and cornelians set in relief, some of the cameos being of such a size that I dare not mention it. But everything is left far behind by a ruby, not larger than a man's thumb nail, which is set to the right of the altar. The church is rather dark and particularly so where the shrine is placed, and when we went to see it the sun was nearly gone down, and the weather was cloudy; yet I saw that ruby as well as if I had it in my hand; they say it was the gift of a king of France"; L. F. Salzman, *English Life in the Middle Ages* (London: H. Milford, Oxford University Press, 1926), p. 278. Salzman establishes also that the evaluation of the wealth of the shrine at the time of its confiscation under Henry VIII, barely more than a generation later, was about one million pounds in modern money.

15 The text from here to note 17 is taken from Frankl, *The Gothic*, pp. 30–31.

thing else had been made flat [in relief], as though done with an axe and not with a chisel; here, there is suitable chisel work on almost all things.[16] No marble columns were to be found there, but here there are innumerable ones. There, in the passage around the choir, there were quadripartite groined vaults . . . here, they are provided with ribs . . . and keystones. . . . There, a wall, built above the piers, divided the arms of the transept from the choir, but here, not separated from the crossing, they seem to meet in the one keystone in the middle of the great vault that rests on the four main piers. There was a wooden ceiling there, adorned with excellent painting; here, there is a vault, gracefully wrought of stone and light tufa. There is only one triforium; here, there are two in the nave of the choir and a third in the aisle. All this, if one wishes to understand it, will be revealed more clearly by the sight of the church than by words. In any case, this must be known, that the new work is as much higher than the old as the upper windows, both those of the nave . . . and those of the aisles of the choir, are raised by the marble intermediate story. But lest anyone in future times be doubtful as to why the great width of the choir next to the tower should be so much contracted at its head at the end of the church, I did not consider it superfluous to give the reasons.[17] One reason is, that the two [surviving] towers of St. Anselm and of St. Andrew, placed in the circuit of each side of the old church [flanking the passage around the older choir on both sides], would not allow the breadth of the choir to proceed in the direct line. Another reason is, that it was agreed upon and necessary that the chapel of St. Thomas should be erected at the head of the church [choir], where the chapel of the Holy Trinity stood, and this was much narrower than the choir.

The master, therefore, not choosing to pull down the said towers, and being unable to move them entire, set out the breadth of the choir in a straight line, as far as the beginning of the towers. . . . Then, receding slightly on either side of the towers, and preserving as much as he could the breadth of the passage outside the choir [ambulatory] on account of the processions which were there frequently passing, he gradually and obliquely drew in his work, so that from opposite the altar . . . it might begin to contract, and from thence, at the third pillar [pier] . . . might be so narrowed as to coincide with the breadth of the chapel, which was named of the Holy Trinity. Beyond these, four pillars [piers] . . . were set on the sides at the same distance as the last, but of a different form; and beyond these other four . . . were arranged in a circle, and upon these the

16 Willis, *Architectural History*, p. 58, fig. 8 and nt, and Webb, *Architecture in Britain* pls. 65b, 66, demonstrate the differences by comparing moldings from the Romanesque choir with those from the new structure; the earlier is geometric and linear, while the later is foliated, rounded and undercut.

17 For a thoughtful clarification of Gervase's terminology, which aimed at the clearest possible distinction between different vault forms, see Frankl, *The Gothic*, pp. 31–34.

superposed work (of each side) was brought together and terminated. This is the arrangement of the pillars [piers].

The outer wall, which extends from the aforesaid towers, first proceeds in a straight line, is then bent into a curve, and thus in the round tower the wall on each side comes together in one, and is there ended. All which may be more clearly and pleasantly seen by the eyes than taught in writing. But this much was said that the differences between the old and the new work might be made manifest.

9. Operations of the Seventh, Eighth, and Tenth Years. Now let us carefully examine what were the works of our mason in this seventh year from the fire [1181], which, in short, included the completion of the new and handsome crypt, and above the crypt the exterior walls of the aisles up to their marble capitals. The [aisle] windows, however, the master was neither willing nor able to turn [complete], on account of the approaching rains. Neither did he erect the interior pillars [last piers in the interior]. Thus was the seventh year finished, and the eighth begun.

In this eighth year [1182] the master erected eight interior pillars [piers at the end of the choir] ... and turned the arches and the vault with the windows in the circuit [ambulatory]. He also raised the tower [of the east crossing] up to the bases of the highest windows under the vault. In the ninth year [1183] no work was done for want of funds. In the tenth year [1184] the upper windows of the tower [over the crossing], together with the vault, were finished. Upon the pillars [piers of the transept arms] was placed a lower and an upper triforium, with windows and the great vault. Also was made the upper roof where the cross stands aloft, and the roof of the aisles [transept arms] as far as the laying of the lead. The tower was covered in, and many other things done this year. In which year Baldwin bishop of Worcester was elected to the rule of the church of Canterbury on the eighteenth kalend of January, and was enthroned there upon the feast of St. Dunstan next after. . . .

ON THE QUESTION OF THE PARTICIPATION OF THE COMMON PEOPLE IN THE BUILDING OF GOTHIC CHURCHES

Nineteenth-century romantic literature, including the early litera-ture on gothic art, abounds in allusions to the pious enthusiasm of the common people of the Middle Ages for their beautiful churches, which caused them to assist physically in their construction. Modern research, on the other hand, has viewed with skepticism all accounts of this nature, maintaining that the occasionally hysterical pitch of the faith of the

masses was encouraged and precipitated by irresponsible priests and monks interested in channeling this dumb devotion into monetary donations and free services.[18]

Curiously enough, both these interpretations rest on the same documented incidents: in 1144, when the cathedral of Chartres was undergoing extensive repair and reconstruction, a pious assembly of pilgrims and local people at Chartres pulled carts heavily laden with building materials and other provisions up the hill toward the cathedral, driven to this act by their love for the Virgin Mary and for her ancient shrine. There are two letters of 1145 which tell of this event as well as of its emotion-laden reverberations as far away as Normandy. Excerpts of both letters follow, written by Hugh d'Amiens, archbishop of Rouen, to Thierry, bishop of Amiens, and by Haimon, abbot of Saint-Pierre-sur-Dives, to the monks of Tutbury Abbey in England. It should be remembered that Suger also claimed that crowds voluntarily hauled carts laden with building materials while construction went on at Saint-Denis. This implies that the general enthusiasm for the rebuilding of Saint-Denis was great, and that, in fact, the pulling of carts at Saint-Denis preceded the events at Chartres. Professor Panofsky suggests that Suger was already familiar with the demonstrations at Chartres and in Normandy and that he was also familiar with the eleventh-century Chronicle of Montecassino, written by Leo of Ostia, who, when speaking of the construction of that abbey church between 1066 and 1071, mentioned that ecstasy of faith led the masses to dragging carts laden with material toward the monastery.[19]

Nonetheless, it would be historically wrong to dismiss as meaningless all church annals speaking of the concern and the participation of the local populace in the important events of their cathedrals or churches.[20] *Gervase of Canterbury, it may be remembered, speaks in a matter-of-fact way of the participation of the people of Canterbury in trying to quench the fire at the cathedral, and his account, though anything but flattering, is not without sympathy. Other accounts too, predominantly of the twelfth and first quarter of the thirteenth century, speak of the sharing by citizens in the joyful and tragic events of their local churches. It would*

[18] Frankl, *The Gothic,* pp. 22, 209; Arthur Kingsley Porter, *Medieval Architecture: Its Origins and Development* (New Haven: Yale University Press, 1912), II, 153–59.

[19] Panofsky, *Suger,* pp. 214–15, reminds us that Hugh, archbishop of Rouen, a frequent guest at Saint-Denis and a close friend of Suger, does not confirm Suger's claim that Saint-Denis was the first site of what is called the cult of carts. Panofsky suggests that Suger used all these sources to dramatize his own account.

[20] No one has been more explicit in condemning greedy priests and recurring excesses of superstitious beliefs among the common people than some of the leading theologians and teachers of the twelfth and thirteenth centuries; see G. G. Coulton, *Life in the Middle Ages,* I (Cambridge: At the University Press, 1928), for passages from Guibert de Nogent, pp. 15–22, Peter the Chanter, pp. 36–39, and Jacques de Vitry, pp. 56–58.

seem reasonable to assume that, in that as yet intimately interrelated world, the members of the clergy derived comfort from the devoted support of the citizenry, and that the drama of the Church's pageant was to a certain degree directed to and dependent upon the participation of the masses. Two further excerpts, one taken from the records of the bishops of Auxerre and the other from the records of the bishops of Le Mans, may demonstrate this interrelation.

Letter of Hugh d'Amiens, Archbishop of Rouen, to Thierry, Bishop of Amiens

Hugh, priest of Rouen to the Reverend Father Thierry, Bishop of Amiens; may thou ever prosper in Christ. The great works of the Lord are shown in all His designs. At Chartres they commenced in humility to draw carts and beams for the construction of the church, and this humility brought forth miracles. The fame of these spread abroad and excited our Normandy. Therefore our diocesans, having accepted our blessing, went to Chartres and fulfilled their vows. After this, in a similar manner, they commenced to come from throughout our diocese to their own cathedral church of Rouen, having made this condition, that no one should come in their company unless he should first confess and repent, and unless he should lay aside wrath and envy. Thus those who were formerly enemies came into abiding concord and peace. These requisites filled, one among them is made chief, at whose command they drag with their own arms the carts, advancing in humility and silence, and bringing thus their offering not without discipline and tears. These three conditions which we have related,—confession with penitence, the laying aside of all malevolence, humility and obedience in following their leader, we required from them when they came to us, and we received them piously, and absolved and blessed them if these three conditions were fulfilled. While in this spirit they were accomplishing their journey, very many miracles took place in our churches, and the sick who had come with them were made whole. And we permitted our diocesans to go out of our see, but we forbade them to go to those excommunicated or under the interdict. These things were done in the year of the incarnation of the word 1145. Farewell.[21]

Letter of Haimon, Abbot of Saint-Pierre-sur-Dives, to the Monks of Tutbury Abbey in England

Brother Haimon . . . to his most sweet Brethren and fellow-servants in Christ that dwell at Tutbury.

Who ever saw, who ever heard, in all the generations past, that

[21] Porter, *Medieval Architecture*, pp. 156–57.

kings, princes, mighty men of this world, puffed up with honors and riches, men and women of noble birth, should bind bridles upon their proud and swollen necks and submit them to waggons which, after the fashion of brute beasts, they dragged with their loads of wine, corn, oil, lime, stones, beams, and other things, necessary to sustain life or to build churches, even to Christ's abode? Moreover, as they draw the waggons we may see this miracle that, although sometimes a thousand men and women, or even more, are bound in the traces (so vast indeed is the mass, so great is the engine, and so heavy the load laid upon it), yet they go forward in such silence that no voice, no murmur, is heard; and, unless we saw it with our eyes, no man would dream that so great a multitude is there. When again, they pause on the way, then no other voice is heard but confession of guilt, with supplication and pure prayer to God that He may vouchsafe pardon for their sins; and, while the priests there preach peace, hatred is soothed, discord is driven away, debts are forgiven, and unity is restored betwixt man and man. If, however, anyone be so sunk in evil that he will not forgive those who have sinned against him, nor obey the pious admonition of the priests, then is his offering forthwith cast down from the waggon as an unclean thing; and he himself, with much shame and ignominy, is separated from the unity of the sacred people. There at the prayers of the faithful ye may see the sick, and those that are vexed with divers diseases, arise whole from the waggons on which they had been laid.... When, therefore, the faithful people ... set on their way again with bray of trumpets and waving of banners borne before, then marvellous to relate, the work went on so easily that nothing hindered them on their way, neither steep mountains nor deep waters rolling between.... When they were come to the church, then the waggons were arrayed around it like a spiritual camp; and all that night following this army of the Lord kept their watches with psalms and hymns....

Such sacred scenes had first taken place in connection with the building of the church at Chartres, and thence the holy institution came to be established among us in consequence of innumerable miracles; at last it spread throughout the length and breadth of almost all Normandy, and especially was established in almost all places dedicated to the Mother of Mercy.... The multitude of faithful ran hither from different and very remote parts of the world, and here obtained the speedy fulfilment of their petitions in whatsoever necessity they supplicated.[22]

[22] The first two paragraphs of this letter are from Coulton, II (1929), 18–22. His translation breaks off before the end of the original letter; the third paragraph is taken from Porter, *Medieval Architecture* p. 153. The Latin text of both letters is given in Victor Mortet, *Recueil de textes relatifs à l'histoire de l'architecture et à la condition des architectes en France au moyen âge, XIᵉ–XIIᵉ siècles* (Paris: A. Picard et fils, 1911), II, 64ff.

From the Records of the Bishops of Auxerre,
the Episcopate of Guillaume de Seignelay,
Bishop of Auxerre between 1207 and 1220

For 1215. How the bishop had the old building of the church of Auxerre demolished in order to construct the new. At the same time the construction of new churches everywhere heightened people's zeal. And so the bishop, seeing his own church at Auxerre, which was of ancient and crude construction, suffering from neglect and old age, while others all around were lifting their heads in marvelous beauty, determined to provide it with [a] new building so that it might not be inferior to these others in form and treatment. He had the east end completely torn down so that, as the squalor of the old was removed, it might become rejuvenated in the elegant shape of its reconstruction. The building of the first years, as the church lifted its head aloft beyond what had been hoped for, proclaimed the great generosity with which he poured large sums of money into it; indeed he disbursed for the work's expenses about seven hundred livres of his own in the first year, apart from the offerings of the faithful and the income from the land under his jurisdiction which he had assigned to it at the beginning; and at times in the remaining years, ten livres a week, at times approximately a hundred sols [sous], apart from the sums aforementioned and the taxes from his own and neighboring dioceses.[23]

For 1217. Concerning the fall and miracle of the towers. Incidentally it is urgent that . . . that miracle be told . . . which is known to have occurred in the demolition of the old structure. Now in the year 1217 on the Sunday before Advent, we were celebrating the day in honor of the Holy Trinity. In the old church there were on either side two towers of no small height and of vast solidity, one south, one north, containing beneath them the whole width of the choir and the choir stalls. Since the buttresses (*antae*) of the old structure, which used to support them firmly, had been removed for the new building, these towers began to crack, at first only by a small fissure, thanks to their cohesion over so many years. No one anticipated that they could collapse so speedily. During this service . . . (not only the smaller but the larger bells were being rung) . . . the southern tower spread with a more than ordinary gap; some, observing this, began to talk, and this reached the clergy. The architect was summoned as the third hour approached. He was asked whether there were any immediate danger of collapse of the towers and whether the clergy could safely celebrate the divine service below. Upon his steadfast assur-

[23] As far as I know, no translation into modern monetary terms has been made of these donations in money, landholdings or other property.

ance that there was nothing to fear, one of his disciples who was present said it was not safe to remain under them through the hour. The architect started to upbraid him for bringing unnecessary fear upon the clergy, pointing to certain beams stretched from tower to tower which were keeping the whole structure from falling. When he was more pressingly asked to give no assurance except of what was certain, he said, as if overcome by the persistence of his questions, "I can say nothing certain at all, being ignorant of what the future is preparing." At these words, as by some sort of presentiment, there was a consensus of opinion shared by all that, after the procession, which was now impending, was over (for it was the third hour), Mass should be celebrated in the church of the Blessed Mary, which adjoined the cathedral. This was done. Nonetheless, in customary fashion, as if there were no fear, all the bells were formally and solemnly rung. Only a strong frame would have withstood their striking, according to human reckoning; but the collapse was postponed so that both the divine power which could restrain their sudden collapse and the mercy which wanted to spare might be more evident when all the striking had ceased. Further, even as the place of holding the divine services was moved, so also were the books which were in daily use, and likewise all those that were kept in the closet under the south tower, as if everyone expected the tower to fall immediately. After Mass had been celebrated and the canons were sitting together at their meal, the southern tower, shaken violently, fell onto the opposite tower with a sudden crash, its foundations having been impaired deep within. . . . The people, aroused by the crash, came running. The northern tower still stood and seemed to rest on a solid base: all of a sudden, after scarcely half an hour, it fell to earth and cast the whole mass of its weight on the one that had fallen earlier. . . .

The devotion of the people, evoked by the proclamation of the priests, made them eager to remove the rubble. The outer walls of both towers had survived the collapse. What remained of the south tower had a fissure and cavity that constantly threatened immediate collapse; nevertheless, the dedicated people and others hired for wages exerted themselves to remove the rubble, and the danger of imminent collapse did not deter them in their zeal.[24]

From the Records of the Bishop of Le Mans, the Episcopate of Geoffrey of Loudun, Bishop of Le Mans between 1234 and 1255

For 1254. The dedication of the new choir of the cathedral and the simultaneous translation into this choir of the relics of Saint Julian

24 Victor Mortet and Paul Deschamps, *Recueil de textes relatifs à l'histoire de l'architecture et à la condition des architectes en France au moyen âge* (Paris: Editions Auguste Picard, 1929), II, 202–9; translated from the Latin by Professor Margaret E. Taylor, Wellesley College.

by Bishop Geoffrey of Loudun on April 20, 1254. And now let us hear with what honor the bishop transferred the body of the Most Blessed Julian to the new structure. . . . In order to bring to happy fulfillment the desire of all Mans, he and the chapter ordered that a day be appointed on which the body of the Most Blessed Julian should be transferred to the new structure. This was done a week after Easter Monday, 1254.

On the morning after the Easter service, in the church of the Most Blessed Confessor, a great multitude was at hand, of every condition, sex and age of the whole city of Mans. To free the church of building debris they carried out the rubbish, vying with one another in their eagerness. Matrons were there with other women who, contrary to the way of women, not sparing their good clothes, carried the gravel outside the church in various garments, in clothes bright with green stripes or some other color. Many who carried the sweepings out from the church in their dresses rejoiced that the dresses themselves were stained with the dirty dust. Others, filling the tiny garments of babies with the rubbish from the church, carried it outside the church. Small wonder. It was fitting that the praise of infants attend the divine work. In order that infants and little children might seem to have contributed their labor to so great a service, three-year-olds and little children in whom one could already discern signs of holy faith and who until then could scarcely walk carried the dirt outside the church in their own little garments. Those who were older and stronger carried great pieces of wood and stone outside the church more quickly and easily than could be believed. The younger ones attended to light loads, according to their strength, while the older ones, according to theirs, toiled to carry heavy ones. In a short time they did voluntarily what many hired men had not accomplished over long periods of time. And this they did on their holiday, without interruption and without having been asked to do so. What more need be said? Such was the zeal of people's faith, such the ardor of their devotion, that onlookers marveled. The people also wished the light within their hearts to be made visible without. Hence they resolved and ordered that each trade should provide candles of a size according to its means, to burn on the solemn day. Some of the larger trades made candles containing two hundred pounds of wax; others made candles of different weights, according to their means. . . . Apart from the great number of these candles, the church provided candles around the choir and arranged in a circle in the presbytery. There were also little holders in the nave of the church adorned with a great number of candles. . . . It is a pleasure to tell also of the locksmiths and vinedressers, who, seeing the candles of the others and having done nothing themselves, said to one another, "Others have made light for the moment; let us make windows to lighten the church in the future."[25] They made a window having five lancets in which they

[25] For the style and quality of the stained glass in the choir of the cathedral, see *Le Vitrail français, sous la haute direction du Musée des Arts Décoratifs de Paris* (Paris: Editions des Deux Mondes, 1958), pp. 155–56.

themselves are depicted in their trades. Nor did we think we should withhold praise of them, simply because they made a window in which they depicted themselves in their trades, for, after all, they did make a splendid window.... The day is at hand, awaited by all but most eagerly desired by Bishop and Clergy, who long for the transfer from the squalor and cramped size of the old building to the beauty and spaciousness of the new cathedral.[26]

TWELFTH-CENTURY CRITICS OF THE NEW ARCHITECTURE

The Church has always maintained the attitude of encouraging the artistically beautiful, in that the beautiful leads man to greater awareness of the Sublime Godhead; it has condemned beauty for its own sake under the title of Pride and Luxury, two of the Vices offending against the Laws of Holy Scripture. This broad and open, if not ambivalent, position of the Church produced a wide range of interpretations within the medieval institutions of the Church and among its spokesmen. Each generation produced those who looked with grave misgivings at the corrupting influence of a style of life other than of the severest and simplest kind; witness the considerable number of monastic orders of the twelfth and early thirteenth century which chose to follow the example of the strict Rules of the Cistercians in modeling their customs, rejecting all sources and manifestations of luxury and wealth.[27] Almost immediately, warning and shocked voices were raised from outside the monastic establishment against the new architecture. We hear, for instance, several of the theologians and moralists teaching at the Schools of Paris launch their rebuke against the lavish building of their time, a rebuke which may have been provoked by the construction, before their eyes, of the cathedral of Paris, in building since 1163, under the episcopate of Maurice of Sully.

One such critic was the English scholar Alexander Neckam (ca. 1157–1217), educated at the abbey school of Saint Alban's and at the Schools of Paris, where he then taught for many years. He continued teaching after his return to England and finally became abbot of Ciren-

[26] Mortet and Deschamps, pp. xiv and 257–59, translated from the Latin by Professor Margaret Taylor. The choir was begun after agreement on its size was reached in 1217; see A. Ledru, *La Cathédrale du Mans Saint-Julien*, 2nd ed. (Le Mans: Imprimerie E. Benderitter, 1923), p. 9.

[27] Dom David Knowles, *The Monastic Order in England: A History of Its Development from the Times of St. Dunstan to the Fourth Lateran Council, 943–1216* (Cambridge: At the University Press, 1940), p. 210.

cester. His manual De naturis rerum, *which in general deals with the scientific knowledge of his time, contains the following brief chapter on contemporary architecture.*[28]

Chapter CLXXII. Of Buildings. The extent of human affectation is shown in part by the expenditures dedicated to pleasure which an empty boastful pride consumes and squanders in the superfluous magnificence of buildings. Towers are erected that threaten the stars, excelling the peaks of Parnassus. The summit of Nysa [one of the peaks of Parnassus in Thessaly] marvels that it cannot equal the heights achieved by human toil and skill; nature complains that she is surpassed by art. Are the builders of lofty towers striving to take from the spirits, whose dwelling-place is the misty air, their own places and abodes? O affectation! O vanity! O vain affectation! O affected vanity! Man, suffering from the disease of his fickleness, "destroys, builds, changes the square for the round" [Horace, *Epist.* I, 1, 100].

Now the appearance of the building lot is made level with the roller, now the roughness of the surface is vanquished by frequent assaults of the builder's ram, now with stakes, thrust into the vitals of the earth, the firmness of the base is tested. There rises and is lifted up the high wall built of stone and mortar according to rule of level and plumbline. The smooth surface of the wall is due to the leveling and polishing of the mason's trowel.

One must, however, understand that no walls, even those built of wooden beams, are parallel. Suppose that wooden walls have been constructed so proportionally that they are no thicker at the bottom than the top, still the surfaces will not be equidistant. For it is inevitable that the farther the walls rise from the earth, the greater will the distance between them be found to be. For since every object naturally gravitates toward a center, understand that walls gravitate toward the center of the earth, and you will find that the walls themselves are joined [with each other] at an angle; do you see how spokes extending from the hub of the chariot wheel are joined at a greater and greater distance until they are wed to the rim itself? Thus also do walls rise, looking to the vault of the sky.[29]

[28] Alexander Neckam, *De naturis rerum, libro duo, with Neckam's Poem De laudibus divinae sapientiae,* ed. Thomas Wright (London: Longman, Green, Longman, Roberts and Green, 1863); Mortet and Deschamps, pp. 179–80, with comments; translated from the Latin by Professor Margaret Taylor. See also Victor Mortet, "Hugue de Fouilloi, Pierre le Chantre, Alexander Neckam et les critiques dirigées au douzième siècle contre le luxe des constructions," *Mélanges d'histoire offerts à M. Charles Bémont par ses amis et ses élèves à l'occasion de la XXVᵉ année de son enseignement à l'Ecole Pratique des Hautes Etudes* (Paris: Librairie Félix Alcan, 1913), pp. 105–37.

[29] The preceding paragraph is both instructive and amusing, for Neckam, who clearly has not the slightest notion of architectural principles, displays here his erudition by quoting from the Aristotelian principles of the gravitation of objects toward the center of the earth. According to Professor Charles Haskins,

A roof is superimposed, consisting of wooden beams and panels. What shall I say of the carvings and paintings except that wealth gives way to folly? Roofs that keep out the weather would suffice. But from the time that luxury, destroyer of wealth, and deadly ambition subjected men of the city to the yoke of wretched slavery, so many and such unlawful inventions have been devised that no one would have strength to count them. Presumably it was necessary for carved capitals to support the spiderwebbings. Behold the superfluous and vain contrivances connected with buildings, clothing, food, trappings, furniture and finally various adornments, and rightly will you be able to say: "O vanity! O superfluity!"

Another comment on the same subject occurs in the Summa theologica, *written after 1180 by Peter the Chanter, one of the greatest teachers of theology at the Schools of Paris for twenty-five years. He was a member of the chapter of Notre-Dame in Paris and was known to his contemporaries as "a man mighty in word and in deed." He died in 1197.*[30]

Chapter LXXXVI. Against the Superfluity in Building. Even as, in the superfluity and curiousness of raiment and food, the labour of nature is perverted and the matter falleth into wrong if it be without art, so also is it in the superfluity, curiousness and sumptuosity of buildings. For behold how far we are departed from the simplicity of the ancients in this matter of buildings.... Wherefore said a certain clerk of Reims, *If these builders believed that the world would ever come to an end, no such lofty masses would be reared up to the very sky, nor would such foundations be laid even in the abysses of the earth.*[31] Wherein they

Aristotle's *De caelo* was translated into Latin from the Arabic by Gerard of Cremona in the second half of the twelfth century, and Neckam's application of this newly available knowledge, which must have reached the Schools of Paris and other centers of learning very quickly, is remarkable evidence of the rapid spread of information among scholars of the twelfth century; Charles H. Haskins and Dean Putnam Lockwood, "The Sicilian Translators of the Twelfth Century and the First Latin Version of Ptolemy's *Almagest,*" *Harvard Studies in Classical Philology,* XXI (1910), 82.

[30] J. P. Migne, *Patrologia latina,* Vol. 205, Chap. lxxxvi, cols. 255ff.; the translation from the Latin used here is from Coulton, II, 25–28. Marcel Aubert, *Notre-Dame de Paris: Sa place dans l'histoire de l'architecture du XII^e au XIV^e siècle* (Paris: H. Laurens, 1920), p. 63, suggests that Peter's attack on the superfluity of building was mainly directed against the extravagantly costly building of the cathedral.

[31] The italics are mine, for here the great theologian goes to the very heart of the conflict between the teaching of the Church and its display of luxury. And a few lines later, Peter's reference to the building of churches and monasteries with the "ill-gotten gains" of usury reflects his known violent objections, as a teacher or theology, to the acceptance by the Church of this kind of expiatory donation; see Aubert, *Notre-Dame de Paris,* p. 28n, and his reference to Caesarius of Heisterbach (ca. 1180–ca. 1240), who recounts in his *Dialogus miraculorum* an episode on the divergence of opinion in this matter between

resemble those giants who built the tower of Babel.... Moreover, this superfluity and costliness of buildings and stone walls is a cause why we have in these days less pity and alms for the poor; since we are not rich enough to feed them while we spend also upon such superfluous expenses. ... As one prelate said to another, "What meaneth this loftiness of your buildings? Wherefore have ye towers and bulwarks withal? Thou shalt not, thereby be better defended against the Devil, but all the nearer to him." Moreover this lust of building is testified by the palaces of princes, reared from the tears and the money wrung from the poor. But monastic or ecclesiastical edifices are raised from the usury and breed of barren metal among covetous men ... and whatsoever is built from ill-gotten gains is in much peril of ruin: for as Ovid saith [*Elegy* 1]: "A sordid prey hath no good issue." For example, Saint Bernard wept to see the shepherds' huts thatched with straw, like unto the first huts of the Cistercians, who were then beginning to live in palaces of stone, set with all the stars of heaven.... Men sin even in building churches; for their heads [*caput*] should be more lowly than their bodies for the sake of the mystical idea which they symbolize, since He who is at our head, which is Christ, is more humble than His Church.[32] To-day on the contrary the choirs of churches are built higher and higher.

THE SYMBOLISM OF CHURCHES AND
CHURCH ORNAMENTS

One particular type of twelfth- and thirteenth-century scholastic writing is concerned with the symbolic and mystical interpretation of the church edifice and its ornaments. This was a subject with which theologians were familiar, for symbolic allusions to church buildings or their parts exist from the time of the Early Church, when they were coined in the spontaneous and often brilliant metaphors of the Church Fathers. Over the following centuries, the number of such symbolic images multiplied, but it was left to the thirteenth century to produce systematic glossaries on this subject.

One such text, forming the first book of a treatise on the symbolism

Maurice de Sully, archbishop of Paris and builder of the cathedral, and Peter the Chanter; see also *The Dialogue on Miracles, Caesarius of Heisterbach (1220–1235)*, trans. H. von E. Scott and C. C. Swinton Bland (London: George Routledge and Sons, Ltd., 1929), I, Chap. xxxiii, "Of Contrition," 119–20.

32 See also paragraph 14 of the text by Durand which follows. Both Durand and Peter use the Latin word *caput* to denote the apse of a church as well as to designate Christ as the "head" of the Church.

of the Christian Ritual, the Rationale divinorum officiorum, *was written about 1286 by the French churchman and professor of canon law and onetime bishop of Mende, William Durand (1230–1296). The modern reader, who has been thoroughly conditioned to see gothic architecture as symbolic of the Christian transcendental thinking of that time, will be amazed to discover that Durand is completely oblivious to the nature of the architecture of his own time. This brings to light the fact that, even among the most learned men of the gothic period, there were probably only a few like Suger and Gervase of Canterbury who grasped the magnitude of the new formal solutions in architecture and fully saw the lofty structure as an expression of their time.*

Of a Church and Its Parts.

1. First of all, let us consider a church and its parts. The word church hath two meanings: the one, a material building, wherein the Divine Offices are celebrated: the other, a spiritual fabrick, which is the Collection of the Faithful. The church, *that is* the people forming it, is assembled by its ministers, and collected together into one place by Him Who maketh men to be of one mind in an house (Psalm 68:6). For as the material church is constructed from the joining together of various stones, so is the Spiritual Church by that of various men.

2. The Greek *ecclesia* is in Latin translated by *convocatio,* because it calleth men to itself: the which title doth better befit the spiritual than the material church.

The material typifieth the spiritual Church: as shall be explained when we treat of its consecration. Again, the Church is called Catholick, that is universal, because it hath been set up in, or spread over, all the world, because the whole multitude of the faithful ought to be in one congregation, or because in the Church is laid up the doctrine necessary for the instruction of all.

3. It is also called in Greek *synagoga,* in Latin *congregatio,* which was the name chosen by the Jews for their place of worship: for to them the term synagogue more appropriately belongeth, though it be also applied to a church. But the Apostles never call a church by this title, perhaps for the sake of distinction.

4. The Church Militant is also called *Sion:* because, amidst its wanderings, it expecteth the promise of a heavenly rest: for Sion signifieth *expectation.* But the Church Triumphant, our future home, the land of peace, is called Jerusalem: for Jerusalem signifieth *the vision of peace.* Also, the church is called the *House of God:* also sometimes *Kyriake,* that is, the *Lord's House.* At others *Basilica,* (in Latin, a royal palace), for the abodes of earthly kings are thus termed: and how much more fittingly our Houses of Prayer, the dwelling-places of the King of Kings! Again, it

is called *temple,* from *tectum amplum,* where sacrifices are offered to GOD: and sometimes the *tabernacle of God,* because this present life is a journey, and a progress to a lasting Country: and a tabernacle is an hostelrie: as will be explained when we speak of the Dedication of a church. And why it is called the *Ark of the Testimony,* we shall say in the ensuing chapter, under the title Altars. Sometimes it is called *Martyrium,* when raised in honour of any Martyr; sometimes *capella,* (chapel,) ... sometimes *caenobium,* at others *sacrificium*; sometimes *sacellum*; sometimes the *House of Prayer*: sometimes *monastery*: sometimes *oratory*. Generally, however, any place set apart for prayers is called an oratory. Again, the Church is called the *Body of* CHRIST: sometimes a *Virgin,* as the Apostle saith, THAT I MAY PRESENT YOU AS A CHASTE VIRGIN TO CHRIST (II Cor. 11:2): sometimes a *Bride,* because CHRIST hath betrothed Her to Himself, as saith the Gospel: HE THAT HATH THE BRIDE, IS THE BRIDEGROOM (John 3:29): sometimes a *Mother,* for daily in Baptism She beareth sons to GOD: sometimes a *Daughter,* according to that saying of the Prophet, INSTEAD OF THY FATHERS THOU SHALT HAVE CHILDREN (Psalm 45:16): sometimes a *Widow,* because SHE SITTETH SOLITARY THROUGH HER AFFLICTIONS, AND, LIKE RACHEL, WILL NOT BE COMFORTED. ...

7. Now a church is to be built on this fashion. The foundation being prepared, according to that saying, IT FELL NOT, FOR IT WAS FOUNDED UPON A ROCK (Matt. 7:25). ...

8. The foundation must be so contrived, as that the Head of the Church may point due East ... that is, to that point of the heavens, wherein the sun ariseth at the equinoxes; to signify, that the Church Militant must behave Herself with moderation, both in prosperity and adversity: and not towards that point where the sun ariseth at the solstices, which is the practice of some. ...

10. The cement, without which there can be no stability of the walls, is made of lime, sand, and water. The lime is fervent charity, which joineth to itself the sand, that is, undertakings for the temporal welfare of our brethren: because true charity taketh care of the widow and the aged, and the infant, and the infirm: and they who have it study to work with their hands, that they may possess wherewith to benefit them. Now the lime and the sand are bound together in the wall by an admixture of water. But water is an emblem of the SPIRIT. And as without cement the stones cannot cohere, so neither can men be built up in the heavenly Jerusalem without charity, which the HOLY GHOST worketh in them. All the stones are polished and squared,—that is, holy and pure, and are built by the hands of the Great Workman into an abiding place in the Church. ...

14. The arrangement of a material church resembleth that of the human body: the Chancel, or place where the Altar is, representeth the head: the Transepts, the hands and arms, and the remainder,—towards

the west,—the rest of the body. The sacrifice of the Altar denoteth the vows of the heart. . . .

15. Furthermore, the church consisteth of four walls, that is, is built on the doctrine of the Four Evangelists; and hath length, breadth, and height: the height representeth courage,—the length fortitude, which patiently endureth till it attaineth its heavenly Home; the breadth is charity, which, with long suffering, loveth its friends in GOD, and its foes for GOD; and again, its height is the hope of future retribution, which despiseth prosperity and adversity, hoping TO SEE THE GOODNESS OF THE LORD IN THE LAND OF THE LIVING (Psalm 27:13).

16. Again, in the Temple of GOD, the foundation is Faith, which is conversant with unseen things: the roof, Charity, WHICH COVERETH A MULTITUDE OF SINS (I Peter 4:8). The door, Obedience, of which the LORD saith, IF THOU WILT ENTER INTO LIFE, KEEP THE COMMANDMENTS (Matt. 19:17). The pavement, humility, of which the Psalmist saith, MY SOUL CLEAVETH TO THE PAVEMENT (Psalm 119:25).

17. The four side walls, the four cardinal virtues, justice, fortitude, temperance, prudence. . . . But some churches are built in the shape of a Cross, to signify, that we are crucified to the world, and should tread in the steps of The Crucified. . . . Some also are built in the form of a circle: to signify that the Church hath been extended throughout the circle of the world. . . .

18. The Choir is so called from the harmony of the clergy in their chanting, or from the multitude collected at the divine offices. . . .

19. The Exedra is an apsis, separated a little from a temple or palace; so called because it projecteth a little from the wall. . . .

21. The towers are the preachers and Prelates of the Church, which are Her bulwark and defence. . . .

22. The cock at the summit of the church is a type of preachers. For the cock, ever watchful even in the depth of night, giveth notice how the hours pass, wakeneth the sleepers, predicteth the approach of day, but first exciteth himself to crow by striking his sides with his wings. There is a mystery conveyed in each of these particulars. The night is this world: the sleepers are the children of this world who are asleep in their sins. The cock is the preacher, who preacheth boldly, and exciteth the sleepers to cast away the works of darkness, exclaiming, WOE TO THEM THAT SLEEP! AWAKE THOU THAT SLEEPEST! (Eph. 5:14). . . .

24. The glass windows in a church are Holy Scriptures, which expel the wind and the rain, that is all things hurtful, but transmit the light of the True Sun, that is, GOD, into the hearts of the Faithful. These are wider within than without, because the mystical sense is the more ample, and precedeth the literal meaning. Also, by the windows the senses of the body are signified: which ought to be shut to the vanities of this world, and open to receive with all freedom spiritual gifts. . . .

26. The door of the church is CHRIST: according to that saying in the Gospel, I AM THE DOOR (John 10:9). The Apostles are also called doors. . . .

27. The Piers of the church are Bishops and Doctors: who specially sustain the Church of God by their doctrine. . . . The bases of the columns are the Apostolic Bishops, who support the frame of the whole Church. The capitals of the Piers are the opinions of the Bishops and Doctors. For as the members are directed and moved by the head, so are our words and works governed by their mind. The ornaments of the capitals are the words of Sacred Scripture, to the meditation and observance of which we are bound.

28. The pavement of the church is the foundation of our faith. But in the spiritual Church the pavement is the poor of CHRIST: the poor in spirit, who humble themselves in all things. . . .

29. The beams which join together the church are the princes of this world, or the preachers who defend the unity of the Church, the one by deed, the other by argument.[33]

THE CHRONICLE OF SAINT ALBAN'S CONCERNING SOME OF THE ABBEY'S ARTISTIC ENDEAVORS

For the most part, monastic and episcopal records speak of building activities and the acquisition or the production of art works in simple matter-of-fact terms, even though the recording cleric, in mentioning events of his own time, succeeds in conveying the pleasure and pride of the community not only in the richness but in the beauty of an artistic achievement. A few pages from the chronicle of the ancient and powerful abbey of Saint Alban's in Hertfordshire may convey how this recording was done, interspersed as it was with running accounts of historical, church historical and purely local administrative occurrences.[34]

[33] Translated from the Latin and published under the title *The Symbolism of Churches and Church Ornaments* by John Mason Neale and Benjamin Webb (Leeds: n.p., 1843), pp. 17–30.

[34] *Gesta abbatum monasterii Sancti Albani* (Cottonian MS. Claudius E. IV, British Museum), ed. Henry Thomas Riley (London: Longmans, Green, Reader and Dyer, 1867), I (A.D. 793–1290), translated from the Latin by Professor Margaret Taylor. The *Gesta* commence with the founding of the Benedictine abbey of Saint Alban's by Offa, king of Mercia, in A.D. 793, and the nomination of Willegod as first abbot. They end with the closing days of Abbot Thomas de la Mare, who died in 1396. The first part comes largely from the pen of no less a person than Matthew Paris, whom we quote here. He informs us that he used existing older chronicles of the monastery for the account of that part which preceded him. An Englishman, historian of distinction and monk of Saint Alban's from 1217, Paris was, as historiographer to Henry III, familiar with the events

Abbot Simon [1167–1183] of pious memory[35] started to collect from that time, zealously and with foresight and wisdom, a considerable treasure of gold and silver and precious stones, and to fashion the outside of the repository which we call a reliquary or *feretrum* (than which we have seen none finer at this time), undertaken by the hand of Master John, goldsmith and most excellent craftsman. He completed this most painstaking, costly and artistic work most successfully within a few years. He placed it in a prominent position, namely above the main altar, facing the celebrant, so that anyone celebrating Mass at this altar would have before his eyes and in his heart the memory of the Martyr [Saint Alban]; thus facing the celebrant was portrayed the martyrdom, that is, the beheading. Moreover, around the reliquary, namely on the two sides, he had clearly depicted a series from the life of the Blessed Martyr, which consisted of his passion and the preparation for his passion, with raised figures of gold and silver, which is embossed work (commonly called relief). On the main side, which faced east, he reverently placed the image of the Crucified with the figures of Mary and John in a most fitting arrangement of divers jewels. On the side facing west he portrayed the Blessed Virgin enthroned and holding her child on her lap, an outstanding work surrounded by gems and precious jewels. And thus, with a row of martyrs arranged on both sides of the lid, the reliquary rises to an elaborate and artistic crest; at the four corners it is beautifully and harmoniously shaped with windowed turrets covered by crystals. In this [reliquary] then, which is of extraordinary size, is appropriately enclosed the reliquary of the Martyr himself (being, as it were, his own chamber in which his severed bones are known to be contained), a fitting repository first commissioned by Abbot Geoffrey. . . .[36]

The same Abbot Simon also had made and bestowed to his everlasting renown, and to the glory of God and the church of the Blessed Martyr Saint Alban, a great golden chalice than which we have seen no finer in the kingdom of England. It is of the best and purest gold, encircled by precious stones appropriate to the material in such a work, made most subtle with a delicate and fine composition of interwoven flowers.

of his century both in England and on the Continent. His part of the *Gesta* ends in 1255. Part II is a compilation by an anonymous hand and ends in the year 1308. Part III, beginning in 1308 with the abbacy of Hugh of Eversdone, ends with Abbot Thomas de la Mare in 1396. It is "undoubtedly" (editor Riley's comment) written in the hand of the prolific historian Thomas Walsingham, monk at Saint Alban's at the time of Richard II and head of the scriptorium. It was he who put the several parts of the chronicle into one piece.

[35] Abbot Simon was the nineteenth abbot of Saint Alban's. A prominent scholar in his own right, he was also friend and confidant of Thomas à Becket.

[36] Geoffrey was the sixteenth abbot of Saint Alban's (1119–1146). On page 83 of the *Gesta,* covering the first quarter of the twelfth century, it is mentioned that the reliquary of the saint was then begun by Anketil, also a monk at Saint Alban's and a goldsmith, a man who, for a while between 1100 and 1110, was supervisor of the Royal Mint and goldsmith at the court of the king of Denmark. Anketil's work is called "subtle and elegant" by the chroniclers. The relics of the saint were translated into Anketil's shrine in 1129.

This chalice was made by Master Baldwin, a preeminent goldsmith. He also had made by the hand of the same Baldwin a small vessel, worthy of special admiration, of standard yellow gold, with jewels of divers priceless kinds fitted and properly placed on it, in which "the artistry surpassed the material";[37] this was to hold the Eucharist, to be hung over the main altar of the Martyr. When this became known to King Henry II, he sent with joy and devotion to the church of Saint Alban's a most splendid and precious cup in which was placed the repository immediately holding the body of Christ. . . .

Concerning his scribes and gifts bestowed. It is to be recorded also that this Abbot Simon of immortal memory honorably supported two or three excellent scribes in his residence; he made careful arrangements to have a priceless supply of excellent books and he stored them in a special cupboard [in the church]. He also restored the scriptorium, at that time largely dispersed and neglected, and introduced in it certain praiseworthy practices; also he increased its revenue so that in all succeeding times the incumbent abbot would continue to have a special scribe. Apart from the very valuable books, which it would take too long to enumerate, he presented silver basins and many other vessels and ornaments to God and the Church in bestowing them on the Blessed Martyr.

Under William [of Trumpington], 22nd abbot, 1214–1235. In regard to his great claim to everlasting praise I think it should be added that, amid the important events of a war so great in extent and of such a kind as we have written above,[38] he settled with wisdom all the schismatic upheavals, within and without, those that arose in the world and in the cloister, and in accordance with his will, as no one dared to speak up against him, he brought about peace, arranging all things happily. And so he began to make many embellishments, wishing to employ constantly the work and skills of Master Walter of Colchester, then sacristan,[39] while he enjoyed life and youth. I do not remember having ever seen his peer

37 Ovid, *Metamorphoses*, II, 5, according to the editor.

38 Matthew Paris' *Chronica maiora* reports fully on the bitter conflict between the Church and King John Plantagenet (1199–1216) over canonical elections, a struggle which reached its peak between 1208 and 1213; this dissension was followed immediately by the fight of the English barons with King John which culminated in the Magna Carta in 1215. Saint Alban's was in the center of many of the events in both conflicts and it bore a heavy share of the grave financial losses of all English religious houses of those years. We have Abbot William's written account on the royal extortions from Saint Alban's, which amounted in a single year to as much as a thousand marks. Equally taxing were the constant demands of the barons for money, horses, oxen, sheep, pigs, geese, cocks, wood and silver vessels, so that the total loss to the abbey and its dependencies in these years amounted to over 2500 pounds.

39 A series of art works of all descriptions were done at the monastery by Walter, William, Simon and Richard of Colchester. Two of them, Walter and Richard, became monks, and Walter was made sacristan. The nave of the abbey church appears to have possessed an amount of thirteenth-century wall paintings unique among the major churches of England. Only traces of these paintings remain, and in a much restored state. The Colchesters also painted at least one retable and other wooden panels; Nikolaus Pevsner, *The Buildings of England: Hertfordshire* (London: Penguin Books, 1953), pp. 215–16.

in most arts, nor do I believe there will be another such in the future.
Continuation of material mentioned earlier. First, he [Abbot William] most fittingly perfected the dormitory and the more secluded house adjoining it,[40] as has been touched upon before, with oaken beds and assembled the convent in it. In addition, in his time the transept arms (*alae*) of the church, roofed with oak, with beams excellently attached and joined, were repaired at the top; before that, wasted with rot and worm-holes, they had let in quantities of rain water. Also the tower roof, which projected out like a large parapet (*machina*), was raised and constructed out of excellent material, well joined, far higher than the old one, which had threatened to collapse.[41] And all these, at great expense, were covered with lead. These things, to be sure, were completed with the contribution and perseverance of Richard of Tyttenhanger, our lay monk and chamberlain, without fail or lessening of obedience; nevertheless, out of respect, they should be attributed to the abbot, for he is the doer inasmuch as anything that needs to be done is done by his authority.

Indeed the abbot, after the death of said Richard of blessed memory, had the improperly roofed tower unroofed, and, adding no small quantity of lead, had it redone more properly and conscientiously. He improved the side aisles (*collateralibus*) [of the choir], having them raised eight lengths, extending from the crossing (*tholo*) to the [east] wall, so that the octagonal tower was more clearly visible; this at his own expense, advised and counseled by Master Matthew, introduced with letters and seals and of the surname "of Cambridge." Having been found suitable, he was put in charge of the work as overseer, architect and faithful guardian of the church. Moreover he changed the roof so that it extended over the angles of the transept arms. These joints, commonly called *aristae*, both strengthened the tower marvelously and adorned it in its strength and kept back the rain more surely; before, the eight sides had been indistinct, producing a smooth, narrow and meager shape less fitting and harmonious with the wall.[42]

40 John of Cella, William's predecessor as abbot (1195–1214), had begun to repair the dormitory, the reredortor (the dormitory behind it) and the refectory from the foundations up. Around 1200 the chapter gave up its daily wine ration for fifteen years to help pay for this. The "more secluded house" may have been the reredortor.

41 The present church was first built between 1077 and 1088 by the Norman Paul of Caen, monk of Saint Etienne at Caen and fourteenth abbot, in the same place where the first church had stood, on the traditional site of the martyrdom of Saint Alban in A.D. 303.

42 *Victoria History of the Counties of England: Hertfordshire*, ed. William Page, II (London: Archibald Constable and Company, Limited, 1908), 483–515, interprets (on p. 485) this rather unclear passage in the following free manner: that at this time a tall octagonal spire of wood with a flèche on top was added and that its appearance was aesthetically improved by the addition of angle rolls and broaches at the base; the sturdier proportions thus obtained agreed better with the massive tower from which it sprang.

Continuation of material touched on earlier. Pitying and pitied for the tedious, protracted delay after the ruinous collapse of the west façade of the church, Abbot William took its restoration upon his own shoulders.[43] Thus within a short time he joined to the old structure a roof of choice timber, beams and panels with glass windows, all precisely fashioned, and had the whole covered with fine lead.

He also provided windows with glass panes in the spacious wall above the place where the monastery's great Ordinal rests, where the *minuti* are accustomed to sing Matins and the Hours.[44] In addition, he perfected many other things in the north and south aisles by giving them their glass windows, with the assistance of the custodian of the altar of Saint Amphibal. Thus the church, brightened because of the new light, seemed, as it were, renewed.

Also at this time, when Master Walter of Colchester, then sacristan (an incomparable painter and sculptor), had completed the pulpit in the center of the church with its great cross with Our Lady and Saint John and other sculpture and fitting constructions with money from the sacristy but also through his own persevering labor, Abbot William solemnly moved the shrine with the remains of the Blessed Amphibal and his companions from the place where they had formerly been (namely, near the high altar, close to the shrine of Saint Alban and north of it) to the center of the church, enclosed with a parapet of open ironwork, having constructed there a most fitting altar with an altar table and a richly embel-

[43] The west façade had been started under Abbot John of Cella when three bays were added to the existing nine old ones of the nave. The façade was to have two flanking towers and three projecting vaulted porches. Work was discontinued between 1197 and sometime after 1214, when Abbot William resumed it. He, however, abandoned the idea of flanking towers and of vaulting the porches and design, and details were also modified. On p. 218 the *Gesta* hint at the trouble which underlay the abandonment of the larger enterprise in 1197, for Abbot John of Cella's architect, Master Hugh of Goldcliff, "who showed stealth, fraud, impertinence and above all arrogance . . . so designed the work that when it was covered up for the winter in a partly finished state, the walls fractured and fell with their own weight, so that the wreck of images and flowers became the laughing stock of beholders." See John Hooper Harvey, *Gothic England: A Survey of National Culture, 1300–1550* (London: B. T. Batsford, Ltd., 1947), p. 22, from which the translation of the preceding passage comes; see also *Royal Commission on Historical Monuments and Inventory of the Historical Monuments in Hertfordshire* (London: Jas. Truscott and Son, Ltd., 1910), pp. 177–82; *Victoria History*, II, 485.

[44] A *minutio* was a monk who had just undergone bloodletting, a process all monks underwent at regular intervals for its supposed therapeutic value. Abbot Warin (1183–1195), who, among other sciences, also mastered medicine, devised detailed rules of rest and diet for monks after each bloodletting, such as a two day excuse from night offices. Thus, among other privileges, the *minuti* seem to have had to go no further than the vestry or treasury in the southeast wall of the south transept, close to the entrance to the church from the monks' dormitories and cloister; Knowles, pp. 455–56. For the ground plan of the conventual layout, see *Royal Commission*, p. 176.

lished reredos. . . .[45] Also because the outer [east end] walls, collapsing from too much damage, had been thrust out of position and shape, the abbot, at his own expense, restored those that were in ruins; in addition, he completed the molded stonework for the placement of two large glass windows[46] in order to crown his good work by having everything illuminated with appropriate lighting. He put in charge of the execution of this work Master Matthew of Cambridge, his bailiff, who quickly completed the work assigned to him in praiseworthy fashion. . . .

Concerning the transferring of beams and various statues to more suitable places in the church. This same Abbot William, after transferring the old statue of the Virgin, substituted a new one and placed the old one safely elsewhere in the church. He also transferred the old beam above the main altar (which Adam the Cellarer had made [ca. 1170]) and raised it in the south part of the church over the noble statue of Our Lady. On this beam were depicted the twelve patriarchs and the twelve apostles in a row, and in the center Christ in Glory with Church and Synagogue. Similarly, he had placed in the north [transept] part of our church the old cross, which had once been prominent in the center of the church, and the older statue of the Virgin, which had stood on the altar of the Blessed Blaise, after the substitution of the new one for the edification of laymen[47] and all who came there, and for the consolation of those engaged in the affairs of the word, that he might not in any way diminish the fine work which he had done. . . .

Concerning the painting of the great hall, with many adjoining chambers, especially designated for the entertainment of the king and other important personages, by the aforesaid abbot. . . .[48] He built a very fine hall as a guest house, with many adjacent chambers: a very fine painted one, with rooms, fireplace, atrium and an adjoining hall, called the Royal Residence (*Palatium Regium*) because it consists of two stories and has a small bath chamber. A very fine atrium adjoins the entrance, which is called a porch or antechamber. There are also many chambers for entertaining guests, very handsome with their own adjoining rooms and fireplaces. The hall that was there before had become a dark and

[45] This description seems to provide evidence of the creation of a choir screen west of the crossing at that time. *Royal Commission,* p. 186, agrees that originally the choir screen in the nave's fourth bay (the choir extended to that point) was thought to have been constructed as late as between 1349 and 1396, but that this later screen must have been a replacement for the older screen.

[46] *Royal Commission,* p. 177, confirms the opening of the two easternmost bays of the choir aisles with windows facing east.

[47] The south side of the church, and in particular the south transept, were reserved for the convent. Only the north transept was open to the townspeople, through a secondary gate.

[48] Which took place under the twenty-third abbot, John II of Hertford (1235–1260), shortly after his inauguration.

ugly ruin with old and deformed walls.[49] The roof was repaired with shingles and bricks. He had the new hall, of which we speak now, with its chapels and adjoining buildings, excellently roofed with lead.

In addition, he had it and the chamber adjoining it most appropriately painted and delightfully bordered by the hand of our monk Richard, an excellent craftsman. Likewise the abbot built a fine house, very long and of stone, roofed with tiles, with three fireplaces, opposite the great gate; by its appearance and projection the whole establishment is made charming. This house, which has two stories, appropriately has the administrative offices of the freedmen upstairs and the food storage space downstairs. . . .[50]

THE ARCHITECT OF THE FIRST CENTURIES
OF THE GOTHIC PERIOD

Villard de Honnecourt

Until the end of the thirteenth century, and frequently during the following century as well, the architect was known as "mason", and no distinction seems to have been made with regard to specialization and rank.[51] *We may assume that his professional training was that of any mason, which began with his apprenticeship as a stone cutter, and that he gradually acquired prominence because of his special gifts and his general intelligence. These led him to special tasks, which in turn probably led him to commanding technical, artistic and administrative assignments, to higher pay, and to certain exclusive social privileges. The first steps toward such a career may have been easier for the young mason who was born into a family of distinguished architects, for there is evidence that*

[49] This old hall may still have been the original royal guest house, the Queen's House, built between 1119 and 1146.

[50] Matthew Paris' part of the *Gesta* terminates at this point (1255); he may have spent many of the remaining years of his life at court. His *Historia major* ends in 1273, which may have been the year of his death. The years immediately following 1255 remain unrecorded; the *Gesta* thus leave unmentioned the fact that in 1257 the dangerous condition of the east end of the church made it necessary to pull down the two east bays to avoid collapse. It was then that the eastward extension of the church was planned, consisting of a retrochoir and a Lady Chapel. For want of money this work had to be interrupted a number of times. It was only under the twenty-seventh abbot, Hugh of Eversdone (1308–1326), and with the help of a special donation, that this project was brought to completion; *Gesta*, II, 115.

[51] Nikolaus Pevsner, "The Term 'Architect' in the Middle Ages," *Speculum*, XVII (1942), 549–62.

successive generations of certain families retained leading positions in the employment of the same patron.

The only known personal record of an architect's interests and concerns in the thirteenth century is the lodge book of Villard de Honnecourt.[52] What is known of Villard's life and career has been extracted from this lodge book. His name and dialect indicate that he was born in Honnecourt, a small town near Cambrai in northeastern Picardy at the frontiers of Artois and Flanders. We do not know the dates of his birth or death, but his style of drawing the human figure, his choice of architectural details and his observations imply that he was at the height of his career in the first part of the thirteenth century. We may assume that he received his early training near home, and perhaps at the large Cistercian abbey of Vaucelles, which was built between 1190 and 1216 and dedicated in 1235.[53] It is interesting to note that there is a ground plan of the choir of this church among his drawings.

Together with another architect, Pierre de Corbie, Villard designed a characteristically Cistercian end of a choir with double ambulatory and chapels. He drew the ground plan of the presbytery of the Cistercian church of Saint Stephen at Meaux, a church begun in 1163, far along by 1198 and rebuilt in 1253. He also drew an ideal ground plan of a Cistercian church with a rectangular choir. We may therefore assume that Villard worked for the Cistercians. He was also familiar with the plans of the cathedral of Cambrai and may have worked there, for he drew the ground plan of the choir and the elevation before the church was much beyond the planning stage. The cathedral was begun in 1227 and work

[52] *Villard de Honnecourt: Kritische Gesamtausgabe des Bauhüttenbuches MS. fr. 19093 der Pariser Nationalbibliothek,* ed. Hans R. Hahnloser (Vienna: Verlag von Anton Schroll & Co., 1953); for a more recent reinterpretation of some of the drawings and the text, see Frankl, *The Gothic,* pp. 35–54. Hahnloser's facsimile reproductions should be used for the study of Villard's drawings; all references to plates give Hahnloser's pagination. See also the frontispiece taken from Hahnloser, plt. 20, by the permission of the publishers. Hahnloser also gives a complete bibliography up to 1935 and a history of the manuscript on pp. 5, 8, 9, 189–93, 199–200. Only 33 of the manuscript's original 63 or more leaves are left. Hahnloser's assumption that the loss occurred while the lodge book was still in great demand in the lodge where it was left has much to recommend it. We have more information about the use of lodge books and single drawings from later periods. They existed in an increasing number in the fourteenth and fifteenth centuries where large-scale building enterprises were under way, as at Strasbourg, Cologne, Vienna, Ulm, Prague, Esslingen, Milan, Florence, Cambridge and London, to name a few. An architect who left the service of a patron had to leave behind all drawings he had made in connection with that particular lodge. At least from the fourteenth century on, it is known that drawings frequently served to show the employer how the finished product was to look. Beginning in 1324, English documents mention "tracing houses" in the king's works in London; Pierre du Colombier, *Les Chantiers des cathédrales* (Paris: A. et J. Picard, 1953), pp. 63–64; Hahnloser, *Villard de Honnecourt,* pp. 195–99.

[53] Unless otherwise noted, dates are taken from Hahnloser, *Villard de Honnecourt,* pp. 226–32.

*on it proceeded until sometime between 1230 and 1231, when all building
activity was interrupted. It must have been shortly after 1231 when
Villard wrote of his concern for the future of this construction while
sketching architectural details during building operations at the cathedral
at Reims where, according to his drawings, the choir and the first bays of
the nave were under construction.*[54]

*From Reims Villard went to Hungary, a journey he mentions on
several occasions. It may be that his association with the Cistercians led
to a contract there. The only artistic reminiscence of this trip is a sketch
of the floor mosaic of a church.*

*Perhaps while on his way east, Villard added to his sketches the west
towers of the cathedral at Laon of about 1210; the rose window of the
west façade at Chartres of before 1215;*[55] *and the rose window of the
south transept of the cathedral at Lausanne, also of the first quarter of
the thirteenth century.*[56]

*It is generally assumed that Villard returned from Hungary before
the Tartar invasion of 1241 and that he spent the rest of his active life in
Picardy, perhaps as master of the lodge at the collegiate church at Saint
Quentin, where one of the largest Cistercian abbey churches of France
was then being built.*[57]

*Villard's lodge book was compiled informally over a period of years
as he observed, sketched and recorded solutions to architectural and tech-
nological tasks, human and animal forms and selected other objects.
Eventually he put the drawings into a portfolio and supplied some of
them with comments. Later he added technical drawings dealing with
building methods, measurement and applied geometry for the everyday
needs of a stonemason's lodge.*

*Beyond the evidence of a competent hand in drawing, the book
reveals a discerning eye and mind, astute in absorbing and evaluating a
great variety of ideas; it shows a man conversant with the scientific, theo-
retical and artistic trends of his age. To judge from the variety of subjects
his observations encompass, his tasks must have been as numerous, diverse*

[54] Reims cathedral was begun in 1211 and the clergy entered the choir
in 1241; beyond these, no definite dates are available for that part of the build-
ing. Both Hahnloser and Frankl date Villard's visit to Reims as being about
1235. Villard may, however, have been at Reims any time after 1231, when work
at the cathedral of Cambrai was interrupted; Hahnloser, *Villard de Honnecourt,*
pp. 225–30.

[55] Louis Grodecki, "De 1200 à 1260," in *Le Vitrail français, sous la haute
direction du Musée des Arts Décoratifs de Paris* (Paris: Editions des Deux
Mondes, 1958), pp. 115–44.

[56] Hahnloser, *Villard de Honnecourt,* p. 76, points out that Villard inten-
tionally drew both rose windows—some fifteen to twenty years after their com-
pletion—to appear lighter and more delicate than they actually were, and implies
that he drew them this way to accommodate the increasing demand for lightness
of form.

[57] Hahnloser, *Villard de Honnecourt,* pp. 231, 236–37.

and demanding as those of which the Roman architect Vitruvius speaks.[58]

Villard's associates at a lodge over which he presided later in his life made some additions of a practical nature to the book. Master II, who appears to have been most closely connected with Villard, added various comments and a set of detailed technical drawings relating to the stonemason's daily tasks in applied geometry and measurement. Master III contributed only some textual additions, frequently supplementing earlier entries by Villard. Neither man added to Villard's aesthetic observations or to his collection of engineering constructions and inventions.

Villard's drawings are characteristic of the artistic trends of the first quarter of the thirteenth century. His advice is sober and direct, now and then interspersed with phrases which he must have seen in existing technical literature.[59] *Yet he never fails to convey his own opinion concerning the relative worth of an artistic or technical solution to a problem and he invariably points to the ingenious and to the uniquely satisfactory.*

When his sketchbook became a lodge book, Villard added an opening address to the reader:

Villard de Honnecourt gives you greeting and beseeches all who will work by the aids that are found in this book to pray for his soul and bear him in remembrance. For in this book one can obtain good advice on the grand craft of *maconerie* and the *engiens de carpenterie*, and you will find in it the art of drawing ... the principal features (*les trais*), as the discipline of geometry ... requires and teaches them.[60]

Villard's drawings fall into six main categories: (1) animals; (2) human figures; (3) interior furnishings and ornaments; (4) architectural drawings; (5) carpentry and wooden constructions; (6) masonry and geometry.

In view of the love for animal representations in medieval sculpture and painting for allegorical, symbolic and decorative purposes, Villard's collection is modest; animals are rendered in conventional poses as selected from illuminated bestiaries and sample books. A generation later there was to be closer observation of nature, especially in informal scenes. The

[58] See *Vitruvius: The Ten Books of Architecture,* trans. Morris Hicky Morgan (Cambridge, Mass.: Harvard University Press, 1914).

[59] Hahnloser, p. 4; Frankl, *The Gothic,* p. 48; Julius von Schlosser, "Materialien zur Quellenkunde der Kunstgeschichte," *Sitzungsberichte der Kaiserlichen Akademie der Wissenschaften in Wien,* 177/I, "Mittelalter" (Vienna: Alfred Hölder, 1914), 3–102, esp. p. 93.

[60] The English translation is Frankl's, p. 41; there and on following pages he changes the customary reading of the text to conform with his reinterpretation of the drawings on plates 35–38 and 39–41. Passages reprinted by permission of Princeton University Press. Copyright, 1960. The Old French text—"(et) si troveres le force de le portraiture, les trais, ensi come li ars de iometrie le (com)ma(n)d(e) (et) ensaigne"—is linguistically fully expounded by Hahnloser, pp. 11–17, 272–79.

drawings of a lion and of a lion training scene are the only ones Villard claims were drawn from life. This is the more remarkable because it is quite apparent that here too he used artistic conventions taken from a model book of Byzantine, late classic or oriental derivation.[61] *He says:*

The lion. I will tell you of the training of the lion. He who trains the lion has two dogs. When he wants the lion to do something and the lion growls, he beats his dogs. When the lion sees the dogs being beaten he becomes afraid and does as he is told. I will not speak of the lion when he is in a rage, for then he would not do what anybody tells him, either good or bad. And you should know that this lion was drawn from life.

Hahnloser counts 163 drawings of the human figure.[62] *They are an odd assortment of individuals and groups in biblical, allegorical and narrative scenes. Several times Villard copied the nude male figure from late classic or Byzantine models, indicating an interest in ancient art far greater than the obvious usefulness to him of these figures in the rendition of the nude in biblical representations.*

Advanced for this moment in French art is the suffering expressed in the drawings of two crucifixions, showing Christ with crossed feet pierced by a single nail; equally expressive is a Descent from the Cross, while the bust drawing of the Virgin and Child follows the style and restrained mood of the sculpture of the cathedral of Reims of about 1230. All Villard's examples are of elegant and noble proportions and are eloquent in their gestures. As has often been observed, they reflect in their proportions, poses and drapery treatment the figure style of the transept façades at Chartres and that of the north transept and the earliest west façade statues at Reims cathedral of 1224–1230.

The lodge book also contains drawings describing a great variety of aesthetically pleasing or technically ingenious interior furnishings and ornaments. For example, Villard says of Plate 11: "Of this manner was the tomb of a heathen which I once saw." He shows a full-page architectural setting of a throne with a youthful ruler dressed in a toga, with a pair of standing genii (ignudi) *holding a victory wreath above him and an altar with two acclaiming toga-draped male figures on either side of the altar below. One wonders whether Villard may have seen a stone relief of late Roman origin, showing the apotheosis of an emperor. Despite errors*

[61] Schlosser, "Materialien zur Quellenkunde," p. 93, says that "without doubt Villard did not intend to dissemble when quite clearly he did not draw from nature, for to him 'nature' meant something different from what it means to us; for a man of the Middle Ages it was impossible to consider as meaningful anything but the idea, the concept, behind the appearance of things. The natural form was like soft wax which had to yield to the artistic invention." See also Hahnloser, pp. 268–72. The next two pages in Villard's notebook show several more lions in gladiatorial scenes whose prototypes go back to Roman or Byzantine manuscripts.

[62] Hahnloser, p. 263.

of perspective, the drawing conveys clearly the original object's composi-
tional merits.
 Of Plate 12 he says:

He who wishes to make a clock-case can see here one that I once saw.
From below, the first story is square and has four gables. The story above
is eight-sided and roofed, and above that four small gables, the space
between two and two of them being empty. The uppermost story is square
with four small gables, and the turret above is eight-sided.

 And of Plate 13:

He who wishes to make a lectern from which to read the Gospel, behold
the best manner of making it. First there are three serpents which rest on
the ground and over them a three-lobed slab, and above that three ser-
pents of a different kind and columns of the same height as the serpents,
and over that a triangular slab. After this, you can see for yourself in what
manner the lectern is made. Here is its image. In the midst of the three
columns there must be a rod to carry the knob on which the eagle sits.[63]

 To this group also belong three drawings of arm rests and the wing
of a choir stall with a remarkably beautiful acanthus design. With this
goes Villard's comment: "If you wish to make a satisfactory wing of a
truly good choir stall, see this one." Similarly crisp and luxuriant foliage
occurs in several other plates.[64]
 Other objects in this group include a handwarmer, as we are told by
Villard, for use by the officiating bishop during the cold, damp winter
months. The receptacle, which looks like a brass apple, holds the charcoal
in such a way that no matter how it is turned in the pocket the hot coals
will not spill out. On the same page[65] *Villard shows one of several "won-*
ders" (mirabilia) he drew: a wine or water container working like a
siphon which, when activated, causes a small hollow bird perched on a
tiny tower in the middle of the bowl to drink the liquid.
 Judging from the number and careful execution of these drawings
and the relatively detailed comments, Villard's main interest seems to
have centered on demonstrating in the lodge book the excellence of archi-
tectural design and its structural and aesthetic effectiveness, down to the
smallest detail. On this subject, he comments:

[63] Hahnloser explains, p. 33, that the execution of this drawing is so
sketchy and in such poor perspective that it may be assumed that Villard drew
it from nature rather than from a sample book. It is in fact the first lectern of
its type to be shown in a drawing, although soon it was to become the most
commonly used type.
 [64] Hahnloser, pls. 54a, b, 57; Villard's use of the acanthus ornament to the
exclusion of other floral motifs, as with his use of the clinging pleated drapery, is
characteristic of the generation of sculptors of the early high gothic period. A
new generation of sculptors of the west façades of the cathedrals of Paris and
Amiens were already using indigenous flowers and foliage.
 [65] Hahnloser, pl. 17, d, e.

I have been in many countries, as you can judge from this book, but nowhere have I seen a tower such as the one at Laon. Notice the ground plan of the first story there where it springs at the level of the first windows. At this level the tower is surrounded by eight buttresses. Four square turrets rest on clusters of three colonnettes each. This is followed upward by open arches and a horizontal molding and more turrets with eight columns, and from between two of these an ox peers out. This in turn is followed by an arcade and a horizontal molding, and an eight-sided helmet, each side having a slit for light. Consider this carefully, for you will learn from it about how to construct and raise such a structure and how the turrets alternate in shape. And pay good heed to your work, for if you wish to make a good tower you must choose buttresses of sufficient depth. Do apply all your attention to your work, for only then can you do that which is worthy of a wise and noble man.[66]

Behold one of the windows at Reims from the bays of the nave such as they are between two piers. I was commissioned to go to the land of Hungary when I drew it because I liked it best.[67]

Behold the ground plan of the choir of the church of Our Lady of Cambrai as it rises from the ground. Earlier in this book you will find the interior and exterior elevations and the manner in which the chapels, the plain walls and also the buttresses will look.[68]

Observe here the rising structure of the chapels of the church at Reims and how they are in the interior elevation; the interior passages and the hidden vaulted-in passages; and on this other page you can see the rising structure of the chapels of the church at Reims from the exterior from floor to top, just as they are. Of such a kind will those at Cambrai have to be if one will do them justice. The topmost story must have a battlement.[69]

Behold the drawings of the elevation of the church of Reims [and] of the wall inside and outside. The first story of the aisles must form a battlemented parapet so that a passage can lead around in front of the roof.

Against this roof on the inside are [built] passageways, and, where these passages are vaulted in and paved, there the passages lead outside, so that one can walk past along the sills of the windows.

[66] Hahnloser, pls. 18, 19. On pp. 51 and 54 Hahnloser produces evidence of the admiration all through Europe for the towers of Laon but makes the point that Villard was the first to call attention to the harmony of proportions of single parts and the elegance of transitions from one level to the next.

[67] Hahnloser, pl. 20b, pp. 57–58 (and also see frontispiece); Hahnloser considers this "the most personal artistic judgment of the high Middle Ages." On this same plate also appears the half length figure of the Virgin and Child, the only representation of the Virgin and Child among Villard's drawings. (Reproduced by permission of Buch- und Kunstverlag Anton Schroll Co., Vienna).

[68] Hahnloser, pl. 28c; the drawings of the elevations are lost. Villard appears to have made all these drawings at the lodge of Cambrai with the original plans before him. When building activity was resumed in 1239 the chapels were done in a different manner.

[69] Hahnloser, pls. 60 a–c, 61.

And the topmost story must have battlements so that one can go around the roof.

Behold the manner and method of the whole elevation.[70]

Behold one of the tower piers of the church of Reims [and] one of those which stands between two chapels; and there is one which is a wall pier, and one comes from the nave of the cathedral. On all these piers the joints are as they should be.[71]

Behold the profiles of the chapels on the preceding page, of the window arches and the tracery, of the diagonal ribs and the transverse arches and wall arches above them.[72]

From the next section of the book, the chapter on carpentry and wooden constructions, a number of sketches are missing. Hahnloser ascribes this to the great demand for these drawings in the lodge. Examples of forms of timber roofs are limited to three. The majority of drawings deal with mechanical devices such as machines useful on building sites, in industry and for military operations, surprisingly similar in scope to those discussed by Vitruvius in the first century B.C.[73]

Clearly the architect continued to be called upon to function as a mechanical engineer. Villard appears completely up to date with the mechanical experiments of his own day. His book is the first to demonstrate the operation of a new waterpowered sawmill involving two separate motions; the first on record in Europe to demonstrate a perpetuum mobile, *of which he says that scientists long disputed how to make a wheel turn by itself. He seems absorbed by contemporary experiments with a mechanical clock system and demonstrates a clockwork which enables an angel on top of a church steeple to turn his hand at all times toward the sun and an eagle on a church lectern which follows the words of the deacon reading the Gospel by turning his head toward him.[74]*

Villard introduces the next section of his lodge book thus: "Here begins the art of drawing the principal features, as the discipline of geometry teaches, in order to enable one to work more easily;" and he says further, "On these four leaflets are figures from the discipline of geometry,

[70] Hahnloser, pl. 62, 63. The English translation of this and the preceding three paragraphs is taken from Frankl, *The Gothic*, p. 47. Also on p. 47 Frankl compares Villard's comment with one added later by Master III, who gives a simpler, purely practical interpretation to the complex and aesthetically important architectural detail which Villard had recorded.

[71] Hahnloser, pl. 63a–d.

[72] Hahnloser, pl. 63e–t.

[73] See *Vitruvius*, book X, where Vitruvius discusses and draws hoisting machines, water wheels, water mills, water screws, pumps, catapults, ballistae, and siege and defense machines.

[74] Lynn White, Jr., *Medieval Technology and Social Change* (New York: Oxford University Press, 1966), pp. 118, 122, 131 (with note on p. 173).

but he who wants to know for which [kind of work] each figure ought to be used has to be careful to make no mistake."[75]

There follow a number of small sketches of human and animal heads and of entire figures in various poses, by themselves or in combinations of two or more, with boldly superposed geometric shapes such as the square, the rectangle, the triangle, the pentagram and so forth that fit the individual contour. Villard shows how the same geometric figure that fits the contour of a human head also fits that of a horse and how different geometric figures may be applied to the same head. The purpose of Villard's drawings is to teach the young mason how to transfer small preparatory drawings to the size and the medium which were called for. He also demonstrates the use of the quadratic net of lines, known and used since antiquity for the determination of the standard of proportions of the human form as well as an aid in transferring a small sketch to any desired scale. Villard, however, clearly prefers his own bold method of simple geometric configurations.

Finally, Villard demonstrates the stonemason's first task, that of safe and effective building by means of mensuration. His own examples are few and highly selective. Master II wrote the text to them and added two further pages of drawings of his own with comments dealing with specific stonemason's problems, such as how to cut the voussoirs for an arch covering an oblique opening in a wall.[76]

These additional demonstrations, apparently copied from some other manual, indicate how vital these lessons in applied geometry must have been to the average stonemason in contradistinction to that which the architect had found interesting to demonstrate.

The Condition of the Architect

Some light may be shed on the professional world in which the architect of the high gothic period operated by looking at a few remaining

[75] Hahnloser, pls. 35–38; Frankl's explanation, pp. 41–46, of both text and drawings is simple and convincing. These drawings have aroused the greatest interest and have been interpreted in various ways, though most frequently as a rigorously formal system of fitting figures into a given geometric frame to standardize proportions and beauty, that is, a theory of proportions; Henry Focillon, *Art d'Occident: Le Moyen Age romain et gothique* (Paris: Librairie Armand Colin, 1938), p. 101; see also Hahnloser, pp. 211–13, who speaks of *Leitlinien*, or guiding lines for proportions, which direct the hand of the medieval craftsman, and Schlosser, "Materialien zur Quellenkunde," p. 29. Colombier, p. 89, clearly observes that the geometric configurations are imposed upon the completed figures rather than preceding them, and he raises doubt about the validity of the prevailing theories.

[76] Robert Branner, "Three Problems from the Villard de Honnecourt Manuscript," *The Art Bulletin*, XXXIX/1 (1957), 61–66.

miscellaneous documents such as regulations pertaining to the masons'
guilds, contracts, expertises, and others. Not all the texts date from before
1270, but it may be assumed that established customs and usage continued
for at least a certain length of time.[77]

Regulations concerning the Arts and Crafts of Paris of 1258

In 1258, the masons of the city of Paris deposited their oldest known
body of guild regulations.[78] *This was done within the framework of a*
much needed reorganization of the overall administration of his kingdom
by Louis IX during the last fifteen years of his reign. At that time most
guilds of Paris deposited their statutes, incorporating in them, it may be
assumed, old practices and customs. It is interesting to note that the
masons' guild regulations refer to masons without distinction of rank,
and in fact it appears that precautions were taken to preclude exemptions
of any kind for any of the members.

CHAPTER XLVIII. OF MASONS, STONE CUTTERS, PLASTERERS AND
MORTARERS.

In the city of Paris anyone who wishes to be a mason may be one,
provided he knows his trade and works according to the practices and
customs of his profession, which are defined thus:

No one may have more than one apprentice in his business, and if
he has one he must keep him for six years of service. He may well keep

[77] Within the last 25 years much excellent research has been done on the
economic and social conditions of masons. For a comprehensive survey the reader
should turn to Colombier, *Les Chantiers des cathédrales.* For conditions speci-
fically in England there is the thoroughly documented, immensely valuable
work by Douglas Knoop and G. P. Jones, *The Mediaeval Mason* (Manchester:
Manchester University Press, 3rd Edition, 1967, revised and reset, 1967); John
Hooper Harvey, *Henry Yevele c. 1320 to 1400: The Life of an English Architect*
(London: B. T. Batsford, Ltd., 1944); and L. F. Salzman, *Building in England
down to 1540: A Documentary History* (Oxford: Clarendon Press, 1952).

[78] Georges Bernhard Depping, "Réglemens sur les arts et métiers de Paris
rédigés au XIIIè siècle et connus sous le nom du Livre des Métiers d'Etienne
Boileau," *Collection de documents inédits sur l'histoire de France publiés par
Ordre du Roi et par les soins du Ministère de l'Instruction,* ser. 1, "Histoire
politique," Part I, Chap. xlviii (Paris, 1837), pp. 107–12; the text is written in
French. Boileau was provost of Paris under Louis IX. See also Hahnloser,
Villard de Honnecourt, pp. 13–14, and Frankl, *The Gothic,* App. 8, pp. 848–51,
p. 116. These are the oldest guild regulations we possess, though similar ones
must have existed elsewhere in the thirteenth century. Frankl discusses guild
regulations in Appendix 8 of his book; Knoop and Jones, *Mediaeval Mason,*
pp. 224ff, give the London Regulations for the Trade of Masons of 1355 and
1356, together with various other English regulations. It is interesting to note
that even in 1355 and 1356 no distinction was made between ranks, even though
"twelve of the most skilful men of the trade," and among them, on behalf of the
mason hewers, the then leading architect of London, were selected as spokesmen
for the trade.

him beyond this time if the man is available, but for pay. If he keeps him less than six years he will be fined twenty Paris sous, payable to the chapel of Saint Blaise,[79] unless the apprentices are his own sons born to him in wedlock.

The mason may lawfully take a second apprentice on the same terms as he took the first one after the first one has completed five years.

The king who now rules, to whom may God grant long life, has entrusted, for as long as he may see fit, authority over all masons to Master William de Saint-Patu. The said Master William swore in Paris in the palace lodge[80] that he would protect the guild of masons as best he could, with honesty and justice to the poor as well as to the rich, to the weak as well as to the powerful, as long as the king wished him to serve that guild. Master William then gave his oath in the presence of the provost of Paris in the Chastelet.[81]

Mortarers and plasterers come under the same conditions and organization as the masons.

The master who in the name of the king heads the guild of masons, mortarers and plasterers of Paris can have two apprentices only under the same conditions, as above stipulated. Should he have more apprentices he shall be fined as above stated.

Masons, mortarers and plasterers may have as many helpers and servants in their business as they please as long as they do not show any of them the fine points of their craft.[82]

All masons, mortarers and plasterers must swear to protect their craft by committing themselves to work loyally and well and to report to the master of the guild any case of infringement on the usage and customs of the craft which may come to their attention.

Masters with apprentices whose term of apprenticeship is fulfilled must come before the guild master and testify to the fact that their apprentice has accomplished his term faithfully and well, whereupon the guild master shall ask the apprentice to promise under oath to observe the practices and customs of the craft loyally and well.

No one may practice his craft after nones [3 p.m.] have been rung at Notre-Dame on Saturdays at any time during the year or after vespers

79 Saint Blaise was the patron saint of masons and carpenters.

80 It stands to reason that, if the palace lodge served as a place of jurisdiction for the masons of Paris, the disposers of the king's works had special authority.

81 The Chastelet, originally one of several forts defending the large bridge across the Seine to the inner city, became the seat of the office of the provost of Paris; Depping, p. 19.

82 This regulation is incorrectly translated by Frankl, *The Gothic,* p. 116, as "The number of *aides et vallés* is unlimited provided they are all trained." In fact, however, the text specifically says "pour tant que il ne monstrent a nul de eus nul point de leur mestier." These helpers are clearly not meant to be initiated into the mysteries of the craft.

[6 p.m.] are sung at Notre-Dame unless he is about to close an arch or a stairwell, or is about to lay the last stones of a doorway leading to the street. Should anyone work beyond these hours, with the exception of the above-indicated or similar work that cannot be postponed, he must pay a fine of four deniers [a small coin worth about one penny] to the guild master, and the guild master may take away the tools of him who repeats the offense.

Mortarers and plasterers are under the jurisdiction of the master who, in the name of the king, heads the above-mentioned guild.

If a plasterer delivers plaster for use by anyone, the mason who is employed by him to whom the plaster is sent is under oath to watch that the measure be right and honest. If he is in doubt, he must remeasure it or have it measured before his eyes. If he finds the measure to be wrong, the plasterer has to pay a fine of five sous: two sous to the above-mentioned chapel of Saint Blaise, two sous to the guild master, and twelve deniers to him who will have measured the plaster. It must, however, be proved that the same amount of plaster was missing from every donkey-load delivered for the specific job as was missing from the sack which has been measured; one sack-load by itself cannot be measured.

Nobody may be a plasterer in Paris unless he pays five Paris sous to the appointed guild master. After having paid he must promise under oath not to mix any other material with the plaster and to give good and honest measure.

If a plasterer mixes material with his plaster which should not be used, he must pay a fine of five sous to the guild master every time he repeats the offense. If the plasterer makes a habit of cheating and does not improve or repent, the guild master may suspend him from the craft; and if the plasterer will not obey the guild master, the latter must inform the provost of Paris, who must in turn force the plasterer to abandon the craft.

Mortarers must promise under oath and in the presence of the guild master and other masters of the craft that they will not make mortar of other than good binding material and, should they make it of other material so that the mortar does not set while the stones are being placed, the structure must be undone and a fine of four deniers must be paid to the master of the guild.

Mortarers may not take on an apprentice for less than six years of service and one hundred Paris sous to teach him.

With the king's authorization the guild master has jurisdiction over minor infringements and fines of masons, plasterers and mortarers and of their helpers and their apprentices. Furthermore, he has jurisdiction over the enterprises of their trade, over unauthorized (*sanz sanc?*) builders and over claims, with the exception of property claims.

Should anyone from the above-mentioned crafts, when summoned

before the guild master, fail to obey, the fine to be paid to the said master is set at four deniers; if he appears on the designated day and is guilty, he makes a pledge, and if he does not pay within the designated time he has to pay [an additional] fine of four deniers to the guild master. If he denies any wrongdoing but is at fault he also pays four deniers to the guild master.

The guild master may levy only one fine per quarrel. If the one who has to pay the fine is so furious and so beside himself that he refuses to obey the order of the master or to pay his fine, the master may bar him from the craft.

If anyone belonging to any of the above-mentioned crafts who has been excluded by order of the guild master continues to work beyond the date of exclusion, the master may take away his tools until he has paid the fine; and if he resists with force, the guild master should inform the provost of Paris, who should put down his violence.

Masons and plasterers must do guard duty and pay the taxes and other dues that all other citizens of Paris owe the king.

Mortarers have been exempt from guard duty since the time of Charles Martel, as wise men have heard it said from father to son.

The appointed guild master is exempt from guard duty as reward for the services he renders as master of the guild.

Exempt from guard duty are those who are over sixty years of age, and he whose wife is in bed for as long as she is there, provided they inform the overseer of the guard appointed by the king.

Nicolas de Biard and the Architect

The following two paragraphs come from a collection of sermons attributed to Nicolas de Biard, a Dominican preacher and writer of Paris.

The master masons, holding measuring rod and gloves in their hands, say to the others: "Cut here," and they do not work; nevertheless they receive the greater fees, as do many modern churchmen.

Some work with words only. Observe: in these large buildings there is wont to be one chief master who orders matters only by word, rarely or never putting his hand to the task, but nevertheless receiving higher wages than the others. So there are many in the church who have rich benefices, and God knows how much good they do; they work with the tongue alone, saying "Thus should you do," and they themselves do nothing.[83]

[83] Mortet and Deschamps, II, 290–91, translated from the Latin by Professor Margaret Taylor.

Burchard of Hall and the Architect of
Saint Peter in Wimpfen-im-Thal

The following passage is taken from the chronicle of the monastery of Saint Peter in Wimpfen-im-Thal, near Heidelberg, written by Burchard of Hall in about 1280 in commemoration of the reconstruction of the old church.

Richard of Ditensheim, deacon ... tore down the monastery constructed by the Reverend Father ... Peter Crudolfus, for it was in ruins because of its great age and was in danger of damaging the structures next to it. Having summoned the master mason most skilled in architecture, who had then recently come from the city of Paris in the land of France, he ordered the church to be built of ashlar stone in the French manner. Truly, then, this master built a church of marvelous workmanship, elaborately adorned within and without with images of the saints, with molded window frames and piers, a work that caused much toil and large expenditure, and even now today it so appears to human gaze; thus as people come from all directions, they marvel at so noble a work, praise the master, revere Richard as the servant of God, rejoice that they have seen him, and his name is spread abroad far and wide ... and he is very often mentioned by those to whom he is not known.[84]

Contract between Master Etienne de Bonneuil
and the Cathedral of Upsala

In 1287, a contract was drawn concerning the conditions under which Etienne de Bonneuil, master mason of Paris, was hired to become the chief architect of the cathedral of Upsala, in Sweden.

To all who see this writ, Renaut le Cras, Provost of Paris, gives greeting. Be it known to all that we, in the year of grace 1287, on the Friday before the feast of Our Lady [September 8], examined and confirmed the following contract.

To all who will see this letter, Renaut le Cras, Provost of Paris, gives greeting. We make known that before us appeared Etienne de Bonneuil,

[84] Mortet and Deschamps, II, p. 296. The passage is taken from *Burchardi de Hallis Chronicon ecclesiae Collegiatae s. Petri Winpiensis,* in J. F. Schannat, *Vindemiae litterariae Collectio Secunda* (Fulda and Leipzig, 1724), II, 59, and is translated from the Latin by Professor Margaret Taylor. Georg Dehio and G. von Betzold, *Die Kirchliche Baukunst des Abendlandes* (Stuttgart: Arnold Bergsträsser Verlagsbuchhandlung A. Kröner, 1901), II, 296, barely touch on the chronicle. The new structure was started in 1259 and the main work done while Richard of Ditensheim was deacon, between 1262 and 1278. Frankl says, p. 55, that the construction of the church went on until about 1300, but that the choir and the transept are said to have been completed by 1274.

to be master mason and master of the church of Upsala in Sweden, proposing to go to said country as he had agreed upon. And he acknowledged having rightfully received and obtained advance payment of forty Paris livres from the hands of Messrs. Olivier and Charles, scholars and clercs at Paris, for the purpose of taking with him at the expense of said church four mates and four yeomen (*bachelers*), seeing that this would be to the advantage of said church for the cutting and carving of stone there. For this sum he promised to take said workmen to said land and to pay all their expenses.

The said . . . Etienne declared himself in our presence well paid and promised to deliver the said workmen as soon as he and the men who accompany him arrive in that country, and to compensate them sufficiently in such a manner that they consider themselves well paid for everything.

And should it happen that said Etienne de Bonneuil or the mates whom he has consented to take with him to the land of Sweden should perish on the sea on their way, owing to storms or in some other manner, he and his companions and their heirs shall be clear and absolved of the entire above-mentioned sum of money. And should they go from life to death no one may claim that part of the contract in which said Etienne commits himself under oath to be held bound in person and with all his goods movable and immovable, present and future, wherever he may be found, to stand trial before us or our successors or in whatever court of justice he may find himself. Furthermore, that in that case none of the said sum of money may be claimed either by the two clercs or by those whose agents they are in said church of Sweden, either from said Etienne or from those whom he will take with him, nor from their heirs.

In witness whereof we have put on this contract the seal of the provost's office at Paris in the year of grace 1287, on the Saturday before the feast of Saints Gile and Leu [August 30], and now have sealed the transcript of these papers with the seal of the provost's office in Paris on the day indicated above.[85]

Letters of Charles II, King of Naples, concerning the Monastery and Church of Saint-Maximin in Provence

Given below are excerpts from two letters written in 1295 from the

[85] Mortet and Deschamps, II, 305–6; the contract was made in French, the original document is in the Royal Archives in Stockholm. There is general agreement that the structure of the cathedral was already well advanced when Etienne de Bonneuil went there, and also that he may not have been its first French architect. The transepts, and in particular the portal of the south transept and its sculpture, have a strong resemblance to the style of Jean de Chelles and even later details at the cathedral of Notre-Dame in Paris; these may have been the work of Bonneuil. See also Aubert, *Notre-Dame de Paris*, pp. 213–14.

chancery of Charles II concerning the royal foundation of the Franciscan monastery and church of Saint-Maximin in Provence. The first letter provides an introduction of the chief architect to Pierre d'Alamanon, bishop of Sisteron and seneschal of Provence, who was temporarily in charge of the administration of the new foundation.

Charles II, by God's grace king of Jerusalem and Sicily. . . . On behalf of Master Peter, French architect *(fabricatore)*. This is addressed to the Venerable Father, Bishop of Sisteron, Our beloved counselor and steward of Provence. . . .

I am sending to you the French Master Peter, experienced in the building of houses, churches and other works, for the construction of the church of Saint-Maximin and the Blessed Mary Magdalene, which is close to my affection. I wish and order that he be appointed to direct all those who have been assigned to the fabric because he is acknowledged as being capable and suitable for this appointment on the recommendation of a great many persons. As to Master Matthew, with whom I hear you have reached a certain agreement for the aforesaid position, let him not withdraw from the fabric, and should one of them be prevented from carrying on, let the other continue with it. It is hoped that said Peter will be well received and treated with courtesy. As long as he holds the position his wages should be such that he is satisfied, and he should be provided with a house while he remains on the job. I moreover wish the enclosed letter of mine to be given to said Master Peter to be valid for him henceforth.

Dated at Rome, through Bartholomew of Capua, proto-notary of the kingdom of Sicily, and first magistrate of its central administrative office, on the 5th of December 1295.

The second letter is addressed to the new architect, Master Peter, informing him of his appointment as chief architect of the construction of the new church and giving him full jurisdiction over the craftsmen directly connected with the construction.

On behalf of the administration and construction of the church of Saint-Maximin in Provence.

This is written to the French Master Peter, his faithful friend. . . .

Relying on thy experience in handling the art of building for which thou art widely recommended, I have thought it fit, in accordance with the purpose of this letter, that thou be put in charge of the fabric and the work which we are having done at the church of the Blessed Maximin in Provence in order that masters and laborers may be governed according to the rules customary in building enterprises and so that they may be assured of governance by rules and regulations. I entrust to thee with confidence the authority to correct and even punish in due fashion individual masters, laborers and other workmen, however they are designated, who work for thee and who are delinquent in anything pertaining to

their office. Jurisdiction is given thee by this letter, as far as is proper and necessary but with the priority of said authority in matters other than those which concern thy assignment being reserved for the regular judges.[86]

Dated at Rome through Bartholomew of Capua, soldier . . . on the 8th of December 1295.[87]

Expertise of 1316 concerning the Condition of the Cathedral of Chartres

In 1316 the cathedral of Chartres was found to be in need of repair. A detailed account of present conditions and work required to correct them was rendered by a group of master craftsmen who were retained by the chapter of the cathedral.

In the year 1316, on the Thursday after the feast of the Nativity of the Holy Virgin Mary, the report on the defects of the church made by the masters delegated by the chapter to investigate these defects, was recorded as follows.[88]

Gentlemen, we report to you that the four arches which help to carry the vaults are good and strong, the piers which carry the ribs are good, and the center of the vault which carries the keystone is good and strong. It will not be necessary to take down more than half the vault to the point where one can see what needs to be done. We have also advised that the scaffolding be moved above the molding (*enmerllement*) of the stained glass window. This scaffolding will also help to protect your choir screen and the people who walk under it, and it will also be useful when making whatever other scaffoldings may turn out to be convenient and necessary in the vault.

Here are the defects which exist in the church of Notre Dame of Chartres as seen by Master Pierre de Chelles, master of the fabric of the cathedral of Paris,[89] Master Nicolas de Chaumes, master of the works of

[86] In such a case the master mason of the fabric stood between the chapter (the ruling body of the cathedral) or those among the clergy who were in charge of the overall administration and finances and the masons and laborers.

[87] Mortet and Deschamps, II, 324–27, translated from the Latin by Professor Margaret Taylor; see also Archives of Naples, Angevine Registers, 80 (1295–96), fol. 157.

[88] Victor Mortet, "L'Expertise de la cathédrale de Chartres en 1316," *Mélanges d'archéologie*, ser. 2 (Paris, 1915), pp. 131–52; Mortet's text, taken from the records of the chapter, includes the actual expertise as rendered and recorded in French and the record of the business meetings of the chapter with regard to this matter in the customary Latin. Mortet concludes his essay by giving all available information on each of the three experts from Paris.

[89] Pierre de Chelles was not only chief architect of the cathedral of Paris during the first eighteen to twenty years of the fourteenth century but also master of the works of the city and suburbs of Paris (*magister civitatis et suburbii Parisiensis*) at the time. He must have been a descendent of Jean de Chelles, the great architect of the remodeled transept of the same cathedral in the mid-thirteenth century.

his majesty our king,[90] and by Master Jacques de Longjumeau, master carpenter and juror in Paris,[91] in the presence of Monsignor Jean de Reate, canon of Chartres, originally from Italy, Master Simon Daguon, master of the fabric [at Chartres], Master Simon the carpenter, and Master Berthaust, jurors of this cathedral fabric and responsible to the dean of the chapter.[92]

First, we have seen the vault over the crossing; here repair work is indeed necessary, and if it is not done within a short time there might be great danger.

Furthermore, we have seen the flying buttresses which shoulder the vaults; the joints must be reset in mortar and tightened, and if this is not done very soon great damage may well occur.

Also, there are two piers shouldering the towers which require repair work.

Furthermore, repair work is necessary on the piers connected with the galleries above the portals [porches],[93] and it is recommended that at each bay a further support be added to help carry what is above. One part of the support must rise from above the foundation on the ground to strengthen the corner pier, and the other part must move above to where the body of the church is again free and must have full dimensions in order to reduce the pressure; this should be done in all places where it is judged to be necessary.

In addition we have seen and explained to Master Berthaust how he can work on the statue of the Magdalene right where it is, without moving it.

Furthermore, we have looked into the large tower and observed that it needs repair work very badly, that one of the panels of its sides has large fissures and is in ruins, and that one of the finials is broken and in pieces.

Moreover, the porches are defective in front. The roofing is rotten

[90] Nicolas de Chaumes seems to have been born and trained in the north of France, but is mentioned early in connection with some of the cathedrals in the heart of France, such as that of Sens, with which he appears to have been affiliated in an advisory capacity in 1319 and 1320, and that of Meaux, where he is mentioned in the same capacity in 1326.

[91] Jurors of the city were appointed by the provost of Paris and served as certified experts whenever called upon. Longjumeau's name occurs in an expertise of 1326 in which eight prominent architects were requested to judge a house on the Grand-Pont which threatened collapse.

[92] Simon Daguon appears as chief architect at Chartres, Master Simon as chief carpenter, and Master Berthaust, whose specific job is not mentioned but who is named here among the craftsmen, may well have been a master hewer, entrusted with the maintenance of the sculpture of the cathedral.

[93] In all probability this was the north transept façade, where the buttresses were cut back when the porch was decided upon in the first quarter of the thirteenth century; see Louis Grodecki, "The Transept Portals of Chartres Cathedral: The Date of Their Construction according to Archaeological Data," *The Art Bulletin*, XXXIII/3 (1951), 156–73.

and thin, for which reason it would be good to put an iron rod into each bay to help support it, which would be wise in order to remove all danger.

We have also seen to it, for the good of the church, that the first scaffolding be moved above the window molding for work on the vault of the crossing.

Furthermore, for the good of the church, we have examined the roof shaft which carries the angel aloft and which is completely rotten and unable to connect with the shaft of the nave of the church because the latter is broken where it connects with the joints of the woodwork from above. If this is to be well repaired, two boards should be laid together with those on the chevet; the angel should be placed on top of the second one of these. The greater part of the wood at this end should be replaced and used elsewhere.

Furthermore, the wooden bell carriage for the small bells is inadequate, for it has been old for a long time. The bell carriage for the large bells is also inadequate and must be improved soon.

Furthermore, four of the splices at the ridge of the roof must either be replaced, for the present ones are rotten at one end, or be thoroughly repaired if the chapter does not wish to replace them as we proposed to your masters.[94]

[94] Each expert was to be paid the sum of 20 Paris livres for labor, expenses and expertise. The valet of each was to receive 10 sous.

2

The Gothic Period
between 1270 and 1360

In the period from 1270 to 1360, though the Church continued to be an important art patron, it was no longer leading in this role, for the royal and the feudal courts of Europe had gradually become the chief protectors of the arts. Their palaces and manors were now rebuilt and decorated with an eye to greater comfort and elegance and they contributed generously to the expansion and the improvement of parish and monastic churches with which they were affiliated in life and in which they made provision for resting in death.

At the same time the papal curia, gathered in exile in Avignon, continued to pursue its patronage of the arts with its traditional munificence. The spectacular sumptuousness of the new papal residence and the luxurious style of living of the popes and the churchmen in attendance, while being a source of deep anxiety for Christianity, became the artistic inspiration to many feudal courts of Europe.

New in the mid-thirteenth century was the gradual emergence of the citizenry of the industrial cities of western Europe as patrons of the arts.[1] Speaking in general for Europe, the freedom to assume civic responsibility came only gradually, depending on local circumstances and the intensity of the protracted struggle with the established feudal or church authorities. Often privileges were granted only after open revolt or pressure from king or pope, to whom the people had appealed, or in exchange for the maintenance of roads and bridges, flood control, or the construction of city walls and gates. Laws concerning sanitation and fire protection, such as building regulations for town houses and the width of city streets, were already self-imposed measures devised by city governments growing in the experience of self-governance.

The exception to this was the development in the Italian cities of Tuscany under the leadership of Florence and Siena; here elective government was able to establish itself in 1250, at the death of Frederic II, the last Hohenstaufen emperor. Together with all other tasks these communes undertook also the support of the arts, determined to make their cities beautiful. In this respect all social classes agreed, though in political matters they never were able to overcome mutual jealousies and mistrust. City records and contracts speak of the renewal of public and private buildings and the construction of squares and streets for the sake of

[1] The towns of Flanders, such as Bruges, Ghent, Ypres, Maastricht, Arras and others, great centers of medieval commerce and industry along the waterways and trade roads that led from England to eastern Europe and from Scandinavia to Venice, had been free both administratively and juridically from the early twelfth century. Halls, town halls and belfries of the thirteenth century are evidence of their independence and strength at that time, an independence they were to lose again in bitter battles in the fourteenth century; see M. Kervyn de Lettenhove, *Histoire de Flandre*, II, "1301–1383" (Bruges: Beyaert-Defoort, 1874).

greater order, harmony and beauty. Toward these ends the most distinguished artists available were found and hired, at whatever cost.

Florence was the most powerful among the city-states of Tuscany, owing to its advantageous geographical location and the great wealth of its astute, cosmopolitan merchant and banking class. It was here that participation in government by a large segment of the middle class (medio popolo), *which provided an opportunity for the educated citizen on the city council to be trained in judgment, to express his opinion and to cast his vote in questions of the ultimate appearance of individual buildings and of the city as a whole, bore singular fruit. The citizens and artists of Florence, thus trained in the faculty of consciously appraising harmony and beauty in art, were ready to make room for the Renaissance, when the humanistic movement in literature, starting with Petrarch and his circle and with the Dante commentators and Boccaccio, began to transform European thinking gradually in the second half of the fourteenth century.*

Before records and documents from the Tuscan cities are given, a few existing art historical documents may illuminate the restricted and controlled position of most of the rest of western Europe during the second half of the thirteenth and, in many places, also through much of the fourteenth century.

THE STRUGGLE OF THE COMMONERS OF WESTERN EUROPE

In 1252, Cardinal Legate Hugo confirmed the right of the citizens of Strasbourg to carry on divine services at their city altar in the cathedral of Strasbourg.

Brother Hugo, by divine mercy Cardinal Priest of Santa Sabina [Rome], and Legate of the Apostolic See to those elect of Christ the Master, to the councilors and the citizens of Strasbourg, greetings in the Lord. Your great devotion for the Church of Rome induces me to listen to your petitions with affection, granting them, as far as I can rightly do so, a favorable hearing. Bestowing therefore kind assent to your devout supplication, I grant, by the authority of the bearers, the favor that, on your city altar, in the church of the Blessed Mary of Strasbourg, by authority of my letter and my delegates, divine services may not be suspended or forbidden without a special command from me making full and explicit mention of this grant.[2] Therefore no one may make void this statement of

2 This grant to the citizens by the papal legate reflects the bitterness of the struggle for civic liberties between Walther von Geroldseck, bishop of Strasbourg, his friends and relatives among the canons of the chapter of Strasbourg on the one hand, and the citizens on the other. The conflict was to continue until the spring of 1263, when the bishop died. The altar in question, where

my grant or act against it with reckless daring. If anyone presumes to attempt this, let him know that he will incur the anger of omnipotent God and the Blessed Apostles Peter and Paul.

Written at Toul [Meurthe-et-Moselle], July 31, in the tenth year of the pontificate of Pope Innocent IV [1252].[3]

On September 11, 1253, Cardinal Legate Hugo issued the following letter of indulgence in behalf of the cathedral of Strasbourg.

To all the faithful in Christ throughout the German realm who will see this letter, Brother Hugo, by divine mercy Cardinal Priest of Santa Sabina, Cardinal Legate of the Apostolic See, greetings in the Lord. Since, as the apostle says, we shall all stand before Christ's tribunal to receive good or evil according as we have acted in the flesh, we should anticipate the day of the Last Judgment by works of mercy, and, looking to things eternal, sow on earth what we shall reap with interest multiplied on the Master's giving it, holding firm our hope and faith; even as he who sows sparingly shall reap sparingly, and for him who sows with almsgiving shall alms reap eternal life. Therefore, as the venerable Bishop of Strasbourg, the Prior, the Dean and the chapter of the church of the Blessed Mary in Strasbourg have taken pains to make known to me that they have recommenced restoring the church with splendid work, and that for this restoration the support of the faithful is known to be extremely useful,[4] we ask, advise and urge your whole community in the name of the Lord, adding remission of your sins to the extent that you bestow from the gifts given you by God, righteous alms and the pleasing gifts of charity, so that thus, by your aid, the building can be completed,

early morning Mass was read, had been founded by the citizens. It was one of several which stood in front of and below the choir screen, centered between two doors which led into the choir. The mention of the "city altar" by the papal legate establishes that the altar existed as early as 1252, as did the choir screen in front of which it stood. This screen, otherwise undated, comprised among other pieces of sculpture the elegant and graceful life-size statues of the twelve apostles and the Virgin Mary. The latter statue is now in the Cloisters of the Metropolitan Museum of Art in New York. For the reconstruction of this choir screen, see Hans Reinhardt, "Le Jubé de la cathédrale de Strasbourg et ses origines rémoises," *Bulletin de la Société des Amis de la Cathédrale de Strasbourg*, ser. 2, VI (Strasbourg, 1951), 18–28.

3 *Urkundenbuch der Stadt Strassburg*, I, "Urkunden und Stadtrechte bis zum Jahre 1266" (Strasbourg: Wilhelm Wiegand, 1879), entry 365, p. 278. The Latin text of this grant and of the letter of indulgence which follows (*ibid.*, entry 374, p. 285) were translated by Professor Margaret Taylor of Wellesley College.

4 At that time the nave of the cathedral was still being built. It was completed in 1275 and was followed by the construction of the west façade. Many more letters of indulgence were to be issued before the cathedral was finished. One of these, and one of four to be issued in 1275 alone, mentions that the church, with its varied ornaments similar to the flowers of May, was rising high and attracting more and more the gaze of visitors, enchanting them by its beauty; see Hans Reinhardt, "Les Textes relatifs à l'histoire de la cathédrale de Strasbourg depuis les origines jusqu'à l'année 1522," *Bulletin de la Société des Amis de la Cathédrale de Strasbourg*, ser. 2, VII (Strasbourg, 1960), 17.

and you, because of these and other good deeds which you have done under the Lord's inspiration, can arrive at the joys of eternal blessedness.

Dated Louvain, September 11, in the eleventh year of the pontificate of Pope Innocent IV [1253].

On March 18, 1350, Edward III (Plantagenet) signed the following order having to do with taking painters for work at the royal chapel of Saint Stephen at Westminster.

The King to all and singular the sheriffs, mayors, bailiffs, officers, and his other ministers, as well within liberties as without, greeting.

Know ye, that we have appointed our beloved Hugh of Saint Alban's, master of the painters assigned for the works to be executed in our Chapel, at our Palace in Westminster, to take and choose as many painters and other workmen as may be required for performing those works, in any places where it may seem expedient, either within liberties or without, in the counties of Kent, Middlesex, Essex, Surrey, and Sussex; and to cause those workmen to come to our Palace aforesaid, there to remain in our service, at our wages as long as may be necessary. And therefore we command you to be counselling and assisting this Hugh in doing and completing what has been stated as often and in such manner as the said Hugh may require.[5]

In 1361, Edward III issued orders for taking masons.

The King to the sheriff of Norfolk and Suffolk greeting. We command you as strictly as we can that immediately on sight of these present letters you cause to be chosen and attached within counties, whether within liberties or without, of the better and more skilled masons forty masons for hewing freestone and forty masons for laying stone and cause them to be brought or sent with the tools belonging to their trade, to our castle of Windsor. . . .[6]

[5] Edward Wedlake Brayley and John Britton, *The History of the Ancient Palace and Late Houses of Parliament at Westminster* (London: John Weale, 1836), pp. 170–71; Douglas Knoop and G. P. Jones, *The Mediaeval Mason* (3rd. edition, revised and reset, 1967), published by Manchester University Press. On pp. 81 ff. and p. 110 the authors discuss in detail the Crown's prerogative power of impressment. Orders of this nature were regularly issued whenever workmen were needed for a particular royal building operation. During the years after the Black Death (1348–49) the shortage of labor was particularly in evidence. Resistance by workmen to comply with the order of the king was punishable by imprisonment. Passages reprinted by permission of the Manchester University Press.

[6] See Knoop and Jones, *The Mediaeval Mason*, pp. 219 ff., for the full text in English translation.

THE TUSCAN CITY-STATES DURING A CENTURY OF SELF-DETERMINATION

The records of the cities of Florence and Siena which are presented below could easily be multiplied, and instances of other Tuscan communes could be added to increase the evidence that governments acted with the conviction of moral justification of their endeavor to improve and embellish their cities.[7] It is conceivable that at the start this conviction was founded on Christian, and in particular, on contemporary Thomist doctrines,[8] but quite clearly pride and passionate dedication to their own commune very soon led to rivalry among the cities for the reputation of greatest beauty.

Remarkably efficient methods were worked out to aid in determining and supervising constructions. In both cities citizen councils selected the best available artist or group of artists; when after a while doubt arose concerning the progress of an enterprise, other experts were invited to appraise what had been done, and these experts in turn made recommendations to a specially selected citizen committee whose task it was to advise the executive body of the government on further action.[9]

The Florentine historian Giovanni Villani[10] mentions that during 1237 and 1238, when Florence was under the podestaship of Rubaconte da Mandello of Milan, "all the roads in Florence were paved; for before there was but little paving, save in certain particular places, master streets being paved with brick; and through this convenience and work the city of Florence became cleaner, more beautiful and healthier."[11]

[7] The most thought-provoking study of recent years on this subject is Wolfgang Braunfels, *Mittelalterliche Stadtbaukunst in der Toskana* (Berlin: Gebr. Mann, 1953).

[8] See Rosario Assunto, *Die Theorie des Schönen im Mittelalter,* ed. Ernesto Grassi and Walter Hess (Schauberg-Cologne: M. Du Mont, 1963).

[9] It follows that the old axiom distinguishing between the passive "seeing" of gothic man as opposed to the ability of his Renaissance descendent to "observe" simply does not hold any longer; Paul Frankl, *The Gothic: Literary Sources and Interpretations through Eight Centuries* (Princeton: Princeton University Press, 1960), pp. 247–48.

[10] Giovanni Villani (?–1348) began his chronicle after a visit in 1300 to Rome, where he participated in the Holy Year solemnities ordained by Pope Boniface VIII. Then, "after having seen the great and ancient things of the holy city and having read about the great deeds of the Romans described by Virgil, Sallust and Lucan, Titus Livius, Valerius and Paulus Orosius as well as other teachers of history, all of whom had reported on small as well as large events in Roman history...it seemed appropriate to him to tell in his own chronicle all the facts and beginnings of Florence as far as was possible to rediscover and assemble them, knowing that the city of Florence, daughter and product of Rome, was in the ascendency and about to accomplish great things, whereas Rome was declining"; *Cronica di Giovanni Villani, coll' aiuto de' testi a penna* (Florence: Il Magheri, 1823), Bk. VIII, Chap. xxxvi.

[11] Villani, Bk. VI, Chap. xxvi.

Rubaconte also laid the first stone for a new bridge across the Arno that was named after him. The bridges across the Arno needed and received constant attention. The Santa Trinità bridge, built by the commune in 1252, "the city then being in a happy state because of the assumption of government by the people,"[12] *was carried away by the Florentine flood of October 1269, at which time the Carraia bridge also collapsed.*[13] *The Carraia bridge collapsed once again during the May Day celebrations of 1304. The occasion was a particularly tragic one, according to Villani's report.*

In preparation for the May Day celebrations those of the suburb of San Friano were accustomed to make merry [in competition with other groups] in a more original and different way. They dispatched a proclamation that whoever wanted to have news from the other world should be on the bridge of Carraia and around there along the banks of the Arno on the day of the May festival. They set up a stage on barges and boats in the river, and on this they represented the resemblance and the appearance of hell with flames and other suffering and torment, with men disguised as demons, terrible to behold. Others, who figured as the naked souls of people, were put through those various torments with horrible howls and screams and tempest which seemed loathsome and frightful to hear and to see. Because of the novelty of the show many citizens had come to look. The Carraia bridge, which at the time was built on wooden pilings, was so overloaded with people that it collapsed in several places and fell with the people on it so that many died and drowned, and many were hurt.[14]

In 1284 the city government decided to replace the old city walls with new ones in response to the growth of the city and its new suburbs.[15] *Progress was very slow; Villani speaks repeatedly of the magnitude of the undertaking and attributed the delay to the government's more pressing financial obligations.*[16] *From 1321 on, Villani was a member of the building commission. He mentioned that the walls were being planned with an eye both "for the greater strength as well as beauty of the city."*[17] *In 1324 he wrote two chapters giving a detailed account of this great civic enterprise, "so that the memory of the greatness of the city may never be lost and, moreover, so that other people who never will have been in Florence may know about it." He described the exact location of the walls and*

12 Villani, Chap. 1.
13 Villani, Bk. VII, Chap. xxxiv.
14 Villani, Bk. VIII, Chap. lxx.
15 Villani, Bk. VII, Chap. xcix.
16 Villani, Bk. VIII, Chap. xxxi, for the year 1299; Bk. IX, Chap. x, for the year 1310. Actually the walls and gates were not completed until about 1330.
17 Villani, Bk. IX, Chap. cxxxvii.

*gates on both sides of the Arno, the peculiarities and difficulties of terrain,
the exact measurements of the distances between the walls and its towers
and gates, of buttresses, ditches and roads inside and outside the wall, the
thickness and height of the wall in relation to that of both the main and
the subordinate towers, and concluded by reporting detailed measure-
ments of the wall circuit and of the area within, comprising the city with
its buildings and roads and the remaining open plots of land, orchards
and gardens. By that time, he said, the city had four stone bridges over
the Arno—the Rubaconte, the Ponte Vecchio, the Santa Trinità and the
Carraia—not counting the one that was planned to be built toward the
east, the Ponte Reale. Furthermore, he pointed out that "said city con-
tains within its walls about one hundred churches, counting cathedrals
[Santa Reparata and San Giovanni], abbeys, convents and other chapels.
At almost every other gate there is a church, a convent or a hospital."*[18]

*In the second half of the thirteenth century and during the first half
of the fourteenth, churches, public buildings, city squares and streets in
the heart of Florence began to shape the city as we know it today. Over
and over Villani speaks of the time "when Florence was in peaceful and
good state and the city had grown in population and in large suburbs."
He went on to report that "on October 8, 1278, the first stone of the new
church of Santa Maria Novella of the Dominican order*[19] *was laid by the
cardinal legate and Dominican friar Latino, bishop of Ostia," and that
"in 1284 the loggia of Or San Michele was built for the sale of grain and
the square around was paved with stone and brick. It then was an elegant,
beautiful and useful work."*[20] *Villani went on to say that "in the same
year the renovation of the Badia was begun, starting with the [monks']
choir, the chapels which adjoin the via del Palagio, and the roof, for pre-
viously the Badia was small and insufficient to be in so prominent a place
in the city."*[21]

[18] Villani, Chaps. cclvi and cclvii.

[19] Villani, Bk. VII, Chap. lvi; Walter and Elisabeth Paatz, *Die Kirchen von
Florenz* (Frankfurt a.M.: Vittorio Klostermann, 1952), III, 665, 761 n.16, reason
that Villani's date refers only to the nave and that the enlargement of the church
was begun by 1246, starting with the transept and the choir chapels.

[20] Villani, Bk. VII, Chap. xcix; Karl Frey, *Scritte da M. Giorgio Vasari
pittore e architetto aretino* (Munich: Georg Müller, 1911), I/1, p. 562, corrects
this date to 1285. Frey mentions the burning and the rebuilding of the log-
gia, between 1304 and 1308, in not very solid fashion. On July 29, 1337, Villani
reports (Bk. XI, Chap. lxvii) a new grain hall then in progress "in which
the light brick and poorly founded pilasters were replaced by heavy stone
piers in a solid foundation." It was then that the combination of a guildhall, a
storage place for grain and an oratory in honor of the Virgin were devised and
that "it was ordained that every guild of Florence should take on one pier and on
it have carved the image of that saint whom the guild reveres most. Every year
on the feast of said saint the consuls of said guild and its members should make
their offering and this should go to the Society of Our Lady d'Orto San Michele
for distribution to the poor. And that was a nice and pious ordinance, bringing
honor to the entire city."

[21] *Badia*, or abbey, was the title retained for the oldest monastery within
the walls of the city, a Benedictine foundation.

*From 1292 on the baptistry of San Giovanni was receiving "its black
and white striped marble pilasters which were replacing the old fieldstone
ones by order of the Calimala [guild of wholesale importers of cloth and
bankers]. All the (funerary) monuments, tombs and marble sarcophagi
which surround San Giovanni were removed for the greater beauty of the
church."*22

Of Santa Croce, Villani said:

On May 3 [Day of the Finding of the True Cross] in the year of our
Lord 1294, the new church of the Franciscan order, Santa Croce, was
founded. The consecration of the first stone to be laid in the ground was
solemnly celebrated in the presence of many bishops, churchmen and
monks, and the podesta, the captain, the priors and all the good people
of Florence, both men and women. The church was begun with the choir
where the chapels are; the old church was to remain in use for the service
of the brothers until the new chapels would be completed.23

Villani wrote of the church of Santa Maria del Fiore:

Also in 1294 the citizens agreed to renovate the cathedral church of
Florence, which was of crude shape and small for so great a city. It was
decided to enlarge it toward the rear [toward the choir] and to build it
entirely of marble and [to decorate it] with sculpture. The laying of the
foundation stone was celebrated with great solemnity on the day of the
Virgin in September [September 8] by the papal legate and by various
bishops. The podesta, the captain of the people, the high council of the
priors and the lesser officers of the Signoria also came. The church was
named Santa Maria del Fiore, though its ancient name of Santa Reparata
was not abandoned by the people. It was ordained that the commune
should pay a tax of four denari for each libbra that was paid out of the
treasury of the commune and two denari per head toward the building of
the church. The papal legate and the bishops issued indulgences and
remission of sin to all who would bestow help and offerings.24

Yet in 1331 Villani wrote that:

. . . in that year, in October, when the city of Florence was in relatively

22 Villani, Bk. VIII, Chap. iii.
23 Villani, Chap. vii.
24 Villani, Chap. ix; W. and E. Paatz, III, 325, establish that the correct
date of the foundation-laying ceremony was 1296 but that at that time work on
the cathedral had already begun. The deliberations of the year 1294 were those
which led to the decision to rebuild rather than to renovate the cathedral as had
originally been intended; see also Cesare Guasti, *Santa Maria del Fiore: La
Costruzione della chiesa e del campanile secondo i documenti tratti dall' Archivio
dell' opera secolare e da quello di Stato* (Florence: Tipografia di M. Ricci, 1887),
pp. 34–35.

peaceful and good condition, work on the cathedral was resumed after a long interval during which it had been vacant and no work had been done because of the various wars and the expenses connected with them as mentioned. Now the building was placed by the government under the special care of the wool merchants' guild (*arte della lana*) so that it might go forward faster.[25]

Of the Palazzo Vecchio, Villani reported:

In 1298 the Palace of the Priors was begun for the [use of the] commune and the people of Florence, because two months after the two parties [Ghibelline and Guelph] had worked at the reorganization of the government, both people and patricians realized how great the jealousies and fights between them were, and it did not seem possible to the priors, who ruled the people and the republic, to govern in security as long as they lived in the house of the White Cerchi behind the church of San Brocolo. And there where they began the said palace there used to be the houses of the [Farinata degli] Uberti, rebels of Florence and Ghibellines. On this spot they built a square so that the houses would never be rebuilt. They acquired other houses of citizens such as those of the Foraboschi and founded on that ground the said palace and the tower of the priors, constructed above a tower more than fifty yards high, which had belonged to the Foraboschi, and they called it the tower of the Vacca. In order that the palace which they were about to build might not stand on the land of the Uberti family, they did not make it square but at an obtuse angle [trapezoidal]. It was, however, a bad mistake not to make it square and standing free from the church of San Pietro Scheraggio.[26]

As early as 1290 it was taken for granted that streets and squares would be paved[27] and that streets would be widened and straightened wherever possible, not only for convenience but also for aesthetic reasons. Thus a Florentine ordinance of 1322 says:

In order to increase the amenities and the beauty of the city and of the surrounding land, beautiful straight roads should be built at the

[25] Villani, Bk. X, Chap. cxcii; Villani mentioned here also that both the government and the guild of wool merchants imposed new taxes and voluntary gifts respectively to further the building activity and that in the beginning, at least, money came in in sufficient amounts. For the time being, however, other building enterprises continued to precede the completion of the cathedral. For a short and concise summary of the building phases of the cathedral, see the lucid exposé by Howard Saalman, "Santa Maria del Fiore: 1294–1418," *The Art Bulletin*, XLVI/4 (1964), 471–500.

[26] Villani, Bk. VIII, Chap. xxvi; the palace was completed in its essential parts by 1314.

[27] Robert Davidsohn, *Storia di Firenze* (Florence: G. C. Sansoni, 1965), IV, "I Primordi della civiltà fiorentina," 485 ff.

approaches to the city from one gate to the one opposite, thereby giving free and direct access to merchants and citizens who bring grain or flour from the districts of Mucello and Romandoli to the honorable loggia of Or San Michele, where the grain and flour are sold.[28]

The ledgers of the Calimala between 1335 and 1340 reveal the guild's remarkably systematic and determined preoccupation with the acquisition of houses and land around the then small square of the baptistry of San Giovanni with the idea of enlarging it. As late as 1391 a new piece of land was added, long after the rest of the square was leveled and paved. The city government, with the guild as its agent, evidently never lost sight of its goal concerning the desired proportions of the square.[29]

However, especially when considering specific masters for community projects, all Tuscan cities, and particularly Florence and Siena, demonstrated most clearly their determination to obtain the best services available and to retain great artists with a variety of special grants. Thus in 1300, four years after Arnolfo di Cambio was employed as the first in a series of prominent architects of the cathedral of Florence, the city council ordained that,

in recognition of his being chief architect of the cathedral church of Santa Reparata and in acknowledgment of his fame, expertness and experience, which is greater than that of any other in these parts of the country in the construction of churches, and because his diligence, experience and genius give promise to the people of Florence that out of the already visible splendid beginnings said building will grow into a more beautiful and praiseworthy temple than any other in Tuscany... he be exempted and have immunity for life from payment of taxes and service in or for the city of Florence. This immunity does not extend to his heirs.[30]

In 1334, the city council approved, accepted and confirmed the appointment of the painter Giotto di Bondone as chief architect and administrator of the cathedral and as city architect for the new city walls, fortifications and all other public works.

In the name of the Lord, Amen.... The priors of the arts and professions, the Captain of the Law (*Vexillifer*) and the Council of the Twelve approve the following provisions: they are desirous that all buildings commissioned by and for the city of Florence, both those which already are under construction and those which will be needed in the

[28] Braunfels, pp. 102 n. 342 and 104.

[29] Frey, *Scritte da Vasari*, pp. 338–41; Guasti, *Santa Maria del Fiore*, doc. 53, pp. 51 ff.

[30] Guasti, doc. 24, p. 20; Arnolfo died in 1302. He may have been appointed as early as 1294 but not later than 1296. For his part in the construction of the cathedral see Saalman, pp. 471–73.

future, be carried out with awareness of the city's honor and dignity. They recognize that this goal can be achieved only if they entrust the supervision of these works to an experienced and famous man. It is said that there is no other in the entire world who would be equal to this and other tasks than Master Giotto di Bondone, the Florentine painter. He should be received by his homeland as a great master, and he should be honored and loved and held in such great esteem that it should be an incentive to him to settle down there for good. While he is there, the city will derive great benefit from his knowledge and learning, and no small honor will result to the state. This having been thoroughly discussed on various occasions by the priors of the trades, the Captain of the Law and the Council of the Twelve as the law and the statutes of the city prescribe, the secret ballot with white and black beans had a positive result. . . . It was settled that the above deliberating body was empowered to provide and ordain that said Master Giotto be made chief architect and administrator of the cathedral church of Santa Reparata and of the construction and completion of the city walls and fortifications as well as of all other communal building activity which belongs to or may be considered as belonging to the sphere of the building activity of the city.[31]

Of this appointment Villani said:

In said year [1334] on July 18, the new campanile of Santa Reparata was begun by having the foundation laid beside the façade of the church on the square of San Giovanni. The bishop of Florence was there to give the benediction and to lay the first stone with the entire clergy, the priors, other members of the government, and many people in a large procession. A solid foundation was laid down to water level. Our commune made Master Giotto, our fellow citizen, head and chief administrator of said work of Santa Reparata, he being the sovereign master of painting of his time and the one who more than anyone else drew every figure and action naturally. The commune awarded him an honorarium because of his special professional and personal qualities. Said Master Giotto, having returned from Milan (where our commune had sent him in the service of the lords of Milan [the Visconti]), departed this life on January 8, 1337, and the commune buried him with great honor at Santa Reparata.[32]

It is generally assumed that Giotto's successor on the project of the

[31] Guasti, doc. 44, pp. 443–44; the statement closed with the explicit stipulation that in matters concerning money Giotto would need official approval. Also, in all matters pertaining to the construction of the cathedral and other city structures he would need the approval of the usual decision-making body of the city government. Giotto's participation did not go beyond the initial work on the campanile. It is thought that when he died only the lower part of its base with the lowermost row of relief medallions was completed.

[32] Villani, Bk. XI, Chap. xii.

*campanile was Andrea Pisano. His name appears on a document of 1340
under the title of chief architect of the cathedral. He is first heard of in
the records of the Calimala in connection with the oldest of the three two-
valve doors of the baptistry of San Giovanni, situated on its south side.*[33]

On November 6, 1329, it was decided that the doors of San Giovanni
should be made of metal or brass, as beautiful as possible, and that Piero
di Jacopo should go to Pisa to see the doors in that city[34] and sketch them.
From there he should go to Venice to search for a master to make them
and, if he finds him, that man should be the master to cast said metal
doors./On January 13, 1330, the doors were started in timber./On Janu-
ary 22, Master Andrea d'Ugolino [Pisano], master of the doors, began his
work./On April 2, 1330, the wax model of the doors [frames?] was com-
pleted./On October 14, 1331, Lippo Dini and Piero di Donato worked
on the metal doors./On January 9, 1332, the Administrators of the Mosaic
deliberated over the making and the construction of the doors for the
church of San Giovanni; Andrea d'Ugolino and Lippo Dini, goldsmiths,
and others started work the following day./April 23, 1332: The Admin-
istrators examined the account of Piero di Jacopo, goldsmith, concerning
the amount of time he had worked on the bronze doors of the church of
San Giovanni./April 27, 1332: Master Leonardo d'Avanzo, bell-founder
of Venice from the chapel of the Holy Saviour, presented his final bill to
the Calimala and the workshop of San Giovanni for the remainder of the
salary owed him by said guild of Calimala and workshop of the doors in
connection with the bronze doors of the church of San Giovanni in
Florence. His salary amounted to 600 lire begattozzi[35] plus payment for
board for himself and his two companions for six months in the amount
of 16 soldi per day, except for the time that he lived at the expense of the
workshop./1332: To Master Andrea d'Ugolino of Pisa payment of 72 lire,
10 soldi,[36] for work he is doing on the doors of San Giovanni./1332: To
Piero Donati, goldsmith, payment of 29 lire for the polishing, chasing
and straightening of the valve in the workshop of San Giovanni in like
manner as the other valve in San Giovanni./1332: To Master Andrea of
Pisa payment made of 17 lire, 8 soldi, which amount is due him in partial
payment of the sum of 98 gold florins for the making of the narrative

33 Frey, pp. 350–52; in a note on p. 353 Frey explains that the Calimala
delegated the administration of all work at the baptistry to a group of specially
appointed overseers, the so-called "Administrators of the Mosaic"; a detailed
analysis of every phase of the making of these doors and of their art historical
interpretation is given in the thorough work of Ilse Falk, *Studien zu Andrea
Pisano* (Hamburg: Niemann and Moschinski, 1940).
34 The cathedral of Pisa had three sets of bronze doors, probably all of
them made by Bonanus late in the twelfth century.
35 A small Venetian coin.
36 This corresponds to 50 gold florins; see Falk, p. 47, who says that at the
time 20 soldi were equal to 1 lire, and that 1 lire, 9 soldi, were equal to 1 gold
florin.

plates on the valve of San Giovanni./[Date omitted]: To Master Andrea of Pisa payment of 52 lire, 4 soldi, as final payment of his salary for the execution of the narrative plates on the valve of San Giovanni.[37]/[Date omitted]: To Pasquino Telli, blacksmith, payment of 18 lire, 8 soldi, for cords, trenchers, ropes and pulleys which he lent for the roofing of San Giovanni and for the iron tools he lent and sold when the valve was straightened./November 17, 1332: Piero di Jacopo, goldsmith of Florence, requests a final payment of 70 gold florins from the workshop of San Giovanni due him for his work on the doors of the church of San Giovanni./February 27, 1333: Piero di Donato, goldsmith of the suburb of Santa Felicità in Florence, undertakes to polish and chase the valve in the church[38] of San Giovanni and to straighten and adjust it in the same way as the other valve in the church for the price of 48 gold florins, all expenses included; the whole must be finished next June./July 24, 1333: Master Andrea di Ser Ugolino of Pisa comes to an agreement with the Administrators of the Mosaic to make 24 lion heads of metal between now and the first of December and to gild them in the same way as the other lion heads which are on the valve in the church of San Giovanni; all this at his own expense except for the gold and the metal. After having made and gilded them he will incorporate them as well as possible into the valve which now is in the workshop of San Giovanni. And he shall also gild the narrative plates on that valve as well and sufficiently as those on the other valve, in accordance with the contract. He has promised to do all this for the price of 40 gold florins./May 19, 1334: The building constructed at San Eusebio for the casting of the metal doors for the church of San Giovanni is being demolished./January 30, 1335: Since the bronze doors of San Giovanni have been in the making for a long time without as yet being ready and the Administrators of the Mosaic have deliberated with Master Andrea of Pisa about what should be done to complete work on said doors, and since he has said that 500 florins were not enough, it has been decided that the administrators of San Giovanni have said doors finished so that they may be completed and put in place by the coming Saint John's Day [June 24]./March 7: Master Andrea of Pisa is paid 20 gold florins for the 24 brass lion heads made by him for the metal doors

[37] Falk correctly places, at this point, rather than later in the text where they clearly are out of context, two entries with Andrea Pisano's acknowledgment of receipt of these sums: "February 27, 1333: Master Andrea di Ser Ugolino from Pisa completed his work and acknowledges having received 50 gold florins on account of the 98 gold florins due him by the workshop of San Giovanni for his personal work on the metal valve, and he also acknowledges receipt of 12 gold florins"; and, on August 9, 1333: "The workshop of San Giovanni paid Master Andrea di Ser Ugolino of Pisa 36 florins, which is the remainder of his salary for the making of the narrative bronze plates of the valve which presently is being made in said workshop."

[38] To say "in the church" makes no sense and must be a slip of the pen by the copyist, for we know that this valve was still in the workshop.

commissioned for the church of San Giovanni./Same date: To Piero di Donato, goldsmith, payment is made of 28 florins for the cleaning, chasing and straightening of the above-mentioned bronze doors./August 8, 1335: On the responsibility of the guild of Calimala Master Andrea undertakes to straighten the two valves of the bronze doors which are so warped that they cannot be used. Master Piero had said earlier that he would straighten them, but then he did not have the courage./October 25, 1335: After Piero di Donato had engaged in straightening the valves of the doors for San Giovanni, one of which was twisted and needed refinishing, and then did not have the courage to do it, he was released from the services of the Calimala./December 27: Andrea the goldsmith, son of Ser Ugolino, notary of Pisa, assumed for 10 florins the task of straightening the valve in the workshop of San Giovanni within one month./March 15, 1336: Contract and agreement made with Andrea d'Ugolino the goldsmith to gild and put in place the bronze valve of San Giovanni./June 20, 1336: The cleaning, chasing and buffing of the bronze doors of San Giovanni; they weigh 3315 librae.[39]/1336: Payment of 25 lire made to Master Andrea Pisano for the ordering of marble to be brought to Florence from the region of Lumigiana to be placed beneath the doors of the church for support./February 6, 1338: A marble threshold was placed beneath the bronze doors of San Giovanni.

Villani's comment with regard to these doors was as follows:

In said year of 1330 the beautiful metal doors of San Giovanni, of marvelous workmanship and expense, were begun. The parts were modeled in wax[40] and the figures then chased and gilded by a Master Andrea Pisano; they were cast in a furnace by Venetian masters. And I the present writer, on behalf of the merchants of the Calimala, wardens of the workshop of San Giovanni, was the official to direct said work.

Siena, like Florence, achieved the distinctive characteristics of its

[39] This text has been transmitted to us from a copy of the original records of the Calimala, which are lost, made by Carlo Strozzi, a Florentine scholar of the seventeenth century. The collection is kept under the title of *Spoglie Strozziani* in the State Archives of Florence. The entry for June 20, 1336, is incomplete and ambiguous in its wording. Strozzi's wording reads: "Scarpellatura, ritagli e poluere delle porte di metallo di S. Giouanni pesorno libbre 3315." Falk, *Studien zu Andrea Pisano*, p. 54 (and others who follow), translates this as "Die Ausmeisselung, Abfälle und der Staub der Metalltüren—also die Bronzereste—von S. Giovanni 3315 Pfund wiegen." It seems hard to believe that the finishing process, the chasing, accenting and such, produced waste material in the amount of 3315 librae (2980 pounds). It would also be unusual for a document of the fourteenth century to mention waste rather than positive weight.

[40] Villani, Bk. X, Chap. clxxiv; the Italian text in my edition says "e furono formate in cera." Falk, pp. 49, 190 n. 130, warns that some editions, including the one she used, speak of *terra* (clay) rather than *cera* (wax) as the casting method.

noble silhouette between the mid-thirteenth and mid-fourteenth centuries. As in Florence, agreement among dissenting factions of the people was achieved where matters of beautifying the city were concerned. These projects were carried through despite internal and external strife and warfare and, in the case of Siena, in the face of increasingly severe financial, economic and agricultural problems throughout the fourteenth century.

The rebuilding of the old cathedral was the first major task the city government undertook. In Siena, as in Florence, the state had assumed responsibility for all temporal matters of the Church, and the rebuilding proceeded promptly between the second quarter of the thirteenth century and about 1264, when all but the façade was completed.[41] *In 1265, Nicola Pisano was engaged to make the pulpit for the cathedral, five years after he had completed that of the baptistry of Pisa.*[42] *From 1284–85 on, Giovanni Pisano, Nicola's son, was in charge of the construction and decoration of the façade.*[43] *In 1308 Duccio di Buoninsegna was commissioned to make the altarpiece for the high altar under the dome of the cathedral.*[44] *In the summer of 1306, the city council decided to proceed with its project to level the square in front of the cathedral and the hospice of Saint Mary of Siena. It was to be leveled and enlarged up to the houses of the canons, and the graves on the square were to be paved over with marble flagstones.*[45]

But by 1315 it had been decided that the cathedral was too small, and a complicated scheme was adopted for its enlargement toward the east; the existing church was to be incorporated into the larger scheme. The records tell of the ensuing complications: in 1321 a five-man advisory building commission led by Lorenzo Maitani, chief architect of the cathedral of Orvieto, reviewed what had been done since the rebuilding started. It condemned the lack of sufficiently strong supports for the intended height, the inadequacy of the old foundations for the new parts to be built upon them, and the very idea of combining the old and the new. It objected to the new structure's lack of harmonious scale and said that, if carried through as contemplated, the church would lose its balanced cruciform shape, which it was reasonable to preserve. The visiting masters summed up their findings by advising the city council that, rather than attempting the enlargement as contemplated, it would be better "to build an entirely new structure, beautiful, large and splendid, which would be well proportioned in length, height, width and all other meas-

[41] Gaetano Milanesi, *Documenti per la storia dell' arte senese*, I (Siena: Onorato Porri, 1854), docs. 2–7, 140–45.

[42] Ibid., doc. 8, pp. 145–49; Frey, pp. 725–31, 750–826.

[43] Frey, pp. 845–47; Albert Brach, *Nicola und Giovanni Pisano und die Plastik des XIV. Jahrhunderts in Siena* (Strasbourg: J. H. Ed. Heitz, 1904), pp. 32–34. The first stone of the façade was laid with great ceremony in May 1284.

[44] Milanesi, doc. 22, pp. 166–68.

[45] Milanesi, doc. 21, pp. 165–66.

urements as is proper for a pleasing church provided with every resplendent ornament appropriate to and expected of such a great, venerable and beautiful church."[46]

In 1333, various local masters pressed for acceleration of the work and in 1339 the Great Council not only decided to continue construction but to continue with the enlargement.[47] *In the same year Lando di Pietro, a Sienese then in the service of the king of Naples, was appointed chief architect of the cathedral and the city for three years.*[48] *The minutes of the Great Council speak of his qualifications.*

Master Landus, the goldsmith, is an experienced master not only in his own above-mentioned craft but also in many other arts. He is a great man, subtle and ingenious in devising new things, be it for the building of churches or for the building of palaces, or houses of the commune and roads, bridges, fountains and all other public works. Said Master Landus presently makes his home in the city of Naples, where his distinction still is increasing [he was in the service of Robert of Anjou]. It is suitable and useful for the commune of Siena not to let such an excellent man be away from Siena for long;[49] rather he should take permanent residence here and give his advice and service to the work which is being done at the cathedral as well as in the commune of Siena. ... Said master will receive 200 librae as his personal salary each year he actually spends in Siena for directing and delegating work and seeing to it that it is carried out as ordered, be it for and in the service of the commune of Siena, in the city and in the surroundings, or for the construction of said cathedral.

Clearly the engineering ability of Lando di Pietro would have been ideally suited for the complicated construction tasks at the new church, but his death soon after his arrival deprived the building of his continued advice and supervision. As it was, work on the building seems to have continued until 1355–56, when an urgently needed new evaluation was made

[46] Milanesi, docs. 34, 35, pp. 186–89.

[47] Milanesi, doc. 42, pp. 204–8.

[48] Milanesi, docs. 49, 50, pp. 226–30.

[49] Milanesi, doc. 50, p. 231; Master Landus was well known to the city of Siena from earlier years, for he had worked there between 1323 and 1334. There are several entries in the accounts of the commune for payments made to him for work on the city bells and on the city fortifications. Probably because of his reputation as a specialist in the field of suspending bells, he was also called to Florence in 1322. Then Villani tells us (Bk. IX, Chap. clviii), "A very fine master from Siena was able by his skill to make the big bell of the commune of Florence ring, which bell had not been pealing forth fully for 17 years, since no master could make it ring fully even though he had twelve men. And he contrived to fix it with such skill that two people can set it pealing and once in motion one single man can achieve a full peal (and the bell weighs more than 17,000 librae). Consequently said master received for his services 300 gold florins from the commune of Florence."

by a commission, under the direction of the Florentine architect Benci di Cione.[50] *This evaluation also opposed further construction; it criticized sharply the poor masonry underneath the marble surface, which showed up in the defective piers and arches and in the fissures and warped vaults and walls; it pointed out the uneven thickness of the masonry, the insufficiency of nave and wall supports, which, if proportionately enlarged, would take away so much of the existing space that it would be better to begin anew, "all of which would, in order to be changed, cost over 150,000 gold florins and the church would not be ready in a hundred years." This devastating criticism at a time when, as we know, the commune was struggling under the blows of financial losses, famine and illness, finally made the city council abandon the project in June, 1357.*[51] *The faulty new parts were taken down and the church was completed in its present form some time in the last quarter of the fourteenth century.*

Next to rebuilding the cathedral, the commune was most concerned with providing permanent housing for its various government branches and officials. During the thirteenth century, most offices were installed in rented residences and the city council met in various churches. The plan to consolidate all offices and functions was first approached very modestly by enlarging the old public mint and tax office, a house at one end of the ancient public square of the city. The enlargement included a council chamber, which was in use by 1284; simultaneously the podesta took up residence there. The rest of the government and most offices were still in adjoining rented houses. However, these houses were gradually bought up[52] *in anticipation of a resolution in 1288 to proceed with the construction of a palace to accommodate all government functions.*[53]

With the construction of the Palazzo Pubblico, which in its main features was completed in 1310, the city council immediately undertook to relate the public square to it, clearly intending to express spatially as well as with the towering mass of the building the power and harmony of the state. The square had always been a natural focal point, for it lay just below the meeting point of the three sections that formed the old city. However, until then it had been second to the cathedral square, and only following the decision to build the government palace did the city council determine to make it a civic focal point of equal importance.[54] *A*

[50] Milanesi, docs. 56, 57, pp. 249–52.

[51] Milanesi, doc. 58, pp. 254–55.

[52] Gaetano Milanesi, *Sulla storia dell' arte toscana: Scritti vari* (Siena: Tip. Sordo-Muti di L. Lazzeri, 1873), pp. 128–30.

[53] The central part of the new building was completed first and then the two sides were added before 1310; the whole, including the monumental council chamber with its fresco decoration and the bell tower, almost 300 feet high, was not finished until 1344.

[54] On this point see Braunfels' very provocative inferences derived from the successive plans for the reconstruction of the cathedral and the baptistry, pp. 160–67.

single city ordinance, issued as early as 1297, reveals with what care every detail of the square was planned from the very beginning. The ordinance says that from then on "all houses to be built or renewed around the Campo must have those windows which face on the square done uniformly with [dividing] colonnettes and without galleries."[55] *In fact, the palaces which were built at the same time as the Palazzo Pubblico or immediately afterward were based on its architectural style and building materials. By 1346, the Campo must have been completed, for Agnolo di Tura, chronicler of Siena, has this to say: "The Campo of Siena was completed by receiving its stone and brick pavement on 30 December [1346] and, with its beautiful and abundant fountains and the beautiful and noble houses and shops surrounding it, it is more beautiful than any other square in Italy."*[56]

No more distinguished sculptor could have been found in 1265 for the commission of the new pulpit for the cathedral than Nicola Pisano. His pulpit for the baptistry in Pisa had by then been standing for five years for all to see and admire. Unfortunately, none of the records of the preliminary deliberations have survived between the master and Brother Melano, who then was administrator of the Siena cathedral workshop, and we shall never know how this masterpiece was conceived. It was to be larger than its predecessor and more complex in iconography, figure style and technique. The only remaining documents are the final contract of September 29, 1265, and a follow-up letter of May 11, 1266, two months after Nicola started working in Siena, to remind him that one of his two assistants had not yet arrived. Both these documents are as businesslike and strict in formulating and recapitulating the duties of the employee toward the employer as any contracts known to us from the rest of Europe during the same period.[57] *Nicola was to get, as promptly as possible, the specified and carefully enumerated different marble parts of the pulpit from the quarries of Carrara and to receive for this purpose sixty-five Pisan librae. Other conditions were:*

Nicola will move to Siena this coming March and make his residence there in order to put the pulpit together and work on it without interruption—unless given special dispensation by Brother Melano—until it is completed in accordance with his agreement with Brother Melano. Master Nicola may take a leave of two weeks (not counting travel time) four times a year, especially for consulting in the affairs of the cathedral and

55 Scipione Borghesi and Luciano Banchi, *Nuovi documenti per la storia dell' arte senese* (Siena: Enrico Torrini, 1898), doc. 1, p. 1.

56 From *Cronache senesi*, in L. A. Muratori, *Raccolta degli storici italiani dal cinquecento al millecinquecento*, XV, Part VI (Bologna: Nicola Zanichelli, 1939), 550.

57 Milanesi, *Documenti*, docs. 8–10, pp. 145–53; Frey, *Scritte da Vasari*, pp. 599–600, 725–39, 790–827; George Swarzenski, *Nicolo Pisano* (Frankfurt a.M.: Iris Verlag, 1926), pp. 30–43; Brach, *Nicola und Giovani Pisano*, pp. 13–20.

the baptistry of Pisa and for his own personal affairs, but not for any new commission in Pisa. He must bring to Siena his assistants Masters Arnolfo and Lapo, at the salary mentioned below, and have them live and stay with him until the completion of the pulpit. . . . If these arrangements are not carefully observed and are acted against, the penalty will be 100 Pisan librae plus all expenses which might accrue to the employers. . . .

It is agreed that, after said Master Nicola's arrival next March with the two above-mentioned assistants and possibly another helper, he will stay and live with them in Siena until the work is completed.[58] The master will be paid 8 Pisan denari for every day he personally works on said pulpit and supervises his assistants, and his two assistants will receive 6 Pisan denari per working day. Living quarters and beds will be provided for him and his three above-mentioned assistants. The third helper will be paid less per day. If, however, Master Nicola should be specially summoned by Brother Melano for other work he might want Master Nicola to perform, whether for the cathedral or for the commune of Siena, Master Nicola will receive 8 additional Pisan denari plus payment of his personal expenses and for his horse for every day of employment. Finally it is understood that if Giovanni, the son of said Nicola, comes to work on the pulpit by special wish of his father,[59] he shall be permitted to stay and work. For every day he works he will receive 4 Pisan denari. . . . During their stay and work on the pulpit, Nicola and his assistants will enjoy the freedom of the city of Siena and they will be under the protection of the state for their lives and their property.[60]

The mature Giovanni Pisano is surrounded by an aura of excitement as is no other artistic personality of the Middle Ages. The few documented facts about his life suggest a restless individuality. When he entered the service of the cathedral of Siena as a grown man in 1384, he was immediately given citizenship and was exempted from all communal obligations: "It is established and ordained that Master Giovanni, son of Nicola who was from Pisa, receive the citizenship of Siena; he is given immunity for lifetime from each and all civic obligations, dues, collections, exactions, party membership, and from required service and other burdens."[61]

The same ordinance was repeated in 1299, but by then Giovanni

[58] The last payments to Nicola were made in November 1268, at which time the pulpit must have been completed.

[59] Giovanni Pisano must then have been in his teens.

[60] The date of this contract and its Latin text are taken from Frey, pp. 725–31, rather than from Milanesi, doc. 8, pp. 145–49; for the follow-up letter of May 11, 1266, see Milanesi, doc. 9, pp. 149–50.

[61] Milanesi, *Documenti,* p. 163. Such privileges were often part of the payment of a well-known artist. It is generally assumed that his appointment was connected with the construction of the façade of the cathedral. He undertook making the façade sculpture, yet the façade was rearranged in the fourteenth century, and one can only speculate about its appearance at the time Giovanni left.

was no longer in Siena; he had returned to Pisa to assume new tasks there, with the rank of chief architect of Pisa cathedral.[62] *There is some evidence of friction between him and the authorities while he was in Siena. For example, the minutes of the Great Council of July 17, 1290, contain the information that the council dealt on that day with the request of the administrator of the workshop of the cathedral to the effect that* said Master Giovanni, chief architect of the cathedral, is said to be extremely useful and indispensable to the progress of the building and that it be decided to absolve and excuse him from payment of the fine and to let him go free so that he may continue to work on the perfection of the building, for without him said work which was begun by him could not be completed. The request was granted.[63]

Friction appears to have existed also between Giovanni and the cathedral administrator in Pisa; he himself refers to this in one of two inscriptions on the pulpit of the cathedral of Pisa which he made between 1302 and 1310–11. At first, everything had gone well; there are detailed accounts of the procurement of marble in the fall of 1302. Giovanni and two of his assistants went to the quarries at Carrara "to break and prepare the marble, which was taken from there by barge and thence [by oxcart] to the lodge of the cathedral."[64] *The first of many problems seems to have appeared concerning differences of opinion on the amount of payment due the master. Then, on April 7, 1305, a special ordinance permitted Giovanni Pisano to turn directly to the city council in cases of differences of opinion between himself and the administrator of the workshop.*[65]

Following a fire at the cathedral in 1595 the pulpit was dismantled and dispersed. According to one anonymous account of the fire and a description of the pulpit by another writer in the early seventeenth century, the pulpit had two inscriptions which, as recorded, conveyed the sense of Giovanni's irritations. The inscriptions were written in Latin hexameter, commonly in use for epigraphs in the thirteenth and fourteenth centuries, a longer and more serene one on the cornice below the nine reliefs forming the pulpit itself, and a shorter, much more elegiac one unobtrusively placed on the base. The longer inscription said approximately this:

62 Brach, *Nicola und Giovanni Pisano*, p. 35.

63 See Milanesi, *Documenti*, doc. 18 and notes, pp. 161–63, where he mentions that the master had been condemned to pay 1600 lire. Frey, *Scritte da Vasari*, p. 846, suggests that Giovanni may have absented himself from his work more frequently than the authorities permitted in order to keep up with other commitments.

64 Péleo Bacci, *La Ricostruzione del pergamo di Giovanni Pisano nel duomo di Pisa* (Milan and Rome: Casa Editrice d'Arte Bestetti e Tuminelli, 1926), p. 24.

65 Frey, p. 869n, gives the Latin text.

I praise the True Lord from whom all great things come/Who gave to man the power to shape images./This work was carved single-handed by Giovanni son of Nicola in the year 1311/When Pisa was ruled in unity and divided/by Count Frederic of Montefeltre/who was assisted here by Nellus Falco/Who had charge and jurisdiction over this work.[66]/He was born in Pisa, like Giovanni, who beyond all others/was gifted in the art of sculpture/To create, in turn, beautiful sculpture in stone, wood and gold./Nor could he have carved the offensive or the disgraceful even if he had wanted to./There are many sculptors, but to him alone belongs the praise of fame./He made noble sculpture and varied statues./To admire them is proof of sound judgment./Christ have mercy upon him who was thus endowed. Amen.

The inscription on the base reads:

The circling course of the Eternal Order is shown here by Giovanni/ Who ventured much worthy of study by the grateful./He wrought this with great toil and now cries out: I was not enough on my guard./The more I gave, the more hostility did I experience./Yet with a calm mind I bear in my heart the penalty for my neglect./And to take away envy and mitigate pain/And to entreat fitting honor: I add my tears to this verse./ For he proves himself unworthy who defames him worthy of the crown/ Since with his insults he whom he insults is honored/And it is the assailant who is dishonored.[67]

On October 9, 1308, a contract was drawn up between Giacomo Mariscotti, administrator of the workshop of the cathedral of Siena, and the Sienese painter Duccio di Buoninsegna for painting the retable to be placed on the high altar of the cathedral church of Santa Maria of Siena with the following stipulations:

First, said Duccio promises said Giacomo . . . to paint and construct with God's will said altarpiece to the best of his ability and knowledge. He will work without interruption on the altarpiece as much as the painting will permit and will neither receive nor accept any other commission until the altarpiece is completed. Master Giacomo, the administrator of the workshop acting in its behalf with full authority, promises Duccio for his labor and that of his assistants 16 Sienese soldi for as many days

[66] According to Frey, p. 869, the chief administrator during the entire time of Giovanni's work on the pulpit was Burgundio Tadi, essentially a man of taste and initiative. Nello Falco was assistant to him. Giovanni's omission of the name of Burgundio Tadi indicates open warfare between the two men.

[67] See Bacci, *La Ricostruzione*, pp. 49, 54, for the Latin text and historical evidence concerning the authenticity of the verses. See also Walter Paatz, *Werden und Wesen der Trecento-Architektur in Toskana* (Burg b.M.: August Hopfer Verlag, 1937), pp. 126, 185 n. 483; Harald Keller, *Giovanni Pisano* (Vienna: Verlag Anton Schroll & Co., 1942), pp. 68–69, for the Latin text with German translation.

as said Duccio works with his own hands on the altarpiece. Should he lose any working days, these will be taken off his pay in proportion to the lost hours. Concerning the salary the administrator promises Duccio the following: for each month Duccio works on the altarpiece he will receive 10 Sienese librae and the remainder after deduction of the sum Duccio owes the workshop of the cathedral. Furthermore, the administrator promises to give and provide everything necessary for successful work on the altarpiece, so that Duccio will not want for anything he needs, either for himself or for his work.[68]

Complementing this document is a slightly later one without date, this one in Italian instead of the customary Latin, concerning the work to be done on the back of the altarpiece:

We know that there are above all thirty-four episodes from the life of Christ, those which we at the Council liked most. There are also the small angels above and other work demanded of the panel, so that in fact there are thirty-eight episodes in all. For thirty-eight stories there should be a payment of $2\frac{1}{2}$ gold florins each. Master Duccio will furnish all necessary tools and personnel for the painting, and the administrator will furnish paint and all else that is needed. Of this payment Master Duccio should receive an advance of 50 gold florins; after discounting this sum, he should receive the rest as he attends to each story.[69]

It took three years to make the altarpiece, known as the Maestà. *On June 9, 1311, it was taken to the cathedral, and there exist several reports on the event. The chronicle attributed to Agnolo di Tura says:*

The Sienese commissioned a beautiful and sumptuous altarpiece to be made for the main altar of the cathedral, which is provided with paintings of that time. These paintings were executed by Master Duccio, son of Nicolo, painter of Siena, the finest artist to be found anywhere at his

[68] Milanesi, *Documenti*, doc. 22, pp. 166–68. Duccio is first recorded as a painter in 1282 and may have been born about 1260. He seems to have achieved a high reputation as a painter at a very early age, for in 1285 he was commissioned to make an altarpiece for the chapel of the brotherhood of the Laudesi in Santa Maria Novella in Florence. The contract was tightly drawn: Duccio was to receive 150 gold florins for an altarpiece showing the Virgin Mary and her son and other figures. The panel was to be gilded, and he was to do everything else in his power to ensure its beauty, sumptuousness and richness of appearance. The contract contained the provision that, if the painting were not beautiful and worked according to the wishes and the satisfaction of the patrons, they would not be bound to pay the stipulated price, or any part of it, or to reimburse the artist for any expenses he might have had in redoing the painting (*ibid.*, doc. 16, pp. 158–60). It is generally assumed that the painting involved is the Rucellai Madonna.

[69] Milanesi, *Documenti*, doc. 28, p. 178; he considers a date as late as 1310 for this document.

time. He painted the altarpiece in the house of the Muciatti outside the gate toward Stalloregi, in the suburb of Laterino. On the 9th of June, at midday, the Sienese carried the altarpiece in great devotion to the cathedral in a procession which included Bishop Roger of Casole, the entire clergy of the cathedral, all monks and nuns of the city, the Nine Gentlemen [governors of the republic] and officials of the city such as the podesta and the captain, and all the people. One by one the worthiest, with lighted candles in their hands, took their places near the altarpiece. Behind them came women and children with great devotion. They accompanied the painting up to the cathedral, walking in procession around the Campo, while all the bells rang joyfully. All shops were closed out of devotion, and all through Siena many alms were given to the poor with many speeches and prayers to God and His Holy Mother, that she might help to preserve and increase the peace and well-being of the city and its jurisdiction, as she was the advocate and protection of said city, and deliver it from all danger and wickedness directed against it. In this way said altarpiece was taken into the cathedral and placed on the main altar. The altarpiece is painted on its back with scenes from the Old Testament and of the Passion of Jesus Christ and in front with the Virgin Mary and her Son in her arms and many saints at the sides, the whole decorated with fine gold. The altarpiece cost 3000 gold florins.

And the old altarpiece of the high altar, the one which nowadays is called the Virgin of Mercy, was placed on the altar of Saint Boniface.

And the disciples of said Master Duccio also were distinguished masters in the art of painting.[70]

The so-called anonymous chronicle added to this as follows:

At the time when the altarpiece for the high altar was finished, the altarpiece called "The Madonna of the Large Eyes," or "The Madonna of Mercy," which is now above the altar of Saint Boniface, was taken down, this madonna having been the one who heard the prayers of the people of Siena when the Florentines were defeated at Montaperti. Her place was changed because the new one, which is much more beautiful and devout and larger and has on its back scenes from the Old and New Testaments, was made.[71]

[70] *Cronache senesi,* ed. Alessandro Lisini and Fabio Iacometti (Bologna: Nicola Zanichelli, 1931–1934), pp. 313–14 (a new and revised edition of L. A. Muratori, *Raccolta degli storici italiani dal cinquecento al millecinquecento,* XV, Part VI).

[71] *Cronache senesi,* p. 90; the battle against a strong Florentine army on September 2, 1260, was won by the Sienese against all odds. They ascribed their victory to the miraculous assistance of the Virgin, to whom they had solemnly dedicated themselves in a ceremony on the preceding August 15, the day of the Assumption of the Virgin and the greatest festival day of the city. From then on also the city called itself "Civitas Virginis" on its coins.

Finally, there is among the expense accounts of the city treasury the following entry for the year 1311: "For the transport of the altarpiece made by Duccio, 12 librae, 10 soldi, in payment of the trumpeters, the bagpipers and the castanet players who performed at the festive reception of the altarpiece."[72]

The first important commission for the decoration of the hall of the Grand Council in the Palazzo Pubblico was given to Simone Martini. He was a generation younger than Duccio and, though probably trained in the tradition of the older master, was strongly influenced by the contemporary courtly French gothic style. Thus, the fresco of the Maestà at the upper end of the council chamber, done between 1315 and 1316, was very different from the Maestà by Duccio; instead of following Duccio's solemn simplicity, Simone shows a courtly, charming and graceful gathering. The Virgin is enthroned under a delicate, gay canopy; she is young and beautiful and her throne is surrounded by a loosely arranged group of male and female saints, apostles and angels who seem to divide their attention between her and the child and the world outside, into which they gaze, observers rather than solemn witnesses. As in Duccio's Maestà, the four patron saints of the city of Siena kneel in front of the throne, and two angels flanking the steps of the throne offer flowers to the Virgin. Perhaps it was the location of the painting in a civic rather than a church setting which enabled Simone to deviate so greatly from Duccio's painting. The Virgin's role here is not so much that of the compassionate intercessor for mankind as that of defender of those civic virtues which were to be practiced in this hall. The Christ child, standing on his mother's lap, carries a scroll saying, "Love righteousness, ye who are judges of the earth." On the steps of the throne the following two verses were written in gold letters:

The heavenly flowers, roses and lilies/with which are adorned the heavenly meadows/do not delight me more than righteous counsel./But from time to time I see those/who for their own advantage spurn me and defraud my land./And the worse these people speak the more they are being praised/by all those who are condemned in this verse.[73]

[72] Milanesi, *Documenti*, pp. 168–69, quotes from the above two chronicles, and also this item from the expense accounts of the city.

[73] Verses of this kind have a long tradition. It was customary to add epigrams (*tituli*) to a Roman art work, praising it and thus expressing a kind of art criticism, while retaining the poem's independence as an art form with a mood of its own. The custom found great favor with the early Christian and later medieval poets who used the *titulus* not only to make direct comments on the painting to which it was attached but also independently, in the form of literary programs for cycles of paintings to be executed at some later time. Thirteenth- and fourteenth-century Italian literature transposed the *titulus* into sonnet and canzone form but continued to connect it directly with the art work; see Julius von Schlosser, *Quellenbuch zur Kunstgeschichte des abendländischen Mittelalters*, N.F., VII (Vienna: C. Graeser, 1896), esp. pp. 28–32.

Below this verse is the other one, addressed by the Virgin to her court of saints:

Beloved ones be assured/that your devout and honest prayers/I shall grant as you desire./But if the mighty attack the weak,/oppressing them with shame or harm,/your prayers are not for such as these,/nor for anyone who betrays my land.[74]

About 1339, at the height of his career, Simone was called to the papal court at Avignon into the service of Pope Benedict XII. The papacy had been in exile in Avignon since 1307, and by 1339 Avignon was not only the gathering place for some of the most distinguished minds of the day, but also one of the leading centers of artistic activity. At that time an extensive building program was in progress, comprising churches, chapels, monasteries, palaces and luxurious country residences, and above all a resplendent new papal palace. Not only French artists but prominent artists from all over Europe were being summoned ̇y prelates familiar with the caliber of work of these men in their native countries. In this way also Simone came.[75] His first task was to execute the fresco decoration in the vestibule of the cathedral of Avignon, Notre-Dame-des-Doms.[76] He also painted several small altarpieces. Because of the charm, the delicacy, the sensuous appeal and the intelligence of his compositions, forms and colors for which he was rightly admired, it used to be taken for granted that he had a prominent part in the fresco decoration of the papal palace. Yet Simone died in 1344, less than five years after his arrival in Avignon; payment records of work done at the palace do not mention him; and the painstaking reconstruction of the fresco decoration of the papal chambers by means of the remaining traces give no evidence of the master's hand.[77]

Simone's praise was sung by Petrarch, the great poet and humanist, for whom the master executed the title-page miniature of the Virgin in his possession,[78] and a second drawing, that of Laura, the woman Petrarch loved and whose beauty and gentle personality he immortalized in most of his sonnets:

Had Polycletus in proud rivalry/On her his model gaz'd a thousand

[74] Milanesi, *Scritti vari,* p. 127.

[75] Italian painters began to be called to France from the opening years of the fourteenth century; Millard Meiss, "Fresques italiennes et autres à Béziers," *Gazette des Beaux Arts,* XVIII (1937), 275–86.

[76] These frescoes were commissioned by Cardinal Stefaneschi. They were badly damaged by fire in the early nineteenth century; Robert Oertel, *Die Frühzeit der italienischen Malerei* (Stuttgart: W. Kohlhammer, 1953), pp. 138–41.

[77] Enrico Castelnuovo, *Un Pittore italiano alla corte di Avignone: Matteo Giovannetti e la pittura in Provenza nel secolo XIV* (Turin: Giulio Einaudi, 1962).

[78] Pietro Toesca, *Storia dell' arte italiana* (Turin: Unione Tipografico Editrice Torinese, 1927–1951), II, "Il Trecento," p. 538, pl. xix; the manuscript, provided with comments by Servio, is in the Ambrosiana in Milan.

years,/[79] Not half the beauty to *my* soul appears,/In fatal conquest, e'er could *he* descry./But, Simon, thou wast then in Heav'n's blest sky,/Ere she, my fair one, left her native spheres,/To trace a loveliness this world reveres/Was thus thy task, from Heav'n's reality./Yes—thine the portrait Heav'n alone could wake,/This clime, nor earth, such beauty could conceive,/Where droops the spirit 'neath its earthly shrine:/The soul's reflected grace was thine to take,/Which not on earth thy painting could achieve,/Where mortal limits all the powers confine.[80]

When Simon at my wish the proud design/Conceiv'd, which in his hand the pencil plac'd/Had he, while loveliness his picture grac'd,/But added speech, and mind to charms divine;/What sighs he then had spar'd this breast of mine:/That bliss had giv'n to higher bliss distaste;/For, when such meekness in her look was trac'd,/'Twould seem she soon to kindness might incline./But, urging converse with the portray'd fair,/Methinks she deigns attention to my pray'r,/Though wanting to reply the pow'r of voice./What praise thyself, Pygmalion, hast thou gain'd;/Forming that image, whence thou hast obtain'd/A thousand times what, once obtain'd, would me rejoice![81]

In these two sonnets written in Simone's praise, Petrarch's interest in the art work would seem rather peripheral to his joy over the possession of the portrait of the woman he loved. Nor does the often quoted passage in his will concerning a panel painted by Giotto which had been given to him indicate more than the interest of a cultured layman in the great artistic endeavors of his time. In this will, dated 1361, he says of the panel showing the Virgin and child, that it was painted by "the greatest master of our time ... the panel I own, an image of the Virgin Mary ... whose beauty is not intelligible to the ignorant but whose beauty is a source of wonder to the masters of art."[82]

[79] Julius von Schlosser, "Zur Geschichte der Kunsthistographie," *Präludien, Vorträge und Aufsätze* (Berlin: Julius Bard Verlag, 1927), p. 260, observes that it was Dante's reference to Polycletus in *Purgatory,* X/32, which caused the sudden vogue among Italian humanists of calling Polycletus rather than Phidias the greatest artist of antiquity.

[80] Susan Wollaston, *One Hundred Sonnets Translated after the Italian of Petrarca* (London: Edward Bull, 1841), sonnet 49, pp. 72–73.

[81] John Nott, *Petrarch Translated; in a Selection of His Sonnets and Odes Accompanied with Notes, and the Original Italian* (London: J. Miller, Chancery-Lane, 1808), sonnet 58, pp. 66–67.

[82] Roberto Salvini, *Giotto: Bibliografia* (Rome: Fratelli Palombi, 1938), p. 5. A divergent opinion, that Petrarch's interest in and contribution to art were important, is held by Theodor E. Mommsen, "Petrarch and the Decoration of the Sala Virorum Illustrium in Padua," *The Art Bulletin,* XXXIV/2 (1952), 95–116.

REFINEMENT OF LIVING IN FEUDAL SOCIETY

The luxurious life of the papal court at Avignon presents itself in a variety of contemporary documents, such as in the records of payments made to Master Giovanni di Bartolo, a goldsmith of Siena, for jewelry and precious objects repaired, reset and newly executed for the papal house-holds at Avignon and Rome between 1367 and 1385, amounting to many thousands of gold florins.[83] The chambers prepared for the visit of Pope Clement VI at the country house of Cardinal Annibaldo di Ceccano at Gentilly on the Sorgue in 1343 were described by an anonymous eyewitness as follows:

The large chamber was adorned in this way: at the head of the bed and on its sides there were the finest gold and silk materials from roof to floor, all new, splendid, of various colors and of marvelous beauty; and two curtains, one at the side of the bed and the other at the foot of the bed, completely new with the coat of arms of the pope stretching over the whole. At the distance of a rod from the foot of the bed[84] there was a papal seat covered with rich gold and silk material, strewn with marvelous cushions; and beneath the feet was placed a velvet carpet like the others, except that it was of the finest silk and completely new, lovely to behold. Around all walls there were new wall hangings with novel and varied stories, benches everywhere in the room and tapestries reaching to the floor, and the room was full of them. The bed was unbelievable and hard to describe in writing, it was so rich. The outer cover consisted of the finest red velvet. Above it lay an ermine fur cover of a whiteness like purest snow. The canopy was of gold cloth and silk like the material at the head and around the bed. And a similar bed was in the smaller bed-chamber, decorated around the walls with similar gold cloth curtains and canopy, and full of carpets on the floor.[85]

Handwoven and embroidered materials were admired and highly treasured everywhere. Thus, the chronicler of Saint Alban's starts his enumeration of things contributed by the thirtieth abbot, Thomas de la Mare, during his abbacy between 1349 and 1396 in this manner:[86]

83 Borghesi and Banchi, doc. 22, pp. 38–47.

84 A rod varied in length from district to district and measured between two and six meters; *The Cambridge Italian Dictionary*, I (Cambridge, Eng.: At the University Press, 1962), 127.

85 Castelnuovo, pp. 57–58.

86 *Gesta abbatum monasterii Sancti Albani* (Cottonian MS. Claudius E. IV, British Museum), ed. Henry Thomas Riley (London: Longmans, Green, Reader and Dyer, 1867), III, 380–82; translated from the Latin by Professor Margaret Taylor.

The said abbot, eagerly and with whole devotion for the honor of his church, provided that everything pertaining to the worship of so great a monastery and to the honor of God be elegant and distinguished; hence he exerted himself to purchase from his own portion what could deservedly enhance the glory of the place. Indeed he acquired two white cloths of damask covered with aquatic flowers of gold, along with a similar altar cloth, in honor of the Blessed Virgin Mary, these and many similar altar equipments being both necessary and decorative to the church. To these, Mistress Elizabeth de la Zouche added vestments of similar cloth, namely, chasubles and dalmaticas adorned by her and her maidens with the best gold thread, along with white stoles and maniples. The said abbot added a cape of similar cloth adorned with precious gold thread and had put on it aquatic flowers so that the vestment might resemble the altar cloths and furnishings; 40 pounds and more were paid for these. He contributed besides a white tartarin silk altar cloth, adorned with gold thread. . . . He also presented to the church, for the Lenten season, linen altar cloths for the high altar and other altars of the church, with sewn-on crosses of red muslin. . . . He gave besides a panel, which had been painted in Lombardy and had it placed above the main altar, having first paid 45 pounds, 10 shillings, 8 pence, for it and for its transport to London. . . . He purchased for the church thirty-eight white capes which are in part of samite, in part of gold cloth, along with chasubles, tunics, dalmaticas and capes, and four capes with gold threadwork, more valuable than the others, with stoles and maniples, and eight albs for the same. And so that all might walk in procession in a uniform way, he gave eight capes of coarse white cloth and eight tunics of the same material for the youths who were performing minute tasks in the service; 186 pounds, 12 shillings, 8 pence, were freely given for these.[87]

RECORDS AND ANNOTATIONS OF THE ROYAL HOUSEHOLD AT WESTMINSTER

It was England in economic and social ascendency . . . the England of Edward III, victor in the battles of Crécy (1346) and Poitiers (1356), which the chronicler Froissart says was in the springtime of its bloom, which encouraged strikingly new aesthetic solutions both in church and civic architecture. In London the king's special interest was turned toward the completion of the chapel of Saint Stephen, which belonged to his

[87] Church vestments made and embroidered in England were famous and much in demand throughout Europe and were known as *opus anglicanum*.

residence, the palace of Westminster, in the same way as the Sainte Chapelle in Paris belonged to the royal palace in the City of Paris. Along with this large enterprise went the constant improvements and enlargements of Westminster Palace. Thus the king continued a project first conceived by his ancestors, in particular by Henry III (1216–1272) and his wife, Eleanor of Provence, sister of Margaret, wife of Louis IX of France.

The abbey of Saint Peter, known as Westminster Abbey, on the north bank of the Thames, had been under the protection of English kings from the time of Edward the Confessor in the eleventh century.[88] In 1245, Henry III undertook the rebuilding of the abbey church, and Matthew Paris, his historiographer and our friend the chronicler of Saint Alban's, has this to say:

The king, inspired by the devotion which he felt towards St. Edward, ordered the church of Saint Peter, at Westminster, to be enlarged. He therefore caused the old walls, with the tower on the eastern side, to be pulled down and new and handsome ones to be created by clever architects at his own expense, and the remainder of the building on the western side to be altered to suit the other.[89]

The presbytery, choir and transept and the five easternmost bays of the nave of the church were completed in 1269, when, on October 13, the anniversary of his first translation, the remains of Edward the Confessor were taken in great solemnity and "transferred to a shrine of gold, which he, King Henry, had prepared for it."[90]

[88] It is generally assumed that the monastery, under the Benedictine rule, was established in the seventh century. Edward the Confessor may have been the first king to have his residence close to the abbey. He rebuilt the church and the monastery; both were dedicated on December 28, 1065. Edward died a few days later and was buried in front of the high altar of his new church. Upon his arrival in London, William the Conqueror went straight to Westminster to give thanks at the tomb of Edward, a political gesture which William of Malmsbury correctly recorded as such. The king also ordered his coronation to take place in Westminster. In 1069 the king held court at Westminster for the first time. William's descendents continued to use the abbey church as their coronation and burial church and began slowly to enlarge the royal residence and to keep it in repair inasmuch as they used the palace when holding court in London; Brayley and Britton, pp. 52–56; W. R. Lethaby, *Westminster Abbey and the Kings' Craftsmen: A Study of Mediaeval Building* (New York: E. P. Dutton & Co., 1906); Maurice Hastings, *St. Stephen's Chapel and Its Place in the Development of Perpendicular Style in England* (Cambridge, Eng.: At the University Press, 1955).

[89] J. A. Giles, trans., *Matthew Paris's English History*, II (London: Henry G. Bohn, 1853), 62 (the translation is from Latin); Brayley and Britton, *History of Parliament at Westminster*, pp. 52–53.

[90] *Matthew Paris*, III (1854), 373; *ibid.*, I (1852), 378, reports for 1241 that "in that year king Henry the Third, at his own expense caused a shrine of the purest gold and costly jewels to be elaborately constructed at London by picked workmen, for the relics of St. Edward to be placed therein. In the construction of this, however, although the materials were most costly, yet, according to the

Henry also had the monastic buildings repaired and the chapter house and the belfry built; the great new bells, given by the king, were ringing by 1254. At the same time, the king's and the queen's chambers in the palace of Westminster were being enlarged and decorated by English, French, Spanish and Italian painters. The most famous among the chambers, the "Painted Chamber," was begun in 1262. John of Gloucester was Henry's "plasterer and the master of the king's works at Westminster." In 1254–55 the king granted him "for life that he should be free from all tolls and tallage everywhere throughout the Realm."[91]

Known as a great builder, the king was also dreaded in England for his prodigious squandering of money. From a memorandum in the archives of Westminster Abbey it appears that by 1261 he had spent £29,345 19s. 8d. on the work at the abbey church alone; the final sum spent must have been about £50,000, including the shrine and altar.

Under Henry's son, Edward I (1272–1307), Westminster became the principal seat of justice for the kingdom; also, Parliament continued to be held there when the king was in residence. Edward started the construction of the new palace chapel of Saint Stephen in 1292, while maintenance work at the palace was kept up.[92] *Twelve of the rolls constituting the weekly pay sheets for work done at Westminster for part of the years between 1292 and 1294 have survived intact.*[93] *Master Michael of Canterbury, a stonemason, was in charge of the work; ninety-four masons are mentioned in one week, forty-two in another; fifty-five stonecutters, six carpenters. Painters were employed at the rate of about twelve or thirteen on the average. The wages given in these rolls are as follows: some masons were paid sixpence a day, others between four and fivepence a day; the weekly wages of the apparitor (foreman) were three shillings and sixpence; of carpenters from four and a half to fivepence a day; of plumbers four and a half to sixpence a day; of tilers fivepence a day; the principal painter, Master Walter, was paid fourteenpence a day, the others smaller sums, in general from sevenpence to threepence a day; two painters,*

words of the poet, the workmanship did far indeed the rude material exceed." The chronicler used almost identical words to praise the gold shrine of Saint Alban's. According to Lethaby, pp. 294–96, this shrine, though finished by 1269, had precious stones added to it by the king until his death; the finished shrine was worth between £60,000 and £80,000 in modern money.

[91] Brayley and Britton, *History of Parliament at Westminster,* p. 67; Lethaby, *Westminster Abbey.* pp. 164–73. John of Gloucester was master of the king's works between 1254 and 1261, in which year he died. He held a place of confidence and "the view and counsel of Master John ... was asked for in many matters pertaining to the royal buildings everywhere."

[92] The original chapel of Saint Stephen is traditionally ascribed to King Stephen, and is dated 1141; Hastings, *St. Stephen's Chapel,* p. 43.

[93] Detailed expense accounts concerning the royal household and other private writs, letters and mandates were kept separate from state papers. They are known as Close Rolls, the term "roll" being derived from the custom of keeping the account sheets rolled up for convenience of handling or carrying.

Andrea and Giletto (Italians?) had conjointly six shillings and eightpence for six days, and eight shillings in another week for the same time.[94]

A violent fire which damaged the king's palace and the buildings adjoining it is reported in 1298. An earlier fire in 1263, caused by the carelessness of a servant, had destroyed Henry III's little hall with many other houses joined to it.

In 1307, under Edward II (1307–1327), Richard of Wytham, a mason, was assigned by the treasurer (the administrative head of the king's works) to superintend and direct the works of the buildings, and to be Master at the King's Palace and the Tower at wages of seven shillings per week.[95] *He was followed by Walter of Canterbury in 1322–23. In 1326 William Hurley, a carpenter, and William Ramsey and Thomas of Canterbury, two masons who were shortly to be leading architects in their own right, were working on important details at the palace chapel, the latter being occupied with building the gallery connecting the king's pew at the chapel to the royal chambers in the palace at wages of three shillings a week.*[96]

Hastings makes an excellent case for his theory that the main structural parts of the chapel were completed in these years, and that Perpendicular architecture was developed in London by the court architects of Edward II before 1327.[97] *Stonecutters were employed to cut large Caen*

[94] Brayley and Britton, *History of Parliament at Westminster*, pp. 88–90.

[95] Brayley and Britton, p. 110; Lethaby, *Westminster Abbey*, p. 185; Knoop and Jones, *Mediaeval Mason*, Chap. ii, present an interesting, thorough study of the administration of building operations for the Crown. The "Treasurer," more commonly called the "Administrator," was in charge of administrative and financial matters and appears to have fulfilled the same function as the *operaio* in the Italian commune. The king's master mason had authority mainly over the workmen and everything that concerned the building itself.

[96] Lethaby, pp. 188–89; John Harvey, *English Mediaeval Architects: A Biographical Dictionary down to 1550* (London: B. T. Batsford, Ltd., 1954), pp. 53–54; Henry Thomas Riley, *Memorials of London and London Life in the XIIIth, XIVth, and XVth Centuries, Being a Series of Extracts ... from the Early Archives of the City of London, A. D. 1276–1419* (London: Longmans, Green, and Co., 1868), p. 185, quotes from Letter-Book E, fol. ccxxiii for 1332 (original text in Latin): "It was agreed by John de Pulteneye, Mayor, and the Aldermen, on the Monday next after the Feast of the Translation of St. Thomas the Martyr (July 7) ... that Master William de Rameseye, mason, who is master of the new works at the Church of St. Paul in London, and is especially and assiduously giving his whole attention to the business of the same church, shall not be placed on any assizes, juries, or inquests; nor shall he be summoned by the serjeants of the Mayor, Sheriffs, or bedels of the Wards, to come upon any summonses, special or common, to the Guildhall or elsewhere, so long as he shall be in the service of the church aforesaid, unless his presence shall be especially required for any certain cause."

[97] See Hastings, *St. Stephen's,* particularly his Introduction and Conclusion. The palace and chapel of Saint Stephen were destroyed by fire in 1834 and the remnants of the chapel were pulled down. Prior to that time the chapel had served the House of Commons from the time of the abolition in the second quarter of the sixteenth century and had had to suffer internal adjustments and changes. The lower chapel, or undercroft, dedicated to the Virgin, though

stones, getting four shillings for one hundred feet. Henry Godale, a porter, and his associates received fourteenpence for the porterage and carriage of two barge-loads of Caen freestone (one of many deliveries) from the king's bridge to the palace. John Wisman, a carrier, received six-pence per thousand for the carriage of seven thousand tiles from East Smithfield, near the Tower of London, to the palace. Henry de Schipman, a lighterman, received three shillings and sixpence for seven boatloads of sand from the Thames for making mortar, at sixpence per boat-load.[98]

Although Edward II neither cared particularly for Westminster nor for London and, after the first few years of his reign took residence there only rarely, he had considerable work done on the palace. This work was done in the early years of his reign and in connection with his coronation and marriage to Isabelle, daughter of Philip IV of France, for the palace was still in a poor state of repair after the fire of 1298. A roll belonging to the King's Remembrancer's Office says that:

the Conduit of water, coming into the Palace, and into the King's Mews, for the falcons, which in various places was obstructed and injured, and the underground pipes stolen, was completely repaired, and the water returned to its proper course and issues, both at the Palace and at the Mews.

The Little Hall, which was burnt in the time of the king's father, was completely repaired and new raised; and the walls of the same hall, both within and without, were provided with corbels of Caen and Rey-gate freestone. The gables were heightened and coped, and the walls in many parts strengthened and embattled; and the upper masonry was bound together with large iron ties, with tinned heads, on account of the great weight and size of the timbers. The floor of the hall was newly planked in the middle, and strengthened below in various parts with great timber.

much changed, was preserved and is still in existence. The approximate measure-ments of the chapel were 90 by 26 feet, with a probable height of 92 feet from the ground (Hastings, p. 63). Heavy wall piers divided the upper chapel into five bays. A solid wall about 17 feet high rose to the line of the window sill. It was adorned with an elaborate, 12-foot-high arcade, which rested on a double step of Purbeck marble. The chapel appears to have had octagonal stair towers at the four corners, and these were topped by finials.

[98] Brayley and Britton, *History of Parliament at Westminster*, pp. 110–12; Knoop and Jones, *Mediaeval Mason*, pp. 14–24, say that the building accounts usually commenced with a statement of the receipts, arrears being noted, from the revenues allocated for the works each year in succession. Then followed the expenses for materials; for transport in each year; and for wages. In Appendix I the two authors provide comparative statistics of masons' wages and of prices nad give, p. 210, an average wage of twenty-nine shillings and sevenpence per week at Westminster in 1292. Prices fluctuated from location to location and from decade to decade, however, and for the period before 1300 few examples are actually available. The wages of London masons seem to have been higher than wages elsewhere.

The Queen's Hall, which was burnt in the time of the late king, was completely repaired and restored in the same manner as the little hall, except that the clamps were not of iron. The flooring of this hall, of which the greater portion had been burnt, and the remaining part was weak and decayed, was repaired and raised and ceiled underneath. . . .

The Nursery Chambers of the sons and daughters of the [late] king and queen,—the Maydenhalle, with its chambers, wardrobe, and other conveniences . . . the various houses and chambers appropriated to the use of the earls and countesses, the barons and baronesses, and also of two of the queen's damsels . . . with divers chambers, wardrobes, galleries, etc., all which had been burnt, were fully repaired and restored.

As for the great hall, which was fixed for the coronation,

The roof, which on either side was dilapidated and decayed, was now in some measure amended; and the great exchequer (chamber) was repaired and amended in like manner. . . .

One long hall was erected of the entire length of the upper wall of the palace, reaching along the Thames, for the judgment and solemnities of the treasurer and barons [of the exchequer], and the great men and councillors. This hall was appropriated for the royal seat on the day of the coronation, and it was therefore ordered, that it should be covered with boards . . . and strongly supported at the back along its entire length, on account of the pressure of the people.[99]

No attention whatsoever is paid to the maintenance of the approaches to Westminster, which is the more remarkable if one will remember the care with which the citizens of Florence and Siena, from the early thirteenth century on, were planning the layout and paving of main streets and squares. In the eighth year of Edward II's rule (1315) a writ is addressed to William de Leyre and Richard Abbot, stating that:

the pavement between Temple Bar and the gate of the king's palace at Westminster was so broken and injured, that it was a great nuisance to those frequenting the court, and very perilous both for horsemen and foot passengers; and that a petition had been preferred to the king and council, praying them to provide a remedy for the same.[100]

[99] Brayley and Britton, pp. 113–17.
[100] Brayley and Britton, p. 128; William and Richard were commanded to cause the broken pavement to be repaired and to collect for the expense, *pro rata*, from all persons having houses adjacent to it, between Temple Bar and the palace. The complaint was repeated in 1353; this time the road from London to Westminster had become so dangerous for the transit of passengers and the carriage of goods as to demand the interference of government. It was ordained, by mandate of the king, that the foot pavement adjoining the houses on the line of the road be newly laid at the expense of the owners of the nearest houses and that money be levied by tolls on goods sold at the woolstaple (*ibid.*, p. 222).

In 1327 Edward III (1327–1377) became king of England at the age of fourteen. In the spring of 1330 building activity at the palace chapel was resumed. Many of the expense accounts of this building phase have survived. Items referring to construction no longer count heavily; instead, the largest proportion of accounts is for painting, glazing, sculpture and furnishing of the chapel.[101] Thomas of Canterbury was placed in charge of the works in 1330–31, and he is recorded several times as "designing tracery, making moulds and refinishing them in the tracing-house."[102] His weekly wages were six shillings. Wrought stone for the window casements of the clerestory of the chapel was brought by boat-loads and put in place, starting with the window in the east gable. A roll of about the same date also mentions Master Walter de Hurley, "keeper of carpentry for the King's works." Both men seem to have worked simultaneously also on the London Guildhall, which was completed in 1337. The permanent roof of the chapel must have been placed between 1345 and 1346, and on May 19, 1347, wages were paid to Master Thomas Seli and eighteen other carpenters for work on the wooden vault (vousura) of the chapel; two carpenter apprentices received payment for carving the bosses of the roof for five days. At the same time wages were also paid to forty-one masons working at the chapel.[103]

Preparations for the painting and glazing of the chapel started with the king's orders in 1350 for the taking of painters and glaziers in various counties for the works to be executed "in our Chapel at our Palace at Westminster." Since this was immediately after the plague of 1348–49 had decimated the population of England, and in particular of London, there must have been a great shortage of available craftsmen. Yet as late as 1363 the need for painters at Westminster was still acute enough to require the taking of more painters in London once again.

Between 1351 and 1352 and until 1355 there are lengthy payment accounts for the glazing of the windows of the chapel.

1353.—Aug. 15.—To William Holmere, for 107 *ponder* of white glass, bought for the windows of the upper chapel, each hundred containing 24 ponder, and each ponder containing five pounds, at 16s. per cwt., 1l. 0s. 8d./.... 1352.—Oct. 3.—To Peter Bocher (*Butcher*), for eight pounds of suet, bought for soldering the glass windows, 8d./To Leuen Crawe, for two ponder, and four pounds of blue glass... at 1s. per ponder, 2s. 9½d./ To Henry Staverne, for sixteen ponder of red glass... at 2s. 2d. each ponder, 1l. 14s. 8d./Oct. 10.—To William Holmere, for 110 lbs. of blue-coloured glass... at 3l. 12s. per cwt., 3l. 18s./Carriage of the same from Candlewick Street, 6d./Oct. 17.—To John Prentis, for ten hundred of

[101] Hastings, *St. Stephen's Chapel*, p. 50.
[102] Hastings, pp. 58–59; Brayley and Britton, pp. 150 ff.; Harvey, p. 53.
[103] Brayley and Britton, p. 164; Hastings, p. 34, points out correctly that with the placing of the roof the structural part of the chapel was completed.

white glass, and of various other colours, for the windows of the said chapel, at 18*s.* per hundred, 9*l.*/Carriage and boatage of the same from London to Westminster, 1*s.* 3*d.*

The following glaziers were employed:

1351.—June 20.—To Master John de Chester, glazier, working on the drawings of several images for the glass windows of the king's chapel, at 7*s.* per week, 7*s.*/To John Athelard, John Lincoln, Simon Lenne, John Lenton, and Godman de Lenton, five master-glaziers, working there on similar drawings, five days, at 1*s.* per day, 1*l.* 5*s.*/To Wm. Walton and . . . eleven painters on glass, painting glass for the windows of the upper chapel, five days, at 7*d.* per day, 1*l.* 12*s.* 1*d.*/To Wm. Ens, and fourteen others, glaziers, working at the chapel, on the cutting and joining of the glass for the windows, six days, at 6*d.* per day, 2*l.* 5*s.*/June 27.—To John Geddyng, for washing the tables for drawing on the glass, 4*d.*/To Master J. de Chester, working there on the drawing of images on the said tables, for his week's wages, 7*s.*/To John Athelard, John Lincoln, Simon de Lenn, and John de Lenton, working there on the aforesaid drawings, six days, at 1*s.* per day, 1*l.* 4*s.*/. . . . July 4.—To Simon le Smith, for seven *croysours* (cross irons), to break and work the glass, at 1½*d.* each, 8½*d.*/ For *cepo arietino* (mutton suet) bought, and filings, to make solder for the glass windows, 6*d.*/July 11.—. . . . For *servicia* (cerevisia? ale, or wort) for washing the tables for drawing on the glass, 7*d.*/Aug. 15 and 22, Sep. 12, Oct. 3 and 10:—To Master John de Chester [and others] for drawing the images, or figures, for the glass of the windows. . . . To John Coventry, and thirteen others, glaziers, breaking and joining the glass upon the painting tables, five days, at 6*d.* per day each, 2*l.* 2*s.*/To Thomas de Dadyngton and Robert Yerdesle, grinding different colours for the painting of the glass, five days, at 4½*d.* per day, 3*s.* 9*d.*[104]

On August 3, 1355, the sum of three shillings fourpence was paid to a glazier for a week's work mending the windows of the chapel, and a week later two shillings and nine and a halfpence to the same glazier for five days' work.[105] The last major expense item was £2. 6s. 8d. paid in 1358 to Thomas of St. Bathe, a glazier, for one large glass window to go over the chancel (forty feet, at one shilling and two pence per foot), and two pounds to Nicholas le Peutrer for 160 pounds of tin to lead the window, at threepence per pound.[106]

As with the glazing, the painting of the chapel also continued until

104 Brayley and Britton, pp. 176–80; Master John de Chester was the principal artist, yet five other masters were paid the same wages of 7 shillings a week each for also working on the drawings.

105 At that time the windows were probably in place and the repair work was a finishing-up job.

106 Brayley and Britton, p. 176.

midsummer 1358, but the main thrust of the work occurred during 1351–52. It is hard to visualize the blaze of color in this chapel when it was completed. Even if we keep before our eyes its similarity with the Sainte Chapelle in Paris, we still are far from the truth, for the Sainte Chapelle too must have been infinitely more luminous and radiant in colors than it is now. Gesso work, the "preynt" or "prynt" of the accounts given below, covered all architectural details. Then there was the painting of the tabernacles, the statues and their bases; there were the purely decorative background designs such as stars, the fleurs-de-lys, lions, and others, stenciled on and/or painted; and, finally, there were figures of saints, angels and others painted onto piers, the spandrels, and into the wall arcade. The accounts indicate that Hugh de St. Alban's was the master painter in charge of the layout and the preparatory drawings and perhaps of the underdrawings of individual figures. He rarely worked more than three or four days in a single week, which perhaps means that he worked on several commissions at the same time. We will also see that he, like some of the other masters, was selling materials of his trade to the administration at Westminster. Another man, John de Cotton, was also doing preparatory layout work, while the many other painters carried out the actual painting.

1351.—July 4.—To Master Hugh de St. Alban's and John de Cotton, painters, working there [in the chapel] on the drawing of several images . . . four days and a half, at 1s. per day each, 9s./July 11.—To Master H. de St. Alban's, painter, working there on the ordination . . . of the painting of several images, two days, at 1s. per day, 2s./. . . . Oct. 3.—To H. de St. Alban's and John de Cotton, painting and drawing several images in the same chapel, six days, at 1s. per day each, 12s./Oct. 24.—To John Elham and Gilbert Pokerig, drawing images in the same chapel, five days, at 10d. per day, 8s. 4d./1352 . . . March 12.—To John Elham, Gilbert Pokerigh, and William Walsingham, painting the tabernacles and images in the chapel, six days, at 10d. per day each, 15s./March 19.—To the same, painting images . . . on the walls of the chapel, six days as before, 15s./. . . . April 12.—To Wm. Heston and two others, laying on the gold, as well on the said walls, as on the placing of the preynts on the marble columns in the chapel, two days and a half, at 5d. per day each, 3s. 1½d./. . . . May 7.—To the same [Hugh de St. Alban's], working on the disposition of the painting of the chapel, three days, 3s./To Wm. Walsyngham and Gilbert Pokerich, painting angels for the tabernacles, six days, at 10d. per day each, 10s./May 13.—To H. de St. Alban's, disposer (or rather designer) of the works of the painters, painting there two days, 2s.[107]

On July 27, 1355, John Barneby, a painter, received two shillings

[107] Brayley and Britton, pp. 172–74; Hastings, p. 108.

per day, which was twice the wage of any of the other professional men in the king's works, including the architect-surveyors.[108]

The following materials were used by these painters:

1351.—June 26.—To John Lightgrave, for 600 leaves of gold, for painting the *tablements* (entablature?) of the chapel, at 5*s.* per 100, 1*l*, 10*s.*/To the same, for twelve leaves of tin, for the liessers [borders] of the said tablements, 1*s.*/ For cole and squirrels' tails for the painting of the chapel, 3*d.*/July 11.—For nineteen pounds of white lead, for priming, at 4*d.* per pound, 6*s.* 4*d.*/July 18.—To John Matfrey, for sixty-two pounds of red lead, at 5*d.* per pound, 1*l.* 5*s.* 10*d.*/To Master H. de St. Alban's, for four flagons of painters' oil, for the painting of the chapel, 16*s.*/July 25.—To the same, for two flagons of cole . . . 2*d.*/To the same, for half a pound of teynt . . . 2*s.*/Aug. 8.—To the same, for a pound and a half of oker, 3*d.*/To the same, for two small earthen jars to put the colours in, 1*d.*/For half a pound of cynephe, for the painting of the upper chapel, 17*s.* 3*d.*/Aug. 15—To Lonyn de Bruges, for six and a half pounds of white varnish, at 9*d.* per pound, 4*s.* 10$\frac{1}{2}$*d.*/Sep. 5.— . . . For thirty peacocks' and swans' feathers, and squirrels' tails, for the painters' pencils, 2$\frac{1}{2}$*d.*/For one pair of shears, to cut the leaves of tin, 2*d.*/Sep. 19.—For one pound of hogs' hair, for the painters' pencils, 1*s.*/For nineteen flagons of painters' oil, at 3*s.* 4*d.* per flagon, 3*l.* 3*s.* 4*d.*/ . . . For half a pound of cotton, for laying on the gold, 7$\frac{1}{2}$*d.*/Sep. 26.—To John Tynbetere, for twelve dozen leaves of tin, 12*s.*/ . . . 1352.—Jan. 2.—To John Lambard, for two quatern' of royal paper for the painter's patrons [patterns], 1*s.* 8*d.*/For one pair of scales to weigh the different painters' colours, 1*s.*/ . . . Feb. 6. —To John Tynbetere, for six dozen leaves of tin, to make the pryntes for the painting of the chapel, 6*s.*/ . . . March 19.—To John Matfray, for 4lbs. of oker, for priming of the walls of the chapel, 8*d.*/ . . . for 2lb. of brun [brown], for the same, 6*d.*/March 19.—To Thomas Drayton, for eight flagons of painter's oil . . . 2*s.* 4*d.* per flagon, 1*l.*/ . . . April 16.—To John Matfray, for 2lbs. of vert de grece, 2*s.* 4*d.*[109]

In 1352 Masters William Hurley and William Herland continued working on the stalls of Saint Stephen's at one shilling per day.

As early as 1332–33 Master Richard of Reading was paid £3. 6s. 8d. for making, by task-work, two large images, one of Saint Edward and the other of Saint John as a pilgrim, for the gable of the chapel. Then, in 1351, successive commissions were given to William of Padrington, a mason, to acquire stone at Dunstaple, for ten shillings, for an image of Saint Stephen; ten shillings for two stones for the images of two men-at-

[108] Hastings, p. 109, suggests that the painting must have been of very great importance and may have been the one representing the royal family being presented to the Holy Family by Saint George.
[109] Brayley and Britton, pp. 181–85.

arms; six shillings and eightpence each for making, by task-work, twenty angels to stand in the tabernacles; £1. 6s. 8d. for an image of John le Wayte, the stone for it to be procured by William himself; eight pounds for three kings, made with the King's stone, to stand in the tabernacles of the chapel; and an equal amount for the two images of men-at-arms.[110]

By 1353 or 1354 all work at the palace chapel must have been completed.

In 1365–66 considerable work went on at the palace. Reygate and Caen stone was brought by boat-loads for the clock tower within the palace grounds.[111] *Henry Yevele, who had become disposer of the king's works of masonry at Westminster Palace and the Tower of London in 1360, was its builder. He was paid a fee of twelvepence a day. He also supplied materials such as plaster of Paris and 7000 Flanders tiles for the paving of the courtyards of the palace. In 1369, during the last years of Edward III, Yevele was given a grant of office for life.*

In the last thirty years of the century important construction work was resumed at Westminster Abbey. This was made possible by the shrewd governance of the abbey by two successive, very able abbots, who also endowed it with special revenues.[112] *Yevele was called upon to be consultant mason. Now long-postponed repair work and additions were made to most parts of the monastic buildings; the new abbot's house was built between 1372 and 1376, and about 1375 work was resumed at the nave of the abbey church. Yevele's design of this nave was a brilliant solution of the structural and aesthetic problems posed by the interval of more than one hundred years between the high gothic eastern part of the nave and its Perpendicular western bays.*

Beginning in 1394, under Richard II's rule (1377–1399) (with Geoffrey Chaucer as clerk of the works at Westminster), Yevele, together with William and Hugh Herland, the great master carpenters of the end of the century, designed and built the majestic new Westminster Hall.

[110] Brayley and Britton, p. 164; Lethaby, pp. 247–50. It is impossible to establish a unified iconographic program on the basis of this scanty information. In his frontispiece reconstruction of the interior of the chapel, Hastings appears to have placed kings in all tabernacles, which is nice but does not coincide with the commissions. On p. 108 he tells us that cramp holes for fixing the pedestals and canopies of the statues were found on the piers. The pedestals were about 16 feet above the ground and the canopies about seven feet above these, so that the statues must have been life-size. This reflects once more the arrangement of the statues of the twelve apostles at the Sainte Chapelle in Paris, which stood against the piers of the upper chapel. Closer in time, yet following the Sainte Chapelle, this kind of arrangement was also used in the choirs of churches such as the choir of the cathedral of Cologne during the first quarter of the fourteenth century.

[111] Brayley and Britton, pp. 186–89.

[112] Edward Carpenter, *A House of Kings* (London: John Baker, 1966), pp. 62–65; Lethaby, *Westminster Abbey*, pp. 204–11.

THE LONDON REGULATIONS FOR THE TRADE OF MASONS OF 1356

By comparison with other guilds, the official regulations of the guilds of masons all through England were surprisingly slow to come, even though there was some evidence of an existing internal agreement in certain cases among the members of the trade. In 1356 the first indication of the necessity for the deposition of guild regulations arose in London in response to existing disputes among masons. Then a code of government was drawn up in general terms, to be spelled out in detail at a later date.[113] *The text of the Regulations of 1356 reads as follows:*

At a congregation of the Mayor and Aldermen, holden on the Monday next before the Purification of the Blessed Virgin Mary [2 February], in the 30th year of the reign of King Edward the Third ... there being present, Simon Fraunceys, the Mayor, John Lovekyn, and other Aldermen, the Sheriffs, and ... Commoners, certain Articles were ordained touching the trade of Masons, in these words:

> Whereas Simon Fraunceys, Mayor of the City of London, has been given to understand that divers dissensions and disputes have been moved in the said city between the mason hewers, on the one hand, and the mason layers and setters on the other; because that their trade has not been regulated in due manner, by the government of folks of their trade, in such form as other trades are; therefore the said Mayor, for maintaining the peace of our Lord the King, and for allaying such manner of dissentions and disputes, and for nurturing love among all manner of folks, in honour of the said city, and for the profit of the common people, by assent and counsel of the Aldermen and Sheriffs, caused all the good folks of the said trade to be summoned before him, to have from them good and due information how their trade might be best ordered and ruled, for the profit of the common people.
>
> Whereupon, the good folks of the said trade chose from among themselves twelve of the most skilful men of their trade, to inform the Mayor, Aldermen, and Sheriffs, as to the acts and articles touching their said trade, that is to say:—Walter de Sallynge, Richard de Sallynge, Thomas de Bredone, John de Tyryngtone, Thomas de Gloucestre, and Henry de Yeevelee, on behalf of the mason hewers; Richard Joyce, Simon de Bartone,

113 Knoop and Jones, *The Mediaeval Mason*, pp. 224 ff., also given in Riley, *Memorials of London*, pp. 280–82; the original text was written in French. Knoop and Jones, pp. 135–43, provide an excellent summary of the possible reasons for the delay in the establishment of the guild regulations of the masons. They feel that craft guilds were municipal institutions, whereas most of the early stone building was done outside the boroughs and primarily by the Crown and the Church. The point of dispute in this particular case, between the hewers and the layers and setters concerning the type of work each of them might do, was settled in point one.

John de Estone, John Wylot, Thomas Hardegray, and Richard de Corne-waylle, on behalf of the mason layers and setters . . . the which folks were sworn before the aforesaid Mayor, Aldermen, and Sheriffs; in manner as follows.—

In the first place,—that every man of the trade may work at any work touching the trade, if he be perfectly skilled and knowing in the same.

Also,—that good folks of the said trade shall be chosen and sworn every time that need shall be, to oversee that no one of the trade takes work to complete, if he does not well and perfectly know how to perform such work; on pain of losing, to the use of the Commonalty, the first time that he shall by the persons so sworn be convicted thereof, one mark; and the second time, two marks; and the third time, he shall forswear the trade, for ever.

Also,—that no one shall take work in gross, if he be not of ability in a proper manner to complete such work; and he who wishes to undertake such work in gross, shall come to the good man of whom he has taken such work to do and complete, and shall bring with him six or four ancient men of his trade, sworn thereunto, if they are prepared to testify unto the good man of whom he has taken such work to do, that he is skilful and of ability to perform such work, and that if he shall fail to complete such work in due manner, or not be of ability to do the same, they themselves, who so testify that he is skilful and of ability to finish the work, are bound to complete the same work well and properly at their own charges, in such manner as he undertook; in case the employer who owns the work shall have fully paid the workman. And if the employer shall then owe him anything, let him pay it to the persons who have so undertaken for him to complete such work.

Also,—that no one shall set an apprentice or journeyman to work, except in presence of his master, before he has been perfectly instructed in his calling: and he who shall do the contrary, and by the persons so sworn be convicted thereof, let him pay. . . .

Also,—that no one of the said trade shall take an apprentice for a less term than seven years, according to the usage of the City. . . .

Also,—that the said Masters, so chosen shall oversee that all those who work by the day shall take for their hire according as they are skilled, and may deserve for their work and not outrageously.

Also,—if any one of the said trade will not be ruled or directed in due manner by the persons of his trade sworn thereunto, such sworn persons are to make known his name unto the Mayor. . . .

Also,—that no one of the said trade shall take the apprentice or journeyman of another, to the prejudice or damage of his master, until his term shall have fully expired. . . .

FROM THE RECORDS OF THE CITY OF LONDON

From the very beginning of his rule in 1377 (at the age of fifteen) Richard II regularly deposited (pawned) royal jewelry and plate in pledge for loans from the City of London. This he did in 1377, 1379 and 1380,

to mention only three years, for two loans of £5000 and one of £2000. Objects he deposited as pawns are listed as follows:

One coronet, of five large and five small flowrets, set with balasses, emeralds, sapphires, diamonds, and large pearls, weighing, by goldsmiths' weight, 4*l.* 13*s.* 4*d.*; one sword for Parliament, set with gold, with diamonds, balasses, *balesets*, small sapphires, and pearls; and 24 *nouches* [brooches] of various kinds, set with divers stones; of which, there are one great *nouche* and three smaller *nouches*, each with a griffin in the middle; five *nouches* in the form of white dogs, studded with rubies on the shoulders; one great *nouche* with four wild boars azure; four *nouches* in the form of eagles; three *nouches* in the form of white harts, studded with rubies; and six *nouches* the form of keys.[114]

In 1392, when the City of London refused to grant him a further loan, the king put the mayor and the sheriffs into jail and suspended the liberties and privileges of the City, appointing a custos *who was to rule.*[115] *The Commons paid £10,000 in cash and offered many valuable presents to be restored to their old privileges.*

The King was presented by the Major and his brethren with two gilt basins, each containing 1000 nobles of gold, and an altar table of silver gilt with graven images and enameled most curiously of the story of St. Edward of the value of 1000 marks; further a golden tablet of the Trinity, worth £800., another tablet, of St. Anne given to the queen (former princess Anne of Bohemia); a child presented the king with a crown of gold garnished with stones and pearls.[116]

[114] Riley, *Memorials of London,* pp. 410–12, 429–30, 443–44.

[115] At his coronation every king guaranteed to protect the liberties and privileges of the City of London, but this guarantee was continually broken. As early as the rule of Henry III, Matthew Paris tells of the just complaints of the citizens of London in 1249: "Where is the liberty of London, which is so often bought; so often granted; so often guaranteed by writing; so often sworn to be respected?" (*Matthew Paris,* II, 289, 329, 351).

[116] Brayley and Britton, *History of Parliament at Westminster,* p. xix.

3

The Gothic Period
between 1360 and 1450

Once more it is emphasized that the dates used here are not meant to draw the limit of either the opening years or the end of this third epoch of gothic art, for some of the most moving and powerful gothic sculpture and paintings were created far into the sixteenth century. Yet during this span of time vital new forces acted upon the established transcendental and idealistic approach to art, gradually altering its course in new directions.

From a historical standpoint, a number of events created immediate new conditions, while others aided in making the old order obsolete.

In the year 1360 the Treaty of Bretigny was signed, momentarily stopping the Hundred Years' War between France and England. Both countries were financially exhausted and depleted in manpower. The heavy taxation and exploitation of the people in both nations, the terrible ravages of war and marauding soldiers in the countryside in northern France and in all other countries which lay in the path of the two armies, led to unimaginable poverty, hunger and despair. Recurrent uprisings in the cities of France and England in the second half of the fourteenth century indicate the degree of hopelessness among the masses. These, as well as the repeated revolts of the cities of Flanders against feudal rule, were put down without mercy.

We must assume that this unrest was intensified by the horrifying experience of the Black Death, at its worst during the years between 1347 and 1349, but with recurrent episodes until the end of the fourteenth century. Boccaccio says in the Decameron *that the epidemic had been a leveler of class distinctions; yet the experience, for those who came through it, must have deeply affected their belief in the established order and increased their yearning for a better life.[1]*

By 1360 the return of the popes to Rome from Avignon was being urged by the most devoted Christians. The long period of exile and the following open schism within the Church which lasted until 1449, when Pope Nicholas V finally was able to reunite the Church, discredited the papacy as much as chivalry had been discredited earlier.

Between 1451 and 1453 the last strongholds of the English on the Continent fell, and the Hundred Years' War came to an end. In 1453 Constantinople was taken by the Turks while a powerless and essentially indifferent western Europe watched the disappearance of the Byzantine empire and with it the last Christian foothold in the East.

During this period European feudal society increasingly assumed the habit of entrusting affairs of state, such as finances and jurisdiction, to a new group of trained men who had worked their way up from the rank

[1] A yearning which probably was interpreted in a variety of ways at all times. A very excellent account of the conditions and consequences for the city-states of Florence and Siena is given by Millard Meiss, *Painting in Florence and Siena after the Black Death* (New York: Harper Torchbooks, 1964).

*and file of the commoners: a responsible middle class was preparing itself
for future tasks.*

*In the midst of political, economic and social upheavals the arts
flourished, though, significantly, not monumental church and public archi-
tecture, but rather the smaller and, in particular, the portable, arts. The
courts of Paris and London continued to lead in interest and spending
power. In both places the brilliance of the style of living was unparalleled.
The great princely courts were still constantly on the move, but these
moves were now planned with a maximum of comfort; the building and
maintenance of a great number of palaces and houses and their furnish-
ings figure prominently in princely accounts. Portable treasures such as
favorite altarpieces, small shrines, statuettes, silver and gold vessels, jewels,
books, tapestries and precious textiles were carried along or moved around
at intervals. And, as these princes provided for their living bodies, so also
they provided for their burial places.*

*Charles V of France, regent for eight years before he became king in
1364, was a passionate builder and one of the truly great collectors of
books. He installed a comfortable library in three rooms of a tower of his
palace of the Louvre. Books were kept in his various palaces and books
accompanied him whenever he traveled. Two of the king's three brothers,
Jean de Berry and Philip the Bold of Burgundy, shared his passion for
books and for collecting in general, and between them the three princes
attracted and employed the most prominent Continental European artists
of their time at their respective courts in Paris, Bourges and Dijon. At the
death of the duke of Berry in 1416 his collections had to be sold to pay his
creditors. Inventories taken during his lifetime tell of the immense size of
his collections. The collections of Charles V, and later those of the dukes
of Burgundy at the death of the last duke, Charles the Bold, in 1477, were
also dispersed. Our knowledge of their size and content is limited to sur-
viving inventories and other contemporary observations.*

*The artists employed by these three Valois princes were no longer
exclusively French as they had been a generation earlier; a consistently
growing contingent of Flemings had begun to join the famous Parisian
school of artists and craftsmen. Philip the Bold, and much more so Philip
the Good, his grandson, who resided in Flanders after his break with the
royal house of France after 1420, increasingly employed artists living at
Ypres, Bruges, Ghent and Tournai.*

*In this northern setting a new artistic development took place which,
often before shown as latent in gothic art, unfolded with revolutionary
force in the second half of the fourteenth century: the study of nature and
the representation of the specific object which entailed minute observa-
tion and recording of line, texture and light. This observation and record-
ing became the primary goal, indeed the very subject, of representation.
Beauty was discovered to be inherent in every shape and surface, and the*

artist showed with equally undivided delight and candor the transparent wing of a dragonfly or the dulled eyes and veined, wrinkled surface of an old human face. So eager was the artist to add detail to detail with utmost care and truthfulness that compositional unity was temporarily disturbed. Beginning with the second quarter of the fifteenth century this compositional unity was gradually restored by the great Flemish masters.[2]

In Italy, meanwhile, an equally powerful intellectual revolution was taking place, and Florence, though not its only center, was its chief artistic center. Petrarch and his like-minded circle of distinguished men impressed upon the wider world of learning their own awareness of the need for the study of Latin and Greek culture (humanitas). *They exchanged thoughts on the deeds of the great men of antiquity, on Greek and Roman philosophy and literature, and they borrowed hard to obtain books from one another and copied and exchanged them. The study of ancient art, coins and medals was included in their effort to establish as close contact as possible with the ancient world to which they felt kindred and heirs. And though it had been no novelty in the Tuscany of the thirteenth century to cherish and record the discovery of ancient pieces of art, this was different now: such finds were pursued with a new eagerness, as tangible evidence of a past so great that it made the present and the immediate past appear childish and despicable. The courts of the Carrara in Padua, of Azzo di Correggio in Parma, of the Visconti in Milan and Pavia, where Petrarch was a frequent guest, became influential early patrons of the study and imitation of classic antiquity.*[3]

The commune of Florence gave men and ideas to this humanistic movement. It provided two more ingredients. Giotto, the city's acknowledged greatest artist, was admired and praised for the reality of his figures and compositions. Though this praise remained without clear and unequivocal definition by either laymen or artists, it created in Florence a lasting craving for the portrayal of reality in art, an ideal as strong as the humanists' urging for a revival of antiquity and the north European quest for the observation of natural phenomena. Lastly, the Florentine policy of involving its citizens in public service which included the making of decisions in matters of art, produced a considerable body of men able to observe and weigh aesthetic questions. Thus, while it stands to reason that Dante's genius encompassed art intuitively, it may be that his precise references to the art of his day and his frequent use of imagery derived from the visual arts, came from his years of practical experience in the service

[2] See Max Dvořák *Kunstgeschichte als Geistesgeschichte* (Munich: R. Piper & Co., 1928), pp. 95–147, a chapter which contains some of the finest observations to have been made on gothic art. See also Erwin Panofsky, *Early Netherlandish Painting: Its Origins and Character* (Cambridge, Mass.: Harvard University Press, 1953).

[3] Theodor E. Mommsen, "Petrarch and the Decoration of the Sala Virorum Illustrium in Padua," *The Art Bulletin*, XXXIV/2 (1952), 95–116.

of the Florentine city council. It is generally assumed that his quotations in the Divine Comedy *were the point of departure for modern art criticism*[4] *started by the Dante commentators of the mid-fourteenth century. It matters little whether this or the habit to discuss current matters of concern among the educated Florentine citizens was the cause. What matters is that from then on Florence and Florence alone was engaged in an art-critical debate in which the artist himself joined to define his goals in theory, goals he had never stopped to pursue in practice.*

PRINCELY TOMBS OF THE FOURTEENTH CENTURY

A relatively large number of contracts, wills and payment accounts concerning the construction of tombs have survived from the fourteenth century. Some tombs were prepared during the lifetime of the occupant, while others were commissioned and executed only years after his death. How meaningful and important the tomb was in the thinking of men of the time is vividly expressed in a small poem by the English poet John Gower (ca. 1325–1408). It describes the ruler on his high dais in the hall of his palace at the end of his coronation day, well satisfied with food and drink, the playing of the minstrels and the tales of the jesters (disours). *At last he receives also his masons, who come to inquire "where that he wolde be begrave,/and of what ston, his sepulture/they scholden make, and what sculpture/he wolde ordeine thereupon."*[5]

In keeping with the general trend of fourteenth-century design, the tomb and its decoration went from simplicity to elaborateness. The chief element of the tomb was, as before, a stone or metal slab on which rested the full-length effigy of the dead. Beyond this there were variations in structure and materials, the former depending partly on the position (against a wall or freestanding), and partly on the emphasis the occupant

[4] Meiss, p. 5; Julius von Schlosser, *Quellenbuch zur Kunstgeschichte des abendländischen Mittelalters,* N.F., VII (Vienna: C. Graeser, 1896), 348–50; Schlosser, "Zur Geschichte der Kunsthistographie," *Präludien, Vorträge und Aufsätze* (Berlin: Julius Bard Verlag, 1927), pp. 248–95; Schlosser, "Materialien zur Quellenkunde der Kunstgeschichte," *Sitzungsberichte der Kaiserlichen Akademie der Wissenschaften in Wien,* Vol. 177/I, "Mittelalter" (Vienna: Alfred Hölder, 1914), pp. 47–50. *The Divine Comedy of Dante Alighieri* with translation and comment by John D. Sinclair (New York: Oxford University Press, 1968), II Purgatorio, Canto XI, lines 79–99.

[5] I am indebted to Professor John Hooper Harvey, *Gothic England: A Survey of National Culture, 1300–1550* (London: B. T. Batsford, Ltd., 1947), App. I, pp. 162–63, for calling my attention to this poem. It is contained in John Gower's *Confessio amantis,* Bk. VII, lines 2412–31, ed. G. C. Macaulay, *The English Works of John Gower* (London: Kegan, Paul, Trench, Trübner & Co., Ltd., 1901), II, 299.

expected to achieve by means of an elaborate tomb chest, superstructure,
or both. Shrine and tomb c chitecture at times flowed into one another.[6]
Several stonecutters—they could be architects or sculptors—from Paris and
London, Franco-Flemish and Flemish—achieved international renown and
were summoned to different courts.

On June 4, 1312, a contract was drawn between Mahaut, countess of
Artois, and the renowned sculptor and tomb maker Jean Pépin de Huy
for the making of the tomb of her husband, Otto IV of Burgundy, count
of Artois.

To all those who will see these letters, Jean Ploiebanch, keeper of
the Provost's office in Paris, sends greetings. We wish to make known that
before us Jean Pépin de Huy, tomb maker and citizen of Paris, acknowl-
edged in person having made a contract with the high, noble and power-
ful lady the Countess of Artois, to make and carve at his own cost and
expense, partly from stone and partly from white alabaster of fine and
good quality, the image of an armed knight, with shield, sword and
armor, a lion under the feet of the statue and two small angels at his
shoulders supporting a pillow under the head of the reclining figure.
There will be an inscription surrounding the tomb and, as was said before,
the tomb will be of alabaster, the whole for the price of 140 Paris livres.
Of this the aforesaid Jean has already received into his hands, from the
aforesaid lady, 70 livres, as he confirms, and with the sum of which he
considered himself in our presence well paid.[7]

The above-named Jean promised in our presence upon the Bible to
make the image and all other things mentioned above as well as he knows
how to make them and to bring them to Paris and deliver them at his
own expense in perfect condition and complete a year from the coming
mid-August. From Paris the aforesaid lady will have these objects trans-
ported at her own expense, although said Jean will be held responsible
for their safety, to the place which she will select for the location of the
tomb. Jean promised to go there and install the tomb at his own expense

[6] Maurice Hastings, *St. Stephen's Chapel and Its Place in the Development
of Perpendicular Style in England* (Cambridge, Eng.: At the University Press,
1955), pp. 118–46.

[7] M. le Chanoine Dehaisnes, *Documents et extraits divers concernant
l'histoire de l'art dans la Flandre, l'Artois et le Hainaut avant le XVe siècle* (Lille:
Imprimerie L. Danel, 1886), I, 202–3. As early as May 18, 1311, Mahaut had ordered
an advance payment of 80 Paris livres to be made to Pépin de Huy, at which
time she must have first engaged him (p. 198); André Humbert, *La Sculpture sous
les Ducs de Bourgogne* (Paris: Henri Laurens, 1913), pp. 29–35: Jean Pépin de
Huy, one of the greatest tomb makers of the first thirty years of the fourteenth
century, came from Flanders but lived and worked in Paris. He was the teacher
of Jean de Liège, who worked for Charles V and also made the tomb of Edward
III's wife, Philippa of Hainaut (d. 1369), in Westminster Abbey. The countess of
Artois was a great patroness of the arts in her own right. The count had died in
1303; the tomb no longer exists but designs were preserved.

at the request of my lady. In addition he promised to surrender and pay to said lady all costs, expenses, damage and days which she would lose if he did not carry through his obligations, which he gave his promise to keep toward the countess by simple oath as these letters confirm.

After this there came before us the following people in person: Raoul, hatmaker, weaver and citizen of Paris, living on the Champ aux Bretons, in pledge for the said Jean; Yvon the shearer (*retondeur*), living in the Pelaterie; and Jean de Mitterie, maker of chasubles, living at Tire-chape; who all agreed to be each for all, without division, responsible and principal debtors, liable, bound and obliged for all the above-mentioned agreements and for each one of them separately, to fulfill and accomplish in the manner as above stated the contract which was made by Jean with my lady. All are responsible for and debtors in the amount of the above-mentioned sum if need be and also are responsible for all expenses and damages as mentioned above if there should be any breach of the contract or of part of it. And the aforementioned Jean and his guarantors have accepted and committed themselves each for all, themselves, their heirs and the possessions movable and immovable of their heirs, now and in the future, at the court of the Provost of Paris or under any jurisdiction wherever they may be found, to keep firmly and loyally their word, to accomplish everything in the manner as above outlined. And with their oath given in person here before us, they renounce to use any devices, obstacles, fraud, force, deception or to undertake or to assist knowingly or unknowingly in the undertaking of finding any reason, exception or allegation which would give them any right against those who hold these letters. In witness whereof we have put on these leters the seal of the Provost's office in Paris, in the year of grace 1312, the Wednesday after Saint Barnabas the Apostle (August 30). J. de la Croiz.[8]

Edward the Black Prince, son of Edward III, made provision for his tomb in his will, dated June 7, 1376.

We ordain . . . that our body be buried in the cathedral church of the Trinity at Canterbury, there where the body of the martyr Lord Saint Thomas rests, in the middle of the chapel of Our Lady Undercroft,[9]

[8] In 1313 Pierre Boye received 6 livres for emblazoning the shields and Jean de Huy and Jean Brequessent received 64 livres for the "arcade and the images" of the tomb (Dehaisnes, I, 208). This probably means—and Dehaisnes also mentions it *ibid.*, I, 423)—that in addition to the effigy on top of the tomb, the base was decorated by a surrounding arcade with statuettes of mourners inside the niches. Finally, the tomb was gilded by one Jean de Rouen, who received 8 livres for his work. In the same year, on April 25, 1315, a contract was made to take the whole tomb from Paris to the abbey of Chielleux in Burgundy (*ibid.*, I, 213).

[9] Robert Willis, *The Architectural History of Canterbury Cathedral* (London: Longman and Co., W. Pickering, and G. Bell, 1845), pp. 131–132; the prince made his will, written in French, in June 1376; he died July 8, 1376. Willis assumes that an error crept into this text, or that the prince confused the layout, for his tomb was placed in the Trinity Chapel, east of the choir, above the chapel of Our Lady Undercroft, in the exact relative position.

directly in front of the altar, so that the foot end of our tomb shall be ten feet from the altar. The tomb shall be made of marble and of good craftsmanship. And we request that the tomb be surrounded by twelve shields of brass, each one the diameter of one foot, of which six shall show our complete coats of arms and the other six ostrich feathers, and that on each shield there shall be an inscription, both, on those bearing our coats of arms and those bearing the rising plumes of ostrich feathers. And above the tomb chest there shall be a slab of gilded brass[10] of equal length and width as the tomb chest, on which an effigy of gilded brass shall be placed in our memory complete in full war array, with our quartered arms, the face not uncovered,[11] and our leopard helmet placed underneath the head of the effigy. And we desire that on our tomb from distance to distance there be placed the following readable and visible inscription in the manner which will seem most appropriate to our executors. . . .

The will of Philip the Bold, duke of Burgundy, count of Flanders, the Artois and the Franche Conté, contains the following provisions concerning his burial:

I have chosen my burial place to be in the church of the monastery of the Carthusians at Dijon, called Champmol, founded and begun by me. . . . Because I feel that large funerals are a worldly pomp with little profit to the soul, I request that, as the only light to burn in the church on the day of my funeral service, thirteen torches of twelve pounds of wax each be ordered, to be held by thirteen poor men, each of whom shall be given a russet coat and cape and one gold franc; where my body lies in state four candles of sixteen pounds of wax each shall be held, and I forbid explicitly that there be other light or other solemnity.[12]

The duke's stated desire for simplicity stands in startling contrast to his actual careful preparation for his burial place (over a period of about thirty years), the Chartreuse of Champmol, and for his cenotaph, which

[10] Brass in combination with marble or alabaster was very fashionable on tombs in England in the period between the reign of Edward I, which began in 1272, and the mid-fifteenth century. The tomb of the prince was simple by comparison with others of the same period; Herbert W. Macklin, *The Brasses of England* (London: Methuen & Co., 1907), Introduction.

[11] The prince evidently wore a bascinet, which encased the entire head, merely leaving the eyes exposed. The tilting-helm with its heraldic accessories formed, in many cases, the pillow of the knightly effigies; in action it was worn over the bascinet; Charles Boutell, *Monumental Brasses and Slabs* (London: G. Bell, 1847), p. 59.

[12] For this and the following extracts concerning the Chartreuse of Champmol see Dehaisnes, *Documents;* Dehaisnes' copy of the will (II, 628–29) is dated November 14, 1386, whereas the original was signed at Arras and dated September 13, 1386; this is quoted by Henri David, *Claus Sluter* (Paris: Editions Pierre Tisne, 1951), p. 28, n. 4. The original document is in the Trésor des Chartes, in the series Testaments des Rois et Reines, cote J.404 B, No. 39, in the Bibliothèque Nationale in Paris; Dehaisnes' copy comes from the Archives départementales du Nord, Fonds de la Chambre des Comptes de Lille, No. 11607.

was to be placed into the choir of its church, as well as to the pomp with which his remains were finally brought to rest there in 1404.[13] *The survival of detailed records of expenditure in the separate accounts of the clerk of the works at the Chartreuse, those of the district of Dijon and those of the exchequer for the duchy of Burgundy permit an estimate of the immense resources the prince commanded and unhesitatingly used; they permit as well a glimpse of his personal involvement as connoisseur and patron of the arts.*[14]

In 1383 the foundation stone was laid for the building of the Carthusian monastery and church on land just outside Dijon, at Champmol, acquired and rounded out over a period of several years.[15] *The monastery was to hold the exceptional number of twenty-four (rather than twelve) Carthusian monks to say perpetual prayers for the duke and his family. Space was provided for the monks, one prior and five lay brothers. The duke's chief mason, Drouot de Dammartin, drew the plans, and lesser architects supervised the actual construction. The church was completed and dedicated on May 24, 1388.*[16]

A sculpture workshop was established in Dijon in 1371 under Jean de Marville, whose name occurs first in connection with the artistic activities of the Valois princes in 1369, when he was paid for sculpture and masonry commissioned by Charles V at the cathedral of Rouen.[17] *Philip of Burgundy attached him to his household with the rank of* valet de chambre. *A contract, dated 1373, included wages for one workman, a servant and a horse. Marville was asked to take up residence in Dijon at eight gros per day on a day by day basis;*[18] *not later than 1376–77 he was*

13 For the funeral procession, see David, *Claus Sluter* p. 115.

14 The reader will find full and carefully analyzed documentation in such monographs as the above-quoted book by Henri David; Aenne Liebreich, *Claus Sluter* (Brussels: Dietrich & Cie., 1936); Arthur Kleinclausz, *Claus Sluter et la sculpture bourguignonne au XVe siècle* (Paris: Librairie de l'Art Ancien et Moderne, 1905). Among the many existing articles on the subject mention is made here of the recent, brief but interesting study by Stephen K. Scher, "André Beauneveu and Claus Sluter," *Gesta*, VII (1968), 3–14. The various monographs provide good photographic reproductions of the remnants of the three major sculptural tasks: those of the sculpture of the church façade, with the statues of the trumeau Virgin, the duke and duchess kneeling in prayer and Saint John the Baptist and Saint Catherine of Alexandria presenting them to the Virgin; those of the base of the Calvary with the statues of six prophets and part of the Christ of the Crucifix; and finally those of the cenotaph of Philip the Bold. The reader will also find there the reconstruction of the layout of the monastery and church and of the Calvary, which originaly stood in the large cloister.

15 Dehaisnes, II, 599; Liebreich, *Claus Sluter*, p. 19.

16 David, *Claus Sluter*, pp. 33, 40; on p. 33 David explains that in the most active years of building, in 1387 and 1388 and until April 1389, about 48,500 francs were spent, or, in modern terms, over 6 million francs.

17 Dehasines, I, 490.

18 Dehaisnes, II, 525. In selecting the material for the following pages no attempt has been made at completeness of the records or to explain each step in its meaning for the whole building—this has been done exhaustively before; rather, an attempt has been made to recreate the day by day preoccupations and interactions between patron (or the authorities delegated by him), artists, workmen and the many craftsmen, tradesmen and contractors connected with the

*paid on an annual basis at a salary of 243 francs tournois, 4 gros, being
kept busy with a variety of tasks for the ducal household.*[19]

*From 1384 on, Marville's workshop was occupied above all with
work for the duke's cenotaph and soon also with the sculptural decoration
of the portal of the church of the Chartreuse.*[20] *In the Spring of 1385
Marville received 340 francs for having gone to Dinant to buy stone for
the tomb; in that year he employed ten assistants. Among them the name
of Claus Sluter appeared for the first time. Claus and four other sculptors
were paid two francs per week each, the other men varying lesser
amounts.*[21] *Also in that year Henry of Langres, a locksmith,*

... was paid 2 francs for locks made and placed on five arcades belonging
to the workshop of Jean de Marville to protect the blocks of alabaster
destined for the tomb of my lord as well as the lodge which has been
newly established in the house where said Jean de Marville lives as a place
of work for his men who are working on the tomb; also for three hides to
replace those eaten by rats on the bellows of the forge of said Marville.[22]

*In 1386/87, the dates of the next accounts, Marville employed two
more stonecarvers. Work on the cenotaph continued*[23] *and, in addition,
certain tasks for the portal of the church were begun. One Perrin Tout-
beau, a stonemason, was paid twenty-four francs for working on five daises,
one of which was intended for the trumeau of the portal of the church of*

building enterprise, which was complicated, even on this small scale. It is inter-
esting to compare these records with those of the much more monumental under-
taking of the building of the chapel of Saint Stephen at Westminster in England
in the previous generation. The church of Champmol was single-aisled, with
three exterior chapels off its north side. The easternmost of these, on a level
with the choir of the church, was the private chapel of the duke. It consisted of
two oratories, one above the other. Similar to the layout of the chapel of Saint
Stephen, the chapel of the duke could be entered from the outside and the
princely occupant could, if he so wished, remain unnoticed from the church
floor. From the upper pew the prince looked straight down at the main altar.
The middle chapel was dedicated to Saint Peter. It had been given by the
duke to his chamberlain, Guy de la Trémoille. The westernmost chapel was
dedicated to Saint Agnes; David, *Claus Sluter,* p. 35; Kleinclausz, *Claus Sluter,*
p. 31.

[19] Dehaisnes, II, 554. Kleinclausz, *Claus Sluter,* p. 40, evaluates the gros of
the period at 1.65 francs; Marville's annual salary was thus 4800 francs per year.

[20] Dehaisnes, II, 599, 602, 604.

[21] Dehaisnes, II, 622–23.

[22] Dehaisnes, II, 623. David, *Claus Sluter,* p. 58, informs us that the work-
shop was situated in the stables of the duke's first chamberlain, Guy de la
Trémoille, adjoining the duke's business and accounting offices. The presence of
a forge in the fully equipped stables is to be expected. It was more than desirable
in the workshop of Marville, who needed it for the constant resharpening of his
and his workmen's tools.

[23] The term "tomb" used throughout the accounts does not really apply,
for the duke was not meant to be buried in this sepulchral monument but
underground. The monument Marville was constructing was a cenotaph; it
consisted of a massive, beautifully profiled black marble socle on which a stone in
the shape of a chest rested, surrounded by a finely carved alabaster arcade filled
with lively, freely moving figures of mourners. On this in turn lay a second
mable slab with an effigy of the deceased in alabaster resting above it.

the Chartreuse.[24] *In addition to masonry and stone sculpture other work was being done:*

Jean Perrin received 39½ francs for carting 1975 pounds of brass and 1400 pounds of steel (*challemin*) from Dinant to Dijon to the workshop of Master Colart Joseph, my lord's cannon maker, to convert the metal into figures which will be located on columns at the main altar and into the eagle [for the lectern] elsewhere at the church of the Chartreuse.[25]

and

Jean called the Carter [probably Jean Perrin] received 7 francs for carting sand to Dijon to the house of Master Colart Joseph for making the molds for the images to be placed on the columns of the main altar as well as for the pits in which the material will be cast.[26]

In 1387–88 seven sculptors, including Claus Sluter, continued in the workshop of Marville, two at two francs per week, four at one franc and the rest, among them two women polishers, for less. In October of that year the duke visited Dijon and the workshop of Marville to see how work on his tomb was progressing, at which time thirty francs were spent for wine with which he treated the workers.[27]

In the following year, 1388–89, the workshop slowed down percepti-bly; only three stonecutters remained along with the two women polishers. Claus Sluter was no longer among them. In April, 1389, Marville ordered some special polishers from Paris for the coloring and polishing of the tomb.[28] *He died a few weeks later, and in July, 1389, "Claus Sluter was*

24 Dehaisnes, II, 645. Records of 1385–86 speak of the beginning of the masonry work on the church portal; Liebreich, *Claus Sluter,* pp. 41–42.

25 Dehaisnes, II, 645. The altar was to be flanked by four bronze columns crowned with angels.

26 Dehaisnes, II, 645.

27 Dehaisnes, II, 647.

28 Dehaisnes, II, 661. This passage becomes clearer when one reads tech-nical treatises on the treatment of marble and other stone available to these men; Eraclius, *De coloribus et artibus Romanorum,* and Theophilus, *Schedula diversarum artium,* were copied many times until as late as the fifteenth century and were in general use. Eraclius describes the preparation of the surface of stone for painting in the following manner:
> If you wish to paint on a column, or on a stone slab, first dry it perfectly in the sun, or by means of fire. Then take white lead, and grind it very finely with oil [linseed oil, or possibly also nut oil] on a piece of marble. Spread the white with a broad brush two or three times over the column, which is (supposed to be) already quite smooth and even, without any cavities. Afterwards prime with stiff white, applying it with your hand or with a brush, and let it remain awhile. When it is tolerably dry, pass your hand with some pressure over the surface, drawing your hand towards you, and continue to do this till the surface is as smooth as glass. You may then paint upon it with any colours mixed with oil. If you wish to imitate the veins of marble on a general tint (brown, black, or any other colour), you can give the appearance when the ground so prepared is dry. Afterwards varnish in the sun....

Sir Charles Lock Eastlake, *Methods and Materials of Painting of the Great Schools and Masters* (New York: Dover Publications, Inc., 1960), I, 34–35. I am indebted to Professor Agnes A. Abbot, Wellesley College, for this reference.

retained by my lord to be his sculptor and to exercise this function at the same salary and in the same manner as the deceased Jean de Marville, who formerly was his sculptor."[29]

The transition from one workshop head to the next seems to have been made efficiently, for the workshop under Sluter went right back to full activity, and work on the cenotaph continued. Eight stonecarvers, instead of the three of the first half of the year, assisted Sluter during the second half of 1389 and throughout 1390. One of them, Philippe van Eram, made thirteen hanging alabaster capitals for the tomb at a price of three francs apiece.[30] From early 1389 on, Pierre Beauneveu, a sculptor, worked with Sluter on the statues and on other work at four gros per day, with one additional gros per day by special request of the duchess. He assisted Sluter in making canopies above the statues at the portal of the church. He also made two stone angels as models for two brass angels, which Master Colart, the cannon maker, was making for two of the columns of the high altar.[31] Beauneveu continued work on the canopies into the early months of 1391, and in that year he was also paid for the purchase and delivery of several Grenoble alabaster blocks to Sluter at Dijon, destined to be made into small angels and mourners for the tomb.[32]

Five additional stonemasons assisted Sluter in 1390, two of them from Brussels.[33] "In February 1390 Sluter received 20 francs as a special gift for the excellent and pleasing services he had rendered in the past, was daily rendering, and was anticipated to render in the future."[34]

During the late 80's and the 90's the decoration and the furnishing of the church and the conventual buildings of the monastery were vigorously carried on.[35]

[29] Dehaisnes, II, 661. Very little is known about Sluter before the time of his coming to work for Marville in March 1385. He was registered in the Brussels guild from 1379 on as "Claus Sluter of Harlem," mason and stonecutter. This indicates that he was a mature and fully trained master when he entered the workshop of Marville and that he came from Brussels, from where he was to draw several of his own craftsmen. There is no trace of his work previous to his appointment at Dijon. He remained in the service of the dukes of Burgundy in Dijon until his death in January 1406; Liebreich, p. 32; David, *Claus Sluter,* pp. 53–56, 60–64.

[30] Dehaisnes, II, 661. These capitals were destined for the arcade around the cenotaph chest.

[31] Dehaisnes, II, 661, 669. There is the possibility that this Pierre de Beauneveu was a young relative of André Beauneveu, the great sculptor and tombmaker in the service of the duke of Berry. The point has been made many times and Scher supports it by good stylistic evidence in his article.

[32] Dehaisnes, II, 678. David, p. 113, notes that Beauneveu introduced a new kind of alabaster at Dijon, of a finer and denser quality than the one used earlier for the cenotaph.

[33] Dehaisnes, II, 678.

[34] Dehaisnes, II, 679.

[35] Master Colart made the copper clock for the bell tower of the church and five brass chandeliers for the high altar in addition to the lectern and four columns with angels to flank the high altar. Jean Beaumez, court painter and *valet de chambre,* like Sluter attached to the ducal household, not only painted the large triptych for the main altar of the church and other major paintings but also painted altar tables of stone and wood. He supervised his workshop's

In 1392 the workshop of Sluter was occupied with the following tasks.

John Paradiset of Asnières, quarrier, was reimbursed 43 francs, 9 gros, for the quarrying and transport of 250 cut stones, quarried and scappled by him at the quarries of Asnières, and transported to Champmol between the 10th of March and the 15th of November 1391, to be worked into various tasks, both for repair work and images made by Claus Sluter at the upper chapel of my lord at Champmol.[36]

A carpenter, Jean Boudet, was paid 2 gros per day for four days for cutting by order of Claus . . . several wooden molds for the canopies of the portal of the church of the Chartreuse.[37]

Belin de Comblanchien, mason, living in Dijon, received 6 francs, 8 gros, for 40 working days of his servant (*valet*) William de Courcelles at the workshop of Claus Sluter . . . in the time between February 16, 1391, to April 12, 1392, occupied with cutting and gaging the stone canopy for the trumeau of the portal of the church of the Chartreuse and recutting its arches.[38]

On December 26, 1392, Sluter was in Paris to receive in the presence of Josset de Halle, treasurer of my lord, a slab of alabaster, delivered to him by Christopher de la Mer from Geneva, living in Paris, which alabaster the duke had bought from him and paid for, intending to have it brought to Burgundy for the effigy of his tomb.[39]

At Christmas 1392 Sluter was once more given a special gift, this time 30 francs, with the proviso that it should also help him obtain a robe.[40]

The accounts for 1392–93 indicate that Claus continued to be occupied with working on the statues, daises and other things. He was assisted

work in the conventual cells and living quarters. Above all he designed and supervised the decoration in wood, gold and inlay of the lower and upper oratories of the duke. Jean de Liège, the highly valued cabinetmaker of the duke, made several doors and the stalls for the church, and it was he who made benches, bookcases, desks and shelves for the scriptorium and the liberary. The stained glass windows were not locally made but brought to Dijon, as were two carved wooden retables which had been commissioned in Termonde, near Ghent, from the renowned woodcarver Jacques de Baerze. Melchior Broederlam of Ypres gilded and painted them.

36 Dehaisnes, II, 698. The stone of Asnières, a village not too far north of Dijon, was fine-grained and soft. It was used in particular for sculpture; see David, *Claus Sluter*, p. 35.

37 Dehaisnes, II, 698.

38 Dehaisnes. Comblanchien himself worked with Sluter on the changes and the adjustments of the façade of the church, which became necessary when Sluter began to execute the façade sculpture; Liebreich, *Claus Sluter*, pp. 45–47.

39 Dehaisnes, II, 695. The large alabaster block did not arrive in Dijon until the following March (*ibid.*, p. 705). The duke paid as much as 300 francs for it (*ibid.*, p. 719).

40 Dehaisnes, II, 696.

by four masons, three of whom worked directly with him at the portal
sculpture, while the fourth, Poncelet Carne, servant (valet) *of Robert*
Loisel, tomb maker and sculptor in Paris, received eight sous per day for
polishing six blocks of alabaster and for having turned several of these
blocks in the name of his master, Robert.[41]

In 1393,

Jean Bourgeois, mason, was paid 3 francs for breaking and cutting
four large stones, each 6 feet long, $2\frac{1}{2}$ feet wide and 2 feet in thickness at
the quarries at Asnières and for carting and bringing them to Dijon to the
workshop of Claus Sluter to make statues and canopies for Champmol.[42]

Veruot, the vatmaker of Dijon, was paid 5 francs, 2 gros, for 65 oak
boards sold by him to make four wooden boxes which were put into the
house of Claus Sluter in Dijon, for the transport from there to Champmol
of the stone statue of my lady, which was placed at the portal of the
church of the Chartreuse of Champmol and of the statue of Saint George
and of several others placed in the chapel of my lord, called the chapel of
the angels, above his lower oratory, as well as for the chapel of Sir Guy de
la Trémoille at the same place. The said boxes were then taken back to
the house of said Claus so that other statues could be transported in them
to Germolles.[43]

On November 21, 1393, Jean Beaumez, painter and *valet*...and
Claus Sluter, his sculptor, were paid 40 francs for their expenses for trav-
eling from Dijon to Mehun-sur-Yèvre, where they were sent by my lord to
inspect certain paintings, statues, carvings and other things which the
duke of Berry has in work at Mehun.[44]

From November 1, 1393, to October 1394 Sluter continued working

[41] Dehaisnes, II, 699. This, of course, was work done in connection with
the cenotaph.

[42] Dehaisnes, II, 711.

[43] Dehaisnes, II. Germolles was the private estate of the duchess in the
south of Burgundy and it was just then under construction; David, *Claus Sluter*,
p. 135.

[44] Dehaisnes, II, 707. This entry has aroused much speculation over the
years. It has been interpreted by some as meaning that Beaumez and Sluter were
sent to Mehun-sur-Yèvre to learn certain things from the artists in the employ of
the duke of Berry, especially from the great painter and sculptor André Beau-
neveu. Others believe that the two artists from Dijon, who were at the peak of
their own artistic careers at the time of the visit, had little to learn, but rather
went to inspect the works in progress at Mehun. The former standpoint, which
is defended by David, *Claus Sluter*, pp. 60, 136–37, rests on the great fame of
Beauneveu, going back to the '60s of the century, when he carried out various
commissions for Charles V in Paris. Froissart mentioned him as sovereign in his
art. The argument against this standpoint is that Beauneveu was an old man by
1393 and that his art in comparison to Sluter's just-completed powerful statues
at the portal of the Chartreuse, clearly belonged to an earlier period. This view
has been convincingly presented by Dr. Scher in his recent analysis of the situa-
tion at the time of the visit. David's and others' argument that the duke of

with four stonemasons; then, an additional mason, Perrin of Besançon, placed the remaining statues at the portal of the church of Champmol.[45]

In September 1395 Sluter was paid twenty-nine francs for having gone to Dinant in July to buy stone (marble) for the duke's tomb and, before the end of the same year,

. . . . he was given 60 francs in special recognition of the good and pleasing services he had rendered in the past, was daily rendering, and in order that he might have all he needs in the duke's service.[46]

On November 2, 1395, Hugneuri Le Gosset, quarrier at the quarry of Asnières, was paid 8 francs for the breaking, dressing and transporting of eight blocks of stone at said quarry, dressed by him. Five of these are 6 feet long, 3 feet wide and $1\frac{1}{2}$ feet thick; and the three others are $4\frac{1}{2}$ feet long, $2\frac{1}{2}$ feet wide and $1\frac{1}{2}$ feet thick; they were carted from said quarry to Dijon to the house of Claus Sluter at a price of 1 franc apiece . . . to be made into the stone cross which said Claus is making and which is to be set up in the large cloister of the Chartreuse at Champmol.[47]

Between June 14, 1395, and September 10, 1396, Jean de Rigny, stonemason of Dijon, was paid 42 francs, $6\frac{1}{2}$ gros, for 78 working days for himself and several other masons and workmen for having gone back and forth five times from Dijon to Tonnerre by order of Claus Sluter: the first time for cutting six large blocks of stone at the quarry of Tonnerre for the cross in the middle of the large cloister of the Carthusians; the second time for the shaft of said cross; the third time for its foundation; the fourth time for the pinnacle of the dais [for the trumeau statue] of the church portal of the Carthusians;[48] the fifth time for its buttresses, for which, when he went the first time, said Jean did not find the stones prepared nor the quarry bed from which the stones were to be broken ready.

Burgundy would not have paid for his artists' trip had it not been to his advantage is not convincing, for in 1392 he had also sent, at his own expense, his master carpenter and his mason to Mehun to "see," and as the records in that case say, "advise on certain works done" there; Dehaisnes, II, 698. Actually, several entries in the duke's expense accounts over the years speak of his continued generosity toward his older brother.

[45] Dehaisnes, II, 712. David, p. 69, says the statues were in place at the portal in December 1391. It would seem, however, that the transfer of the statues to the portal occurred gradually and that it was not completed until late in 1394.

[46] Dehaisnes, II, 726.

[47] Dehaisnes, II, 728. The church façade having been completed, Sluter was immediately charged to move on to the last major project, the Calvary in the large cloister of the monastery, which served the monks as a burial place. The base of the cross rested on a foundation 11 feet deep. It consisted of a hexagon with six prophets around it; above it was a platform with the cross rising from it, carrying the crucified Christ. On this platform, at the foot of the cross, were the statues of the Virgin Mary, John the Evangelist and the Mary Magdalene.

[48] The new canopy of the trumeau statue was apparently shaped in the form of a church spire, giving a vertical accent to the center of the portal; see David, *Claus Sluter*, p. 71.

He then had to find the right quarry and quarrier. The next time he went back to take the correct measurements for these stones, given to him by Claus; the third time to have the above-mentioned three stones [for the cross] dressed by several stonemasons; the fourth time to have the stones broken for the crossbars of the large cross; and the fifth time for the roughhewing of the stones for the above-mentioned foundation of the cross and the pinnacle, for helping to load five of the said stones and to bring them to the house of said Sluter and for directing the removal of a large chain with which said stones were chained.[49]

Jean de Rigny also received the sum of 8 gold francs, 2 gros, for 49 days of work from September 10 until the last day of November for the cutting of stones for the foundation of the cross which Claus Sluter is making . . . as well as for the precise squaring of the crossbars brought from Tonnerre for said cross, as well as for having assisted in breaking and dressing at the quarry of Asnières a large stone for a tree called oak and several other stones to make sheep for the castle of Germolles.[50]

The quarriers Jean de Chappes and others were paid 20 francs, or 5 francs per hundred, for the digging and hewing to size of 400 stones, transported and delivered by them between the first of September and the fifth of November 1396, to be shaped into the side walls of a large well destined for the center of the large cloister of the Carthusians at Champmol, and for the base of a cross of stone which is to stand in the middle of said well.[51]

Jean le Grant was paid 12 francs, 3 gros, for having sent from the quarry at Tonnerre to Dijon, to the house of Claus Sluter, two large stones, one 30 feet long, wide, and thick for the shaft of the cross for the large cloister of the Chartreuse, and the other 36 feet long, wide, and thick for the base of said cross.[52]

Perrenot le Corderet received 20 francs for the portage of three large stones from the quarry of Tonnerre to Dijon to the house of Claus Sluter for the construction of the cross for the large cloister and also for the construction of the canopy [of the trumeau] at the portal of the Chartreuse.[53]

Stephen Gouppy was paid for the portage of dressed ashlar stone from the lodge at Champmol to the spot in the middle of the large cloister of the Carthusians, where a well is being made in the middle of which a cross will be raised on a base which stands in said well.[54]

49 Dehaisnes, II, 739–40. Jean de Rigny was one of Sluter's stonemasons. As can be seen, the transport of these large blocks of stone required much careful planning.

50 *Ibid.*, p. 735.

51 *Ibid.*, p. 739.

52 *Ibid.*

53 *Ibid.*

54 *Ibid.*

Sluter's workshop was getting ready for this major thrust of new work in the following manner:

On August 3, 1396, Jean de Tonneurre, locksmith at Dijon, acknowledged receipt ... of 5 livres, 14 sous, 3 deniers, for eight hinges, eight screws and six locks with bolts, placed on a large door and on another, divided, door at the workshop of the house of Claus Sluter near the back door of said house.[55]

On December 22 of that year, Stephen Larchier of Dijon received ... 7½ francs for various tasks of my trade made by me and delivered at the house of my lord in Dijon in which Claus Sluter lives, who is sculptor in the service of my lord: first, for having made over entirely with oak boards provided by me, the floor of the court (*saule*) in front of the house and remade and fitted the doors and windows of the workshop of Claus which were in need of repair; also for making four heavy workbenches of solid pieces of wood so that the statues could ·be placed on them while being worked upon; also for a trough for pointing stones and images.[56]

[Jean le Tonneurre, the above-mentioned locksmith, was also paid] 1 gros for a solid iron clamp, pierced at either end, to fasten a statue of Saint Michael holding the enchained devil, weighing 15½ pounds, for the oratory of my lord called the chapel of the angels; also for one heavy iron rod to reinforce and hold together the stone statue [of the crucified Christ], the large shaft and the arms of the cross which Claus is making.[57]

Perrenot Barbisey was paid for two wax torches to burn and give light at night to the laborers who were emptying water from the well under construction in the middle of the cloister because, for reasons of the overflow of water by night, the laborers and masons were unable to work during the day.[58]

In 1397/98 Sluter employed five masons: Heinne de Beaumerchier, sculptor, who worked closely with him on statues, canopies and other things for two florins a week; Anthony Cotelle, of Namur, mason, for working with Claus on the marble and alabaster of the tomb base, at one franc a week; Humbert Lambillon, of Namur, specialist in marble cutting, and Gilles de Seneffe, for working with Claus on the marble chest of the cenotaph; and Jean de Honet, stonecarver, ordered by Claus to prepare in Claus's workshop the canopy of white stone for one of the statues [the trumeau figure] at the church portal of the Chartreuse.[59]

In 1398/99 Sluter was ordered to be given 682 francs for the specific

55 *Ibid.*, p. 733.
56 *Ibid.*, p. 735. This wooden trough or bowl was filled with water and sand and was used when sawing or grinding marble and other stone.
57 *Ibid.*, p. 740.
58 *Ibid.*
59 *Ibid.*, p. 759.

purpose of using the sum to purchase, place, carve and complete the tomb
by buying certain marble blocks which the duke had acquired at Dinant
for this purpose, and to place it into the church of the Carthusians at
Champmol.[60]

In that year ten stonemasons worked with the master; Jean de Salins
and Jacques Franchette were paid fifteen deniers per day for work with
him on certain stones for the tomb of the duke.

Jean Arniet, stonecutter, received 1 franc per week for work on the
tomb and the polishing of marble. Claus de Werve, sculptor, received 1
franc per week for work with Claus on an image of Our Lady and on the
crucified Christ for the large cross as well as on an image of Saint Anne
and on other images. Hennequin Prindalle received 2 francs per week for
work on the capitals for the large cloister and on the statues. [Gilles, a
stonecutter from Dinant, is mentioned, but neither his specific tasks nor
his pay are given.]

Jean de Rigny and Jean Frappart, stonemasons, were occupied with
carving the base and the moldings for the large cross. Jean Hulst, stone-
cutter, was paid 18 gros per week for work with Sluter on the coats of
arms of my lord and my lady for the capital of the large cross made by
Sluter and for the canopy for the main entrance [of the church] above the
statue of the Virgin, as well as on a second image of the Virgin which
Sluter was making to be placed above the entrance of the castle of
Germolles.[61]

In 1399, 7 livres, 15 sous, were paid for red plaster delivered in
Dijon to the house of Claus Sluter for the joining of various stones and
stone statues, carved by Claus, for the platform of the cross which is being
constructed in the middle of the large cloister.[62]

In 1399 only four sculptors were at work, all of them experienced
men: Jean de Rigny continued to work directly with Sluter; Pierre de
Liquerque, specialist in fine masonry, worked on the canopy for the portal
of the church; Claus de Werve assisted Sluter in making the angels
intended to surround the cross in the large cloister; and Hennequin
Prindalle worked with Sluter on the statue of the Magdalene for the
cross.[63]

A payment made to Sluter by order of the duke, issued at Rouen in

[60] *Ibid.,* p. 768.

[61] *Ibid.,* pp. 770–71. Claus de Werve was Sluter's nephew and he began
regular work in Sluter's workshop on December 1, 1396. Although he never
seemed to have been one of the leading assistants in the workshop, it was he
who became Sluter's successor.

[62] *Ibid.,* p. 780.

[63] *Ibid.,* p. 781. The accounts ran from All Saints' Day (November 1) 1399
to the same day in 1400.

November 1399, accounts for the reduced number of assistants: the Calvary was in place and good progress was being made toward its completion, and Sluter himself had been ill.

To Claus Sluter ... *valet de chambre*, stonemason and sculptor of my lord, in special recognition of the excellent and pleasant services he has rendered my lord in past times, is rendering and, it is hoped, will continue to render in the future, especially at the monastery of the Carthusians at Champmol, where he has lately set up a large Crucifixion in the middle of the large cloister together with several statues which belong to it; also to aid him with the great expenses and services he has required since last Easter and still needs for physicians and apothecaries because of a grave and dangerous illness he has had: 60 écus.[64]

In 1400 Jean, a merchant of Dijon, was paid for gold foil to be used for gilding the crucified Christ and the cross in the middle of the large cloister.[65]

In 1400–1401 only three men worked with Sluter, of whom only Claus de Werve was a former working companion.

Claus de Werve, sculptor, made several statues for the platform of the cross in the middle of the large cloister, at 15 gros per week; Pierre Aplemain, sculptor, cut and shaped several stone canopies for the portal of the church of the Chartreuse, for 18 gros per week; and Roger of Westerhen received 10 gros per week for several statues either already in place or about to be placed in said large cloister as well as for several canopies.[66]

The accounts for 1401 mention the following additional expenditures:

For the wood and the making of two boxes of fresh wood in the workshop of Claus Sluter ... for the purpose of transporting the statues of prophets from the house of said Claus to Champmol, to be placed around the [base of the] cross in the large cloister ... 30 sous tournois.[67]

On August 28 of that year the duke once more awarded his great

[64] *Ibid.*, p. 792. The écu was a 5-franc piece; David, *Claus Sluter*, p. 61, considers the amount equivalent to 11,000 francs in modern money.

[65] Dehaisnes, II, 792. Jean Beaumez, the court painter who had worked side by side with Sluter for many years, died in 1397, and Jean Malouel took his place. It was he who gilded the Calvary.

[66] *Ibid.*

[67] *Ibid.*, p. 796. Three of the prophets were ready to be put in place and were set up in the spring of 1399. As will be seen from the text which follows, these prophets were David, Moses and Jeremiah; no specific mention is made of the artist who carved these prophets, for they were Sluter's own work.

sculptor a special gift, this time the large sum of one hundred écus. The citation mentions that it was for the good and pleasant services which Sluter had rendered in the past, not only in his performance as a sculptor but also in other ways.[68]

On December 17, 1402, the carpenters were paid for making a passageway around the cross in the middle of the large cloister as well as a scaffolding near the parlor. The former was necessary in order to place the prophets around the base of the cross and for Malouel to paint the cross and parlor. They were also paid for a shelter, or lodge, to be used by Malouel while he was painting the statues around the pier of the cross and the statue of the Magdalene on the platform. In addition, the carpenters were paid for helping to box the three large stone statues of the prophets David, Moses and Jeremiah, which Sluter had made in his house, to be transported to Champmol. Malouel was paid for color, oil and other material and for painting and gilding the cross in the middle of the large cloister, for the three prophets around the base and six angels just below the platform of the cross between the six prophets, as well as for the Mary Magdalene on the platform.

Payment was also made in that year for the shaping and delivery of a brass crown for the statue of the Magdalene on the platform and for a pair of spectacles for Jeremiah the prophet. In November 1402 payment was made for the installation of the large black marble slab which the duke had ordered to be brought from Dinant.[69]

The accounts for 1403 mention that Jean Malouel and an assistant, Herman of Cologne, painter and craftsman of flat-gold painting employed by Malouel since February 13, 1401, painted the Christ of the cross of the large Calvary and other statues on its base in the large cloister, with which task they were occupied until April 1404.[70]

On April 27, 1404, Duke Philip of Burgundy died. His heir, Jean sans Peur, made a new contract with Sluter in July 1404, according to which the latter was, within four years, to complete the cenotaph. This was to include the effigy of the deceased with two large angels holding a helmet, or bascinet, above his head; a lion at his feet. The entire figure was to be dressed either in his coat of arms or in royal garments, as he preferred; and also forty statuettes of mourners like the two which were already completed; and fifty-four small alabaster angels.[71]

68 *Ibid.*, p. 799.

69 *Ibid.*, pp. 796–97.

70 *Ibid.*, p. 797. No records exist concerning the completion and emplacement of the remaining three prophets, Zachariah, Daniel and Isaiah, with the exception that the ducal commission dealing with Sluter's affairs at the time of his death noted that the three remaining prophets had been completed and installed by him; Kleinclausz, *Claus Sluter*, p. 67; David, p. 90.

71 Liebreich, *Claus Sluter*, p. 139, n. 3.

Sluter, who died a year and a half later, did not finish this task; it was Claus de Werve who completed it in December 1410.[72]

BOOKS AND TAPESTRIES

Within the scope of this volume only brief reference can be made to the inventories and lists of books and other treasures in the princely households of the late fourteenth and fifteenth centuries, but they need to be mentioned, even in passing. The most famous inventories of books were those of Charles V, compiled for his own use in 1373 and, after his death in 1380, in 1411 and 1424;[73] *those of his brother Jean, duke of Berry, compiled in 1401 and 1413, during his lifetime, and immediately after his death in 1416;*[74] *those of the dukes Louis and Charles of Orléans, brother and nephew of Charles VI;*[75] *and those of the dukes of Burgundy, whose collections began with Philip the Bold in the last quarter of the fourteenth century and ended with the death of his last male descendent, Charles the Bold, in 1477.*[76] *Charles V and his brothers also owned important collections of tapestries.*

Paris was the artistic center for the making and illuminating of books, probably from the time of Saint Louis. This was still true at the beginning of the fifteenth century, when it was confirmed by the poet and novelist Christine de Pisan (1363–ca. 1430), who, though Italian by birth, lived at the courts of Charles V, Charles VI and Louis of Orléans. She called the Paris artists "sovereign in the world in the art of painting." In the mid-fifteenth century there was a shift: Martin le Franc, court poet at the court of Philip the Good of Burgundy, claimed that the center of great painting was the court of his master: "Whether you speak of the art of painting, of decorating, illuminating or of engraving by great masters, were there ever better ones?" This statement may well have been more than flattery, for David Aubert, poet, copyist and librarian of the same prince, also said of the ducal library, "Philip duke of Burgundy . . . is today the prince who, without exception, is leading in all of Christendom with an authentic great library."[77]

[72] Kleinclausz, p. 88.

[73] Léopold Delisle, *Recherches sur la librairie de Charles V*, 2 vols. (Paris: H. Champion, 1907).

[74] Jules M. J. Guiffrey, *Inventaires de Jean Duc de Berry (1401–1416)*, 2 vols. (Paris: E. Leroux, 1894–1896).

[75] Aimé (Louis) Champollion-Figéac, *Louis et Charles Ducs d'Orléans: Leur influence sur les arts, la littérature et l'esprit de leur siècle d'après les documents originaux et les peintures de manuscrits* (Paris: Comptoir des Imprimeurs–Unis, 1844), pp. 124–27.

[76] Otto Cartellieri, *Am Hofe der Herzöge von Burgund* (Basel: B. Schwabe & Co., 1926), pp. 179–95, 297–303; Dehaisnes, II, 839–40, 880–81.

[77] Cartellieri, pp. 179, 222; Christine de Pisan, *Cité des dames*, Bk. I, Chap. 41.

At the time of Charles V, the duke of Berry and Philip the Bold, most books were still produced by court artists in the princes' direct service. For the most part they were selected from among the cosmopolitan school of Paris, but Philip the Good (1419–1467) sent his books out to be illuminated, since most of his artists were established masters in Bruges, Ypres, Ghent and Tournai.

Many of the titles in the book collections of Charles V and of his brothers were alike. There were in each collection a number of bibles, breviaries, books of hours, psalters and Christian philosophical and didactic books, such as the writings of Augustine, Jerome, Gregory and Boethius. There were theological tracts and meditations; memoirs and chronicles; classic texts such as those of Terence, Ovid, Aesop, Caesar, Sallust, Titus Livius, Valerius Maximus, Josephus, Suetonius, Lucian, Cassius; novels from the Arthurian cycle and tales of the Golden Fleece, the history of Troy, Alexander the Great, Godefroy of Buillon; the Roman de la rose; works of Dante, Brunetto Latin, Petrarch and Boccaccio as well as other past and contemporary Italian, French and English writers; travel books such as the travels of Marco Polo and the Merveilles du monde by Jean de Mandeville; legal codices, medical books and books on the human body; Priscian's grammar, military science; chivalry and the hunt; chess playing and so on. Beyond this, each collection contained certain books, or different copies of the same books, reflecting the individual interests of the bibliophile.

The tapestries commissioned by these princes took their subject matter from the same books. There were biblical scenes and scenes of a didactic and moralizing nature, scenes from history and from popular novels, and frequently also depictions of pastoral scenes, the seasons or the occupations of the months. The expenditures for these tapestries, judged by modern standards, were enormous, and the appetite for them was insatiable. Did they really only serve utilitarian needs, to cover bare, humid walls, to keep out winter drafts and cold and to light up hunting lodges and palaces? Or should we not assume that they—like the illuminated books—were deliberately intended art works, combining usefulness with the greatest possible beauty and, at the same time, evoking in the observer a sense of intimacy with all of creation as it was known to him? Here the Virgin Mary and her baby son set in the hall of a palace, there in a rose garden, there again in the city square or in a burgher's house; prophets and heroes of antiquity; martyrs and famous men and women of the past shown as in a pageant staged by the guilds, the Church, the court. All of man's heritage—his distant past, faraway parts of the world—were included in this imagery with an unconscious assurance that, strange though much of it seemed, this was part of their own world. It was itself that this society mirrored, curious, eager and exhilarated by its own strength. Interest in the art work and connoisseurship played as great a part in that society as in that of any other creative period in man's history.

Here only a sampling of the complicated history or description of

the appearance of books can be given.[78] *Thus a historiated bible of the
early second half of the fourteenth century, decorated with paintings
framed with a narrow tricolored border, originally belonging to the book
collection of Charles V, was lent by Charles VI to his uncle the duke of
Berry in 1383. The duke never returned it, and so it figures among his
own books in all three inventories of his possessions under the following
title:*

Item, a very beautiful bible in French, written in gothic book script,
richly illuminated at the beginning, decorated with four gold clasps, two
with two light-colored rubies and the other two with sapphires, each with
two pearls, enameled with the arms [of the king] of France; the bars on
the other side each having a pearl at the ends and on top tiny gold fleurs-
de-lys nailed to them, the edge being rimmed with two heads of serpents
adorned with small swans.

*At the end of the Book of Ezra is a note in the duke's hand saying:
"This Bible belongs to Jean, son of the king of France, duke of Berry and
the Auvergne, count of Poitou and Auvergne and of Bologne, Jean."*
*Lastly, there is the following note in the accounts of the executor of
the duke's will:*

To Master Jean Maulin, clerk of the king in his Chambers of
Accounts in Paris, and caretaker of his books and his library, to whom the
executors of the will have ordered that this very beautiful French bible
be returned to be reincorporated into the library of the king. It is written
in gothic book script, and is valued at 240 Paris livres. This bible was
loaned by the king to my liege lord so that he could see it as per order to
Gilles Malet on November 6, 1383.[79]

*The second volume of a bible of small format copied between 1362
and 1363 for the dauphin Charles (later Charles V) by Raoulet d'Orléans
came into the possession of the duke of Berry in 1407 and was registered
as follows in the inventory of his possessions of 1413.*

Also another bible in two small volumes, written in French in gothic
book script, well illuminated with narrative and decorative designs; at the

[78] In this field the exceptionally careful and up-to-date research done for
the inventories of the private libraries of the late Middle Ages by French scholars
such as Delisle and Guiffrey in the nineteenth and early twentieth century is
equaled by the research on the miniatures and paintings in France and the
Netherlands by Panofsky in *Early Netherlandish Painting* and by Millard Meiss,
French Painting in the Time of Jean de Berry (London: Phaidon Press, Ltd.,
1967).

[79] Delisle, I, 150–51. The bible itself is now in the Bibliothèque Nationale
in Paris, MS. fr. 20090. Meiss says (*French Painting*, p. 315) that proof is lacking
that this book was ever in the possession of Charles V.

beginning of the second leaf of the first volume it contains the sermon and on the second leaf of the second volume the inscription: "Whatever is born (*nais*) will be destroyed." Each volume is covered with a flowered silk cloth having four gold clasps, each enameled with the royal arms and with a portrait. There is also a gold border enameled with said arms. The whole is covered with a jacket of purple damask, lined with black *tiercelin* [a textile woven of three kinds of thread]. The bible was given to my lord in August 1407 by the now deceased commander (*Vidame*) of the province of Laon, who used to be great master of the palace of the king. My lord had the jacket made.

According to an appended note, the duke gave this bible to his daughter, the duchess of Bourbon. After the Apocalypse (fol. 367ᵛ), the following note of the copyist occurs: "Here endeth the Apocalypse of Saint John, written down by Raoulet d'Orléans on December 20th of the year 1362."

The next folio (368) contains a prayer in verse which Raoulet d'Orléans put into the mouth of the future king, whose name and title are given in the form of an acrostic, which says, in essence, "Charles, oldest son of the king of France, duke of Normandy and dauphin of Vienne." It carries the date 1363 and is placed underneath a small image of the Virgin Mary with the well-recognizable image of Prince Charles kneeling on a prie-dieu, the sloping back of which is covered with a tapestry. Finally, Charles V wrote in the bible: "This bible belongs to us, Charles, fifth king of France of this name; it consists of two volumes and we had it made and perfected. Charles."[80]

All who served him praised Charles the Bold, the last of the Burgundian dukes of the Valois line, for his seriousness and his love of books, learning and history.[81] *Once, when Louis XI wished to make a present of*

[80] Delisle, I, 153–55; Paris, Bibliothèque Nationale, sub MSS. fr. 5707. Delisle adds that among the fine miniatures in the volume the frontispiece deserves special mention. It represents, in four compartments, scenes of the Judgment of Solomon, the whole being framed by a tricolored border.

[81] The finest character study is contained in the second of two so-called eulogies by the court historian Chastellain. With singular insight and objectivity he deals in his first eulogy with the personality of Philip the Good and in the second with that of Charles the Bold; Georges Chastellain, *Chronique des Ducs de Bourgogne*, published for the first time by Jean Alexandre Buchon (Paris: Verdière, Libraire, 1827), pp. 35 ff. Jean Molinet, who continued the chronicle after the death of Chastellain in 1475, said of his master, "After refreshing his body he thought of refreshing his soul and employed his days not in foolish vanities and mundane spectacles but in reading from the Holy Scriptures and from such history as was pronounced good and had been recommended." In spite of Charles' rash and often offensively arrogant behavior, he was a man of his time and was evidently deeply interested in the humanistic literary movement. He had Xenophon's *History* and Caesar's *Commentaries* translated: Vasco de Lucena translated Xenophon's *Cyropaedia* from Poggio's Latin version for him; Cartellieri, pp. 187, 188. Charles the Bold ruled between 1467 and 1477, when he was killed in battle.

a book to Charles, he turned to Galeazzo Maria Sforza, duke of Milan, for assistance. His middleman wrote:

King Louis [XI] . . . wishes to present a beautiful book, written in Italian and containing the life and deeds of Charlemagne and of some other French kings, to his highness the duke of Burgundy; and he has asked me to mention that all illustrations of costumes, customs and actions should be Italian, so that he might enjoy the book even more.

When Louis XI sent the book to Charles he told him that he thought Charles might be interested in this Italian work with the deeds of Charlemagne and of other French kings because he knew that Charles was familiar with the customs and the spirit of the Italians.[82]

At the turn of the fifteenth century Paris was famous also for the production and trade of tapestries, and such great tapestry designers as Pierre de Beaumez, Jacques Dourdain and Nicholas Bataille were established there. Philip the Bold, as lord of Flanders, placed his commissions increasingly at Arras, which from the fourteenth century had grown in reputation and which now had such great weavers as Jean Cosset and Michel Bernard. Later, Philip the Good chose to place his commissions at Tournai so that the great fame, and with it the prosperity, of Arras declined rapidly. To the Paris school belongs the credit for the creation of one of the finest sets of surviving tapestries, originally seven hangings representing the Apocalypse done by commission of Louis I of Anjou, the second of the four Valois princes, for his palace at Angers and now repaired and reassembled as much as can be at the cathedral of Angers. The series was commissioned in 1376 at the shop of Nicholas Bataille, with Jean Bondol, the king's painter, providing the cartoons. Three annotations of payments have survived in the ducal accounts.

To Nicholas Bataille payment of 1000 francs, the second installment for the weaving of two of the tapestries telling the story of the Apocalypse which he made for my lord the duke (of Anjou) and acknowledgment by Nicholas Bataille of April 7, 1377.

To Jean [Bondol] of Bruges, painter of the king our lord, 50 francs in payment for what is due him for the designing and the preparation of the cartoons for said tapestries of the story of the Apocalypse as per order of the last day of January 1377; also acknowledgment by said Jean of Bruges dated the 28th day of January.

To Nicholas Bataille, weaver in Paris, with regard to 3000 francs which are due to him from my lord in fulfillment of the contract concerning the production of three tapestries of the story of the Apocalypse to be delivered before Christmas 1379 by order of my lord the duke, dated

[82] Cartellieri, pp. 188, 301.

the 9th of June of the above year and confirmed by said Nicholas on the 16th of said month.[83]

On September 30, 1386, Philip the Bold sent word to the mayor and the aldermen of the city of Arras that he wished to inform them that

. . . . in consideration of the good and pleasant services which Jean Le Cambier [weaver], our *valet de chambre* and overseer of our tapestries, has rendered in the past, is rendering and, it is hoped, will continue to render, we have decided . . . because said Jean Le Cambier has constantly been with and attended to our tapestries, guarded them and transported them many times to France, to Burgundy and the Artois as well as else-where, he has often been away from our residence; for that reason we have ordered that instead of receiving a regular salary, as he would if he were constantly here, he will have an annual pension whether he is at home or elsewhere, in the amount of 250 gold francs, to be paid in the following manner: 50 francs at All Saints' Day, 100 francs at Candlemas and 100 francs at Ascension Day, the first payment to fall due this coming All Saints' Day.[84]

How great was the demand for tapestries at the court can best be judged from the expense accounts of the ducal household over two aver-age years. For the year 1385/86 this account contains the following items, costing a total of 11,616 livres.

Pierre Leconte, citizen of Arras . . . for a high-loom tapestry with the story of Saint Anthony, commissioned February 12, 1385 . . . 2100 livres.
Jean Cosset, *valet de chambre* . . . for several pieces . . . and for the

[83] Dehaisnes, II, 556–57, an extract from the Archives Nationales de Paris, KK. 242 (section historique), with accounts for the years 1373–1379 of the treasury of the duke of Anjou. See W. G. Thomson, *A History of Tapestry* (London: Hodder and Stoughton, 1906), p. 70, where the author says that the size of the whole set must have been 144 meters long and about $5\frac{1}{2}$ meters high. There were originally some 90-odd scenes, of which 72 have survived. Five of the hangings were done between 1376 and Christmas 1379. There is no record of the other two, but they too must have been completed a year or two later. Panofsky, pp. 38, 375, discusses Bondol's use of a French illuminated manuscript of the thirteenth century which the king had lent to serve as a model for the cartoons. Bondol used other illuminations as well, among them some early fourteenth-century Flemish manuscripts.

[84] Dehaisnes, II, 627–28. The tapestries of Arras became known under the Italian name *arazzi*, a name which soon achieved wide fame and was used as a generic name. Their peculiarity—apart from the famous fine thread of Arras wool—was that they were worked exclusively on a high loom (*haute lice*). This letter, including the brief confirmation by the mayor and the aldermen, leads one to speculate that at the time the weavers' guild in Arras was strong enough to dictate that such a change in the form of employment be officially registered even when this concerned the household of such a personage as the duke of Burgundy. The weavers received their statutes in 1398.

purchase of about 100 pounds of gold thread for the making of the tapestry of the Apocalypse with which Robert Poisson is charged . . . 1176 livres.

To the same, also for one tapestry, commissioned in 1386 . . . with the story of Alexander the Great and that of Robert the Fusilier . . . 1360 livres.

Jacques Dourdain in Paris, for the sum owed him for two tapestries with gold thread, work of Arras, one with the story of the Golden Apple and the other with the story of Jourdain, commissioned in August 1386 . . . 2520 livres.

Michel Bernard, burgher of Arras, paid by order of September 1386 for a high-loom tapestry of 56 aunes' length and 7½ aunes' width, telling the story of the battle of Roosebeke, paid in four installments . . . 4460 livres.[85]

In the year 1387/88 the following items totaling 7,182 francs are mentioned.

To Pierre de Beaumez, weaver in Paris, for a high-loom tapestry 32 aunes long and 6 aunes wide, Arras measure, having as subject the Roman de la Rose; given by my lord to the duke of Berry for his efforts in 1387 . . . 1000 francs.

To the same, for a second high-loom tapestry of fine thread of Arras and gold thread of Cyprus, 150 square aunes of Arras, telling the story of the Lion of Bourges . . . 1000 francs.

To the same, for another tapestry of Arras with gold thread of Cyprus, showing the five joys of the Virgin; for a tapestry of Arras thread with the story of the king of Friesland, and for others . . . 1610 francs.

To the same, for a high-loom tapestry, thread of Arras, showing the history of the Credo of the twelve prophets and the twelve apostles of about 75 square aunes of Paris [done in two pieces] . . . 1500 francs.

To the same, for a high-loom tapestry with several stories of the Virgin Mary, done in gold of Cyprus and silk, 4½ aunes of Paris long and 2½ aunes wide, for the chapel of my lord . . . 300 francs.

To Jean Cosset . . . for the sale and delivery of a high-loom tapestry,

[85] Dehaisnes, II, 638–39. The unit of an aune (or aulne) was equal to 1.25 meters. The battle of Roosebeke (outside Bruges) took place in November 1382 during the first of several punitive expeditions against the cities of Flanders conducted by Philip the Bold, aided by his young nephew, fourteen-year-old King Charles VI (1380–1422). The citizens lost the battle in a bloodbath in which, as recorded by the chronicler Eustache Deschamps who was an eyewitness to the battle, about 26,000 citizens lost their lives; Ernst Hoepffner, *Eustache Deschamps: Leben und Werke* (Strasbourg: Verlag von Karl J. Trübner, 1904), pp. 64–66. The great size of this tapestry, upwards of 285 square yards, was not entirely exceptional, but relatively rare. The cost of 4460 livres, which was equal to 2600 gold francs, was large; Julius von Schlosser, "Die höfische Kunst des Abendlandes in byzantinischer Beleuchtung," *Präludien, Vorträge und Aufsätze* (Berlin: Julius Bard Verlag, 1927), pp. 68–81.

thread of Arras with gold, with the story of shepherds and shepherdesses, which my lord presented to the duke of Berry for his efforts in 1387 . . . 700 francs.

To Jacques Dourdain in Paris for the delivery of eight blue tapestries, thread of Arras and gold thread of Cyprus, belonging to the chamber of blue satin strewn with turtledoves which my lord intends to give to the count of Vaduz, each piece having a length of 6 aunes and a width of 3 aunes of Paris . . . 842 francs.

To the same, for sale and delivery of a high-loom tapestry, fine thread of Arras and gold, with the story of the son of a king of Cyprus who went in search of adventure, the tapestry being 15 aunes long and $4\frac{1}{2}$ aunes wide; and a second tapestry of same work with the history of Hector of Troy, of 11 aunes' length and $3\frac{1}{2}$ aunes' width; finally for another tapestry, fine thread of Arras, with the story of two lovers . . . 230 francs.[86]

It will be noticed here, as elsewhere, that gold was abundantly used, probably to create strong reflections of light and the effect of a colorful glow, which was so much cherished. Colors seem to have been chosen with great care and consideration for the person and the purpose the tapestry was to serve. On special occasions the choice of tapestries depended on the event, and both host and guests seem to have interpreted the chosen themes as partaking in the event. Thus when in 1454 Philip the Good arranged for large festivities at his residence at Lille in order to urge his nobles to join in a crusade for the reconquest of Constantinople, lost to the Ottoman Empire in the previous year, the hall in which the banquet was to take place was hung with tapestries telling the deeds of Hercules. And when Charles the Bold met in Brussels with a delegation of citizens from Ghent who came to ask his pardon after having once again revolted in 1467, the hall in which he received them was decorated with tapestries showing the deeds of Hannibal and Alexander the Great. One of his conditions for reestablishing peace was that the citizenry present him with a series of tapestries telling the story of the destruction of Troy (a thinly veiled threat against repetition of the act that every citizen must surely have understood).[87]

[86] Dehaisnes, II, 650, 651.

[87] Cartellieri, p. 188. On this see also J. Huizinga, *The Waning of the Middle Ages* (New York: Doubleday Anchor Books, 1954), p. 245, according to whom, in the year 1384, when representatives of the French and the English met for an interview at Lelingham for the purpose of bringing about an armistice, and the duke of Berry had the walls of the old chapel where the negotiating princes were to meet covered with tapestry representing battles of antiquity, John of Gaunt, duke of Lancaster, demanded that these pictures of war be removed because those who aspired to peace ought not to have scenes of combat before their eyes. The tapestries were replaced by others representing the instruments of the Passion.

A short essay, probably written in 1400 in contemplation of a tapestry, may give an idea of how intensively the tapestries' imagery was studied and how much enjoyment they gave on several levels of association. It was written by the emperor Manuel II Palaeologos of Byzantium, a noted literary figure.

Spring. This is the season of spring; this is announced by the flowers and the clear air which lies above them. For this reason also the leaves of the trees rustle softly, the grass seems to sway back and forth when touched by the air, which caresses it with gentle breeze. Surely this is a lovely sight. The rivers are returning to their beds and their powerful swell is diminishing; everything which had been covered by the flood is re-emerging from the water, offering human hands a chance to harvest that which is useful. To this belongs what this youth here is clutching with his left hand, crouching with his head low down, so that up to his nose he is touching the water, feeling with the fingers of his bare hand in the waves the crevices below very gently and carefully, so that the water may not be stirred by his feet and thereby disturb by its gurgling that which is hidden in these holes [a crab]. The partridges are enjoying themselves, for their strength, of which they had been bereft by nature, is coming back; the rays of the sun, pleasant in their mildness, are awakening them to new life. Now they dwell gladly in the fields, taking their young ones to feed, first tasting that which they will offer them, thus preparing their table. The songbirds are sitting in the trees, hardly touching the fruit, for they are spending most of their time singing. Their voices, I believe, will announce that all will be better now that the queen of the seasons is here: the fog gives way to a clear sky; the storm calms; that which is troublesome gives way to pleasure. Everything moves more freely, even the smallest animals: moths, bees, grasshoppers and the many other kinds. Some of these have just emerged from their hives, others have barely been born, encouraged by the mildness of the season, or, if you prefer, at the blending of warmth and humidity; they hum around man and fly ahead of the traveler, and those among them gifted with a voice sing with him who sings. Some play, some fight with each other; others sit on the blossoms.

All of this is beautiful to watch. Yet the boys who play in this garden are attempting to chase these little beasts in a charming and gay mood: this one, bareheaded, is using his cap to catch [butterflies]; since he usually does not catch anything, he causes his companions to laugh aloud. A second one is trying to catch the small creature [a beetle] by throwing himself, hands close to his body, with his entire weight upon it. Why should not this be cause for gay laughter? Do you see yonder slim youth? He has just caught a singing bird and is so filled with joy that he is acting like a bacchant. As he lifts the lower end of his garment to put his prey

there in order to be free to catch another one, he is unaware in his eagerness that he is uncovering what otherwise is covered. Yonder smaller boy is even gayer; he has tied two small animals [ladybugs] with a thin thread and is making them fly, yet again preventing them in their effort. He laughs and is glad and jumps around playing as if he were engaged in some serious business. Thus, the art of weaving smiles at us and offers the onlooker deep pleasure. The real reason for all of this, however, is that spring chases away sadness, or, if you prefer, causes us to be gay.[88]

ON ARCHITECTURE

It has been said many times here and elsewhere that building activity all over Europe during the late Middle Ages was negligible in comparison with the great attention the other arts were receiving; this was unquestionably so, if this period in architecture is compared with building under the patronage of the Church during the early and high gothic periods, or with the building activity of the Tuscan city-states during the late thirteenth and the first half of the fourteenth century. Yet like all such generalizations, such a statement needs modification for, as has been shown in the previous chapter, the second half of the fourteenth century was a brilliant period for architecture in England, particularly in London. The greatest significance of the period between 1360 and 1450 in the field of architecture, even in England, may, however, prove to rest not so much with new, large-scale building requiring a new approach, as with finding technically and aesthetically satisfactory solutions for the long-postponed completion of old buildings.

To the new tasks belonged the designing of open, elegant town

[88] Schlosser, "Die höfische Kunst," pp. 69–70; Schlosser translated the essay from the Greek into German; the translation of the German into English is mine. Manuel Palaeologos became emperor in 1380 and in 1419 he gave the crown to his son John VII. He died in 1425. His writing included works on theology, politics and rhetorical treatises. Schlosser assumes that the essay, which describes a typical Arras tapestry, was either written when the emperor may have seen it as a guest at the Louvre, or, more probably, at greater leisure after his return home, assuming that it was among the many presents he was reported to have been given in Paris. He was in Europe between 1399 and 1402 to ask for assistance from the rulers of Europe for the protection of his gravely imperiled empire. Receptions were given in his honor all the way from Venice to the court of London, but his mission failed. This type of rhetorical description accompanying a work of art was first used in Greece and was called *ekphrasis*. The development of this literary form is described in J. F. Pollitt, *The Art of Greece, 1400–31 B.C.: Sources and Documents* (Englewood Cliffs, N.J.: Prentice-Hall, Inc., 1965), Introduction, p. xvi. Byzantine literature continued and preserved the custom and the form.

*houses and comfortable manors, college buildings and well-lit spacious
guild- and manorial halls. In order to provide the latter, the master car-
penters of England contributed the single-arched open-timbered roof with
solid abutments but omitting posts and tie beams, a style of roofing that
was soon taken up in other northern countries. Open space and a maxi-
mum of light were in demand also in church architecture, partly in
response to new liturgical customs with emphasis on communal services
and preaching, but surely also in response to aesthetic preference. The
single-aisle nave as well as the three-aisle nave of uniform height without
transept, known from the twelfth and thirteenth centuries but restricted
in use, were now used widely everywhere; for the time being, at least, the
symbolism of the cruciform transept seemed forgotten.*

*It was at this time that, between 1377 and 1400, the nave at Canter-
bury was built, replacing the ancient Norman nave. Work on the nave of
Westminster Abbey was resumed about 1362, adding to the existing five
eastern bays and the choir of more than a hundred years earlier. Both
naves were built by Henry Yevele, one of the great gothic architects, who
was both technically and artistically admirably suited for such enormous
tasks.*[89] *With equal elegance and apparent ease, various high-gothic naves
were provided with new, open, glass-filled choirs, such as the perpendicu-
lar choir of Gloucester Abbey, built between 1337 and 1349. Towers of
great weight and proportions were built, often replacing old ones, on old
foundations, and new portals with new sculpture were added to severe old
entrances.*[90] *Under ordinary circumstances such a task was probably sim-
ple enough, as may be judged from a contract for the building of the nave
of the church at Fotheringhay, in Northamptonshire. However, there are
records which tell of wrong starts, of complications arising from a discrep-
ancy between the lack of theoretical knowledge and the ambitiousness of
plans which, unless first-rate advice could be obtained, led to the dragging
on of work. This of course was the case at the cathedral of Siena, where
discussions, expertises, recriminations and an infinite waste of time, mate-
rial and money went on for almost a century.*

*The records of the deliberations in the opening years after the
resumption of the construction of the cathedral of Florence and those of*

[89] John Hooper Harvey, *Henry Yevele, c. 1320 to 1400: The Life of an
English Architect* (London: B. T. Batsford, Ltd., 1944). Harvey presents an
excellent general review of building activity in England during the fourteenth
century. From him also comes the information concerning the choir of Gloucester
Abbey (later to become a cathedral church) and the development in England of
the open trussed roof.

[90] One example is the reconstruction of the south portal of the cathedral of
Rodez and the all-out effort in 1448 by the chapter of the cathedral to decorate it
with 108 or more stone statues and with "stories," and the modified execution
of this plan in 1456, when the original sculptor, Jacques Maurel, departed the
city without taking leave; Victor Mortet, *Mélanges d'archéologie*, Ser. 2 (1915),
pp. 159–66.

the decisive years near the beginning of the construction of the cathedral of Milan tell of the thinking and the procedures applied under different circumstances in the step by step planning of the gothic builder. Excerpts of these debates are given here. A document of 1417 concerning the cathedral of Gerona in Spain shows still another way of settling such problems, displaying once more an attempt to arrive at the most satisfactory solution, keeping structural safety and economy in balance with an aesthetically ideal solution.

In 1434, a contract for building the nave of Fotheringhay church was made between William Wolston, squire, and Thomas Pecham, clerk, representatives of the duke of York, and William Horwood, a master mason of Fotheringhay.[91]

The said William Horwood has agreed to undertake and by this contract has expressed his intention, consent and willingness to make a new nave for the collegiate church of Fotheringhay to be joined to the choir and of same height and breadth as the said choir; and in length 80 feet from the said choir within the walls, a measuring yard of England always accounting for three feet. And by this covenant the said William Horwood shall also execute to satisfaction all the groundwork for the nave: void it at his own cost as well as lay the masonry foundation as durable as it ought to be, under supervision of masters of that craft, the material being sufficiently provided for him at the expense of my lord, as such an undertaking requires. And to this nave he shall add two aisles and take the ground and void it in the manner as said before, the two aisles to correspond in height and width to those of the choir and in height to that of the nave, the foundation for both nave and aisles to be made of rough stone underneath the flat stones of the pavement; and from the pavement upward the rest of the nave and aisle walls to the full height of the choir shall also be altogether of clean-hewn ashlar on the exterior; the interior walls shall be of rough stone except for the flatstone of the base of the window sills, of the piers and the capitals on which the arches and the pendants will rest, all of which shall be altogether of freestone worked truly and duly as it ought to be.

And in each side aisle there shall be windows of freestone similar in all points to the windows of the choir, except that they shall not have any moldings. And at the west end of both aisles he shall make a window consisting of four lancets agreeing in everything with the windows of the aisles. Each aisle wall shall have in all its length an overhanging indented parapet of freestone on top, both battlements to abut against the steeple

[91] Douglas Knoop and G. P. Jones, *The Mediaeval Mason* (3rd. edition, revised and reset, 1967), published by Manchester University Press, Appendix II, pp. 220ff. The publishers have kindly granted me permission to use the original text in making the modern English version given here.

[crossing tower?]. And each aisle shall have six mighty buttresses of dressed freestone; and each buttress shall be topped by a finial corresponding in every respect to the finials of the choir, except that the buttresses of the nave shall be larger, stronger and more powerful than the buttresses of the choir.

And the clerestory both inside and out shall be made of smooth ashlar stone and it shall rest on ten mighty piers each with four attached half-columns, the two upper ones connecting with the choir and the two lower ones joining with the nave. And adjoining the attached upper half-columns at a right angle shall be two perpendicular walls of freestone, cleanly wrought, one on either side of the central door to the choir; and either wall shall have a window of three lancets and there shall be a water basin on either side of this wall which shall serve four others, that is, one on each of the opposite ends of this middle door of the choir and one on either end facing the aisles.

And each of said side aisles shall have five bays rising above the steeple [crossing tower?], each bay having a window and every window four lancets, identical in all points with the windows of the clerestory of the choir. And both aisles shall have six mighty arches butting on either side against said steeple, similar to the arches of the choir both with respect to tablestone and the crest, with a square battement on top.

And on the north side of the church the said William Horwood shall make a porch, the outside to be of smooth ashlar, the inside of rough stone 12 feet long and as wide as the nave buttresses will allow, and as high as the side aisle, with reasonable lights on either side and with a square battement above.

And on the south side of the church, facing the cloister, there shall be another porch adjoining the door of the cloister, having such width as the buttresses will allow and a height somewhere between that of the church [door] and the said cloister door, with a door on the west side of said porch toward the town; on either side as many windows as need be; and a square battement above of a height according to the rest.

And at the west end of the nave there shall be a steeple rising high above the church on three strong and mighty arches wrought of stone, which steeple will be 80 feet high above the ground, according to the measuring yard of three feet to the yard. It shall be made of tablestone and it shall measure 20 square feet within, the walls rising from the ground at a thickness of 6 feet. And up to the height of the nave the steeple shall be square, with two mighty buttresses strengthening it on either side of a large door which shall be at the west end of the steeple.

And when the steeple reaches the level of the battements it shall change into eight sides and at every joint there shall be a buttress decorated with a finial, the finials to correspond to those of the choir and the nave, this upper spire to be surrounded with a large square battement. Above the door of the said steeple there shall be a window rising in height as high as the great vault of the steeple and in width as the nave will per-

mit. And the said steeple shall have two floors and from each floor eight clerestory windows shall rise, set in the middle of each side, each window consisting of three lancets; the outside of the steeple is to be of smooth freestone and the inside of rough stone. And the steeple shall contain a vaulted passage serving the nave, the aisles and the choir both on the lower as well as on the upper level. Finally, all other necessary work should be done which belongeth to such a nave, aisles, steeple and porches, whether or not it is included in this contract.

And for all the work included and enumerated in this contract my lord of York will provide the building material and transportation, that is to say, stone, lime, plumb-rules, ropes, bolts, ladders, wood, scaffolds, gins [hoisting devices] and all manner of material that belongs to the said work. For this work, to be carried out well, faithfully and duly and to be finished in the way as planned and declared above, the said William Horwood will receive £300 sterling, which he shall be paid in the following manner: when he will have prepared the ground for the said church, aisles, buttresses, porches and steeple, cut and set his stones for the foundation and will have built upon it the wall inside and out as it ought to be well and duly made, then he shall receive £6. 13. 4. And when the said William Horwood will have set 000 feet above the foundation, both on the outside and on the inside of said work, then he shall receive payment of £100 sterling; and so for every foot of the said work until it is fully completed as it ought to be, and as it is planned, until it comes to the full height of the highest of the finials and battlements of the church, the hewing, setting and raising of the steeple until it has reached beyond the highest battlement of the said body, he will have received all but 30s. sterling, which shall be paid to him when the work is fully completed and made in the manner as heretofore devised.

And when all the above-enumerated work is fully completed as it ought to be and as it is laid out in this agreement between the said agents and the said William, then the said William Horwood shall receive full payment of the said £300 sterling if any remain unpaid and due to him. And during all the said work the said William Horwood shall employ neither more nor fewer freemasons, rough setters or layers than the number ordained and assigned to him by those who under my lord of York shall be charged to be the administrators and the overseers of the said construction.

It will be remembered from Chapter II that the reconstruction of the cathedral of Florence was begun shortly after 1294, that in 1300 Arnolfo di Cambio was documented as its chief architect, and that in 1331 Giovanni Villani commented that Florence had been remiss in its slow building progress owing to the city's preoccupation with wars and their expense. In 1334 Giotto was made chief architect of the city and the cathedral, but his attention was given to the campanile; he was followed by Andrea Pisano, who continued work on the campanile until the 1340s.

None of the documents gives the slightest clue about the progress of the main structure of the cathedral during the first half of the fourteenth century, and until recently it remained a matter of speculation how much of the cathedral had actually been planned by Arnolfo di Cambio and how much had been completed when work was resumed between 1353 and 1355. A fresco of 1342, containing a view from the west of the exterior of the cathedral, shows the façade and the first bays of the nave behind it, with some marble encrustations and with the side walls on either side up to the height of the entablature over the window zone, narrower and lower than the proportions which were eventually adopted.[92]

In fact, the future appearance of the cathedral was decided only between 1355 and 1368. In endless meetings from 1355 to 1357 the administrators of the cathedral, advised by a selected group of city architects consisting of friars and laymen, determined the size of the nave and its divisions into vaulted bays, the proportion of nave to side aisles, the design and the model of vital details such as the dimensions and the appearance of the nave piers and the shape, size and spacing of the windows. This latter item needed replanning because of a wrong start at the west end of the nave at an earlier moment in the history of the building. The authorized dimensions were laid out on the building site itself. To the master architect of the cathedral, who was a specialist in fine stonework and who had previously completed the campanile, was now added a construction man, Giovanni di Lapo Ghini, who was familiar with the laying of foundations and masonry work, including vaulting. The exchange of opinions and supervision of each step in the construction continued through the years which followed. In 1366 the nave construction reached the stage when final decisions on the shape and dimensions of the east end of the church could no longer be postponed.

To determine this—and to the everlasting glory of Florence—the first to be summoned for consultation now were not construction men but artists: goldsmiths, painters and sculptors to whom the group of consulting architects was added. The question of the artistic solution of the size and proportions of the octagon of the choir in relation to the chapels and the dome above it came before that of the technical solution. Andrea Orcagna, perhaps the best known artist of Florence at that moment, who was an architect, sculptor of the splendid marble tabernacle at Or San Michele of 1359, and fresco and panel painter, and Taddeo Gaddi, a pupil

[92] This information and subsequent remarks on the cathedral of Florence are drawn from Howard Saalman, "Santa Maria del Fiore: 1294–1418," *The Art Bulletin*, XLVI/4 (1964), 471–500. Saalman has re-examined all available documents and concludes that when work was resumed there were no plans, models or records of earlier decisions concerning the shape of the church, its height, length, the relation of its parts, whether it was to be vaulted or how its choir was to be shaped. He gives a brilliant recapitulation of all the crucial decisions that were made in the following half-century.

of Giotto and a distinguished Florentine painter, led the group of painters. It was they, supported by the consulting architects, most notable of whom was Neri di Fioravante, builder of the great vaulted hall of the Bargello, who devised the formal plans for the octagon, the three chapels and the shape and dimensions of the piers to sustain the novel feature of a high drum from which the dome was to rise, much higher than originally planned. The master mason, Giovanni di Lapo Ghini, and his group, violently opposed this plan and defended his own, which was based on smaller proportions for the octagon and less ponderous piers meant to carry less weight. This plan probably went back to the early planning period of 1357. This was also the foreseeable less expensive, less space-consuming, safer (it was called less "dangerous") project and, if carried through, probably would have resulted in a perfectly satisfactory interior design. These were the reasons why a protracted struggle between the two opposing parties continued for so long and why the conservative group almost won. The other plan, that of the consulting committee, was a daring, masterful suggestion for the crowning feature of the exterior of the cathedral. It was this design which was generally recognized as "the most beautiful," "the more honorable" and "the more magnificent." Debates and meetings continued through 1367 and, finally, late in 1367, the two opposing designs were presented to the citizens of Florence in a referendum. The majority of citizens voted in favor of the project as proposed by the committee. When Brunelleschi developed his dome in the 1420s, everything else had been planned for him by that earlier generation of men, including the measurements of the curvature and the height of the dome from ground to apex.[93]

The records pertaining to the opening years of the construction of the cathedral of Milan tend to point to a similar lack of careful advanced planning as noted at Florence during the first fifty years of its construction, but beyond this the situation at Milan was different. Lombardy's chaotic political and economic situation from the second half of the twelfth century on, and during the better part of the next two hundred years, had wiped out a great earlier tradition of church building. Gothic architecture existed in the simple form of Cistercian church architecture which the order had brought from France in the twelfth century.[94]

[93] Saalman, p. 491.

[94] James S. Ackerman, " 'Ars Sine Scientia Nihil Est.' Gothic Theory of Architecture at the Cathedral of Milan," *The Art Bulletin*, XXXI/2 (1949), 84–111; the passages included here are only excerpts of the much fuller text used by Professor Ackerman, and his article should be read by those interested in the arguments. See also Paul Frankl, *The Gothic: Literary Sources and Interpretations through Eight Centuries* (Princeton: Princeton University Press, 1960), pp. 62–83; App. 5, pp. 845–46. On p. 62 n. 6, Frankl summarizes the existing literature on this subject up to the publication of his book. Professor Ackerman tells me that a new and quite different interpretation of the texts is in preparation in Milan.

Nothing had conditioned the local builders either technically or aesthetically for the building of a major church in the contemporary late gothic, open, light, vertically oriented style. And yet such a building was probably in the mind of Duke Gian Galeazzo Visconti (1378–1402), tyrant of Milan, whose strong political and personal ties both with Germany and, in particular, with France (he had been married as a young man to the sister of Charles V, Isabelle of Valois, who died in 1372, and his daughter Valentina Visconti was married to Louis of Orléans, younger brother of Charles VI) would tend to suggest this.

The church was founded in 1386, and between 1387 and 1389 Lombard masters seem to have laid the foundation. Only after this was done did the builders begin to think of the shape and size of the nave piers. It became clear that outside advice would be needed to determine not only the piers but the entire elevation. Two architects, one French and the next German, worked in succession briefly at the cathedral between 1389 and 1392. As far as can be judged, all they were able to accomplish, in an atmosphere of hostility, was to create an awareness of the need for the systematic calculation of the elevation in a predetermined ratio of height to width. The early schemes had aimed at a height corresponding to the width of the nave, a measurement based on the square and known as ad quadratum. *Next, a mathematician was summoned from Piacenza who, in a written exposé, suggested a system* ad triangulum, *whereby the section of the church would be designed according to the geometrical configuration of equilateral triangles, permitting the simple determination of the height in relation to the width of aisles and nave, of the springing points and elevation of each portion of the vaults and, finally, of the greatest height of the nave vault itself, which was determined as twice the height of the vault at the outer aisle (this was lower than the originally intended greater height based on the square).*

This scheme seemed generally satisfactory. It was at once adopted and was the basis for the measurements of the outer side-aisle piers. However, before long the workshop abandoned the system and replaced the section based on the configuration of the equilateral triangle with one based on two adjacent right triangles, the Pythagorean triangle. It did not seem to occur to these Milanese builders that they were thereby destroying the logic of the overall scheme. Their reason for the change seems to have stemmed from the desire to reduce even further the height of the nave and to increase the ease with which to calculate it.

When the German architect Heinrich Parler of Gmünd, who had been asked to carry the program to completion, arrived in 1391, he was justly troubled by the absence of unity of measurements. By May 1392 he and his Lombard colleagues were so much at odds over the discrepancies that a public meeting had to be called. From this we learn:

At the gathering of all the engineers named below . . .

All [of these] gathered in the building office of the Milanese church in order to remove numerous doubts which are being entertained concerning work at this church, which doubts are separately specified below, and to the doubts are added replies and statements by all these engineers, with the exception of this master Heinrich, who, although these replies are given toward [establishing] an understanding, concurs in no way with these statements.[95]

[1.] **Dubium:** Whether the portions of the rear as well as the sides and interior—namely, both the crossing and the other, lesser, piers—have sufficient strength?

Responsio: It was considered, replied, and stated upon their soul and conscience, that in aforesaid [portions] the strength, both of the whole and separate [parts] is sufficient to support even more [weight]. . . .

[3.] **D:** Whether this church, not counting within the measurement the tower which is to be built, ought to rise according to the square or the triangle?[96]

R: It was stated that it should rise up to a triangle or to the triangular figure, and not farther.

[4.] **D:** How many braccia should the piers be made which support the main nave or the middle nave?[97]

R: It was stated that these piers counting bases and capitals ought to rise to 40 braccia and not farther.

[5.] **D:** How many braccia should the half-piers be which are to be made in the wall above these large piers up to the vaults or arches to be made above that point, and how many braccia ought the vaults to be made above these?

R: It was considered and stated that the half-piers should be twelve braccia, and the vault of this main nave should rise to the triangle, that is, twenty-four braccia.

These and most of points 6–11 indicate that the Lombard masters were opposed to the last man to a height customary in the northern gothic

[95] Ackerman, p. 91; the English translation is that of Professor Ackerman. Fourteen masters were present at the gathering, one among them being Parler; following Parler's name the text says, "who does not concur." Some of the questions are not included here even though they are related to the main point of debate, that is, to the question concerning the measurements of the structure as a whole and of its supporting members.

[96] This reference, though expressed in a geometrical configuration, means simply a reference to different proportions. The section *ad quadratum* would lead to much more vertical proportions.

[97] Ackerman, pp. 91–92. The braccio varied, from district to district, between 18 and 39 inches.

*churches. It is probably true, as Professor Ackerman suggests, that the pref-
erence for lower proportions was due, above all, to the reluctance of the
Lombard masters to use a complicated system of flying buttresses and
exterior pier buttresses, which would have been indispensable had the
nave been raised far above the side aisles, or the inner side aisles far above
the outer ones. But to the same degree that all the consultant northern
masters over and over again attempted to return to a transverse section
based on the square and all Milanese masters wished to avoid this, we
must assume too that opposing aesthetic preferences played a consider-
able role. Heinrich Parler was dismissed and Ulrich von Ensingen, his
successor, came late in 1394. Master Ulrich felt equally unable to com-
promise his own ideas and left shortly after.*

*The final break with the northern tradition of building came in
1401–2. The structure had reached the point where decisions on the
methods of vaulting could no longer be postponed. Once more a French
group of experts was summoned to advise the administrators of the work.
One master, Jean Mignot of Paris, stayed on to render the appraisal of
the group and, at a meeting early in January 1401, he presented fifty-four
points of criticism, speaking of the weakness of the piers and buttresses at
the apse and elsewhere in the cathedral, of the poor design of the apse
pier capitals and of poor measurements and workmanship elsewhere. Half
his points were left unanswered and the objections to his other points
reveal, together with an excellent knowledge of the old building tech-
niques and of the building material to which the Milanese stone masons
were used and in which they had a tenacious faith, complete ignorance of
the dynamics of the high gothic building system.*

*Two weeks after the first conference another one was called. The
report on this one gives an idea of the tone and level of the debate:*[98]

Master Jean Mignot has stated to the council here present that he
has given in writing to the said council a note computing to date all the
reasons and every motive which lead him to say that aforesaid work lacks
strength, and he does not wish to give other reasons.

Final statements given by aforesaid Master Jean on the 25th day of
January [1401].

Master Jean Mignot points out to you excellent lords of the work-
shop council of the Milanese church with respect and pure truth, that as
he has demonstrated in writing elsewhere and among other matters, the
defects of said church, he reiterates and affirms that all the buttresses
around this church are neither strong nor able to sustain the weight which
rests upon them, since they ought in every case to be three times the thick-
ness of one pier in the interior of the church.

The Masters reply:

[98] Ackerman, pp. 99–100, 109.

Concerning the first statement, they say that all the buttresses of said church are strong and capable of sustaining their weight and many times more, for many reasons, since one braccio of our marble and *saritium*[99] whatever its width, is as strong as two braccia of French stone or of the French church which he gives to the aforesaid masters as an example. Therefore they say that if aforesaid buttresses are one-and-a-half times [the size]—and they are—of the piers in the interior of the church, that they are strong and correctly conceived, and if they were larger they would darken said church because of their projection, as at the church in Paris, which has buttresses of Master Jean's type, [and there are other reasons why they could be an obstruction].

Moreover, he says that four towers were begun to support the crossing-tower of said church, and there are no piers nor any foundation capable of sustaining said towers, and if the church were to be made with said towers in this position it would infallibly fall. Concerning the claims, however, which were made by certain ignorant people, surely through passion, that pointed vaults are stronger and exert less thrust than round, and moreover concerning other matters, proposals were made in a fashion more willful than sound; and what is worse, it was objected that the science of geometry should not have a place in these matters, since science is one thing and art another. Said Master Jean says that art without science is nothing (*ars sine scientia nihil est*), and that whether the vaults are pointed or round, they are worthless unless they have a good foundation, and nevertheless, no matter how pointed they are, they have a very great thrust and weight.

Whereupon they [the Masters] say that the towers which they wanted to make are for many reasons and causes [desirable]. Namely, in the first place, to integrate aforesaid church and transept so that they correspond to a rectangle according to the demands of geometry, but beyond this, for the strength and beauty of the crossing-tower. To be sure, as if as a model for this, the Lord God is seated in Paradise in the center of the throne, and around the throne are the four Evangelists according to the Apocalypse, and these are the reasons why they were begun. And although two piers of each sacristy are not founded, but begin at ground level, the church is truly strong nevertheless for these reasons, that there are projections upon which the said piers stand, and the said projections are of large stones and joined with iron dowels as was said above with other statements, and that the weight on these three towers falls evenly on their square, and they will be built properly and strong, and what is vertical cannot fall; therefore they say that they are strong in themselves, and for that reason will give strength to the crossing-tower, which is enclosed in the center of these towers. Therefore said church is truly strong.

[99] Ackerman, p. 99 n. 59. A local building stone used in the foundations and under the marble facing.

Later in 1401, when Mignot's design for the vaulting of the cathedral threatened to interfere with one already begun by the Lombard masters, and it was suspected that with his design he was attempting to restore some of the originally planned height for the church, he was dismissed.

The stubbornness of the workshop masters of Milan is strongly reminiscent of the attitude of Giovanni di Lapo Ghini at the cathedral of Florence. It is true that the cathedral of Milan has stood up well these many centuries in spite of all prophecies of doom by the visiting masters. The real point, however, is the difference between what happened here and what happened in Florence. And in this, perhaps lies the most striking example of the sensitivity and maturity of judgment prevailing in Florence among a majority of men at this decisive moment, judgment so infinitely ahead of the rest of Europe half a century before the advent of the Renaissance.

The study of the documents from Milan leads to one more observation: Master Mignot was clearly neither a great nor a particularly ingenious architect. To come from Paris in the year 1400 did not automatically mean one had the ability to produce great architecture—it was one of the most desperate moments in the economic and sociopolitical history of that nation and very little monumental building went on anywhere in France. Mignot's statement ars sine scientia nihil est (art without science is nothing) labels him sadly as an academician and an epigone in his art. His opponents and torturers, the masons of Milan, by contrast, in spite of their stubborn ignorance, seem rather witty in turning his saying around by answering scientia sine arte nihil est (science without art is nothing, either), and in this perhaps more real than prophetic attitude foretold a future in which the lofty structures of the northern gothic were rejected by the fifteenth-century Renaissance critics of northern aesthetics.

The choir of the cathedral of Gerona in Catalonia was built in the first half of the fourteenth century.[100] It was a French high-gothic choir having a rounded apse, an ambulatory and nine radiating chapels. The plan was close to those of the cathedrals of Narbonne and Barcelona. It replaced the east end of an eleventh-century Romanesque church; the nave was left standing. In 1416 William Boffiy, master of the works of the cathedral, proposed a plan for its completion by the erection of a new nave. Though the chevet had an aisle (ambulatory) and chapels round it, he proposed to build a single-aisle nave of the same width as the choir including the ambulatory and to continue chapels along the entire length of the nave.

The chapter of the cathedral found the proposal for a single nave hazardous. It created so much discussion that the chapter, before deciding

<hr/>

[100] See Pierre Lavedan, *L'Architecture gothique religieuse en Catalogne, Valence et Baléares* (Paris: Henri Laurens, Editeur, 1935), pp. 147–51.

what plan should be adopted, called together a group of outside architects and put to each of them separately certain questions, which they answered under oath. The following September these answers were read before the chapter by a notary and the problem was left there. On March 8, 1417, William Boffiy was called in and was in turn asked the same questions. A week later, at a chapter meeting presided over by the bishop, it was decided to carry on the work as proposed, with a single nave. It has been said that this nave is the greatest accomplishment of gothic architecture in Catalonia.[101]

In the name of God Our Lord, and the Virgin our Lady Saint Mary, the "maestros" superintendents and masons summoned for the direction of the works of the cathedral of Gerona, must be asked the following questions:

1) If the work of one nave of the said cathedral church, commenced of old, could be continued, with the certainty of remaining secure and without risk?

2) Supposing that it is not possible to continue the said work of one nave with safety, or that it will not be lasting, whether the work of three naves, continued on, would be congruous, sufficient, and such as would deserve to be prosecuted; or, on the contrary, if it ought to be given up or changed; and in that case unto what height it would be right to continue what is begun, and to specify the whole, in such sort as to prevent mistake?

3) What form or continuation of the said works will be the most compatible and the best proportioned to the chevet of the said church which is already begun, made, and finished?[102]

The "maestros" and masons, before being asked these questions, must take their oath; and after having given their declarations, the Lord Bishop of Gerona and the honourable Chapter shall elect two of the said masters, in order that they may form a plan or design, by which the work will have to be continued. All which the secretary of the Chapter will put in due form in a public writing.

The debates lasted four days. On the first day, Thursday, January 23, 1416, three architects were questioned.

1) Paschasius de Xulbe, stonemason and master of the works at the cathedral of Tortosa, questioned under oath had this to say:

[101] Lavedan, pp. 198–205; George Edmund Street, *Some Account of Gothic Architecture in Spain*, 2nd ed. (London: John Murray, 1869), Chap. xv, pp. 318–20, 501–13. The introductions were in Latin, and the questions and the declarations of the twelve architects, in the Catalan idiom in the original, were translated into Castilian. The English translation used here is Street's.

[102] It will be noticed that, while the first two questions are purely technical, the third one is above all an aesthetic question, and, as Lavedan says (p. 199), it was understood in this sense and answered accordingly.

a) That according to his knowledge and belief it is certain that the work of one nave of the cathedral of Gerona already commenced is secure, good, and firm; and that the foundations or bases of the old work already made are also so, and that the rest will be so if they are constructed in the same manner, and that they will be sufficient to sustain the vault of the said work of one nave.

b) Supposing that the work of one nave is not carried out, it is certain that the one of three naves, already commenced in the said church, is good and firm. But in the event of the plan of three naves being adopted, he says, that it would be necessary that the vault which is over the *coro* toward the altar [*coro* is the choir proper] of the same church, should be pulled down, and that it should be unroofed, in order that it may be raised eight palms—a little more or less—above what it is now, so that it may correspond to its third in its measurements.

c) That the plan of three naves is more compatible and better proportioned to the chevet of the church than that of one nave.

Interrogatus. Whether in joining the lower voussoirs on the capital of the pillar [pier] over the pulpitum,[103] which corresponds to the other of the *coro*, in case the work of three naves is carried out, there will be any risk of causing a settlement in the said pillar [pier]?—I answer, that there will be none, and that it can be done with safety.

2) John de Xulbe, mason, son of said Paschasius, also working on the church of Tortosa:

a) That the work of the nave already commenced can be continued, and that it will be good, firm, and without danger; but that the arches must be made to the tierce point, and that the principal arch must be shored up. That the first abutments of the old work, situated on the south, are good and firm, and that making the others like them, they will be so also, and sufficient to sustain the vault which has to be executed in the said church.

b) That if the plan of one nave is not to be followed, it is possible to continue that of three; and that it will be more beautiful, stronger, and better than the other. But that the three naves ought to be carried on according to those in the choir of the church; and then it will be more beautiful and admirable. And that the new vault which is contiguous to the chevet ought to be taken down, because it is bastard, and because it does not correspond with the said chevet.

c) That the work of three naves in the form which has just been explained is the most compatible and the best proportioned to the chevet of the church.

Interrogatus. Whether in joining the lower voussoirs of the arch

103 The term "pulpitum" is also used for denoting a choir screen, and probably such a screen was there.

above the capital of the pillar [pier] which is above the pulpitum, corresponding to the other of the choir, in case the work of three naves is carried out, there will be any risk of causing a settlement in the said pillar [pier]?—I say no, provided that the arches are well shored, so that they can have no thrust.

3) Peter de Vallfogona, mason and master mason of the cathedral of Tarragona:

a) That the work of the said church, already commenced, of one nave can be continued, and that it will be good, safe, and firm, and without risk. That the abutments and foundations of the old work are so, and that those which have to be made will be so if constructed in the same way, and that they are sufficient to support the vault which such a work ought to have. But that the abutments made towards the campanile require to be strengthened more than those constructed on the south side.

b) That if the plan of one nave is not carried out, that of three is congruous and worthy to be continued, provided that the second bay of vaulting, as far as the capitals and lowest voussoirs inclusive, is taken down; yet if above the principal arch a discharging arch is erected, it will not be necessary to move the lower voussoirs or the capitals, and it would be possible to raise the crossing of that vault all its width as much as is required; and it could have a light in the gable, which could have a clear opening of fifteen or sixteen palms, which would be a notable work. He says further: that the lower voussoirs which are in the northern and southern angles ought to be altered, and that they ought to be reconstructed in accordance with the plan of three naves.

c) That without comparison the plan of three naves, in the form which has just been explained, is more compatible and more proportioned to the chevet of the church than the plan of one nave.

Interrogatus. Whether, in case the plan of three naves is carried out, there will be any danger in opening a hole in the pillar [pier] over the pulpitum, corresponding to the other of the *coro* at the time of joining the voussoirs above the capital? He said, that there would not; and that it could be done with safety.

On the next day . . . the following were interrogated:

4) William de la Mota, stonemason, second master in command at the cathedral of Tarragona:

a) That he considers that the plan of the church commenced with one nave could be well executed, and that the crossing will be firm; but that it is observed in old works, that bulky buildings, as that of one nave would be, sink with earthquakes or with great hurricanes, and for these causes he fears that the work of one nave might not be permanent.

b) That the plan of three naves is good, congruous, and one that deserves to be followed, provided that the second crossing may be new to the lowest voussoirs; and that its principals be demolished as far as the

capitals, and that horizontal courses of stones be carried up to the height of fourteen or fifteen palms. That the springers which are towards the north and the south ought also to be taken down, and that they ought to be reconstructed in proper proportion to the plan of three naves.

c) That without comparison the plan of three naves is more compatible and more proportioned to the chevet of the church than that of one nave.

Interrogatus. If there will be danger in opening a hole in the pillar [pier] near the pulpitum, to place the springers? He said that there would not be any risk.

5) Bartholomew Gual, stonemason and master of the works at the cathedral of Barcelona:

a) That the bases and abutments of the old work of one nave are sufficiently strong, making a wall over the capitals between the abutments, which may rise a "cana" (a measure of two Flemish ells) from the windows, and that from that wall a vault may spring, which will abut against each of the abutments, and in this way they would remain safe. No doubt, the vault may remain firm over one nave, so that it may resist earthquakes, violent winds, and other mishaps which may occur.

b) That the plan of three naves is good, congruous, and such as deserves to be carried out; but that the new vault of the second arch, the last done, ought to be taken down to the springing, and ought to be raised until there is room in that place for a circle (una O) of fourteen palms of opening; and in that way there will be beautiful and notable work, and it will not be necessary to undo the whole to the springing line.

c) That the plan of three naves is beyond comparison much better proportioned and more compatible to the chevet of the church than that of one nave.

Interrogatus. Whether there will be any risk in making an opening in the pillars [piers] in order to join the springers of the arches? He said that there would not be; but he counsels that when the said arch is taken out, the foot of the arch voussoir in the pillar [pier] which has to be altered should be larger than the other, because that has not so much weight on it.

6) Anthony Canet, stonemason, sculptor of the city of Barcelona, master of the fabric of the cathedral at Urgel:

a) That according to his knowledge and conscience the plan of one nave, already commenced, can be continued with the certainty that it will be good, firm, and secure; and that the abutments which the said work has are good and firm for the support of the vault, and all that is necessary in order to carry on the said work.

b) That the work already begun of three naves is good and well-proportioned, but that it is not so noble as that of one nave; and that if the work of three naves is continued it would be necessary that the vault

of the second bay of the middle nave should be taken down to the capitals; and that the capitals as well should be taken down eight or ten courses of stone, and so that the first pillar [pier] may be joined, which was constructed in the head of the grand nave, contiguous to the chevet of the church, and that the opening shall not be made so low in the pillar [pier], and the springing of the arch stones may be introduced in it better. And though it is true that in this way the (triforium) gallery may be lost, it is worth more to lose it than the bright effect of light in the temple, which could be secured by a round window in the said grand nave. But that, if the second nave is followed out as it was commenced, it will be most gloomy. For which reason he is sure that if the plan of three naves is to be good, it is necessary for it to be carried out working in the way he has described.

c) That the plan of one nave would be much more compatible and better proportioned to the chevet of the church as it is already commenced and completed, than that of three naves, because the said chevet was commenced low; and that the plan of one nave will be executed with a third at least of the cost of three naves. That if the plan of one nave is followed, the galleries, which are beautiful, will not be lost, and the church will be beyond comparison much more light.

7) William Abiell, master mason and master of the works at Santa Maria del Pi, San Jaime, and the hospital of Santa Cruz in Barcelona:

a) That according to his understanding and good conscience the work already commenced of one nave can be continued, and will be good, firm, and secure; and that the foundations which it has, the rest being made in the same way, are good and firm to support the work of one nave without danger.

b) That the plan of three naves is good, beautiful, and more secure than the other, wherefore it deserves to be continued. But that the vault of the second bay of the middle nave ought to be taken down to the springers, and be raised afterwards by its third, so that a fine round window may be had there, and to make an upper vault above the principal: and in this way the plan of three naves will be very beautiful.

c) That without any doubt the plan of three naves is more compatible and adequate to the choir of the church as it is now, than that of one nave, because that of one nave would be so wide that it would have great deformity when compared with the chevet of the church.

8) Arnaldo de Valleras, stonemason and master of the works at the collegiate church at Manresa:

a) That the work of one nave, already commenced, can very well be continued, and will be good, firm, secure, and without risk; and that the foundations which the said work has, and the rest which may be made like them, are good, and sufficient to sustain the work of a single nave; and that, though they might not be so strong, they would be firm and

secure. He says further, that the work of the church of Manresa is now being constructed, which is higher than this, which has not such great or strong foundations, and is not of so strong a stone. It is true, he says, that the Manresa stone is lighter, and combines better with the mortar than that of Gerona; and that, if he could have to construct the latter church, he would make the vault of other stone which was lighter, and which combined better with the mortar, but that the vaulting ribs, the lower part of the walls, the abutments, and the rest of such work could be executed in Gerona stone.

b) That the plan of three naves is good, congruous, and deserves to be carried out, provided that the vault of the second arch of the middle nave is taken down to the springers, and that they also are taken down, so that the work may be raised by its dimensions; so that it will be possible to have over the principal of the first arch a round window of twenty palms opening, with which it will look very well and not be disfigured.

c) That the plan of three naves in the manner which has been described is, without comparison, more fitting and better proportioned to the existing chevet of this church than that of one nave; because that of one nave would make the choir appear to be so small and misshapen, that it would always demand that it should be raised or made larger.

Interrogatus. Whether there would be any danger in opening a hole in the pillars [piers] in order to insert the abutments? He said that there would not; and that if he, the deponent, should do the work, he would commence first by opening a hole in the pillars [piers] in order to join the abutments, since in that way they could not settle or give way, as certainly and without doubt might happen. That he was ready to come and continue this work in the manner which he had described; obtaining the licence of the city of Manresa, with which he had contracted to construct the church there.

9) Anthony Antigoni, master of the works in the town of Castellon de Empurias:

a) That the plan of one nave, formerly commenced, could be continued well and firmly without any risk; and the foundations that it has, and the rest which have to be made like them, are sufficient to sustain with all firmness the said work of one nave.

Interrogatus. Whether the work of one nave, in case it were made, would run any risk of falling with hurricanes or earthquakes? He said that there was no cause for fear.

b) That the work of three naves continued of late is not congruous nor of such sort as that its plan could be followed, because in no way could it be constructed with the same dimensions. But it is true that if the vault of the bay last done is taken down to the springers and raised afterwards fourteen or fifteen palms in its measurements, the plan of three

naves would be more tolerable, though it could never be called beautiful or very complete.

c) That he has no doubt that the work of one nave would be for all time without comparison the most beautiful, more compatible, and better proportioned to the chevet of the church than that of three naves, since it will be always clear that the latter was not done carefully and with good taste.

Interrogatus. Whether in case the work of three naves is carried out, there will be any risk in opening a hole in the pillars [piers] in order to join the abutments? He said that it could be done, but not without danger.

10) William Sagrera, master of the works of St. John, Perpignan, in 1416: [In 1426 commenced the Lonja, or Exchange, at Palma, in Majorca, for which he was both architect and contractor, and carried it on until 1448 or 1450, when he quarreled and went to law with his employers. He then went to Naples and commenced the Castel Nuovo there in 1450, of which he is described as *proto magister* in a royal writ of that year].

a) That the plan of one nave, formerly commenced, can be continued, and that it will be good, firm, and secure; and that the foundations which it has, with the rest which must be made in the same way, are sufficient to sustain it.

Interrogatus. Whether if the one nave is adopted there will be risk by reason of earthquakes and violent winds? He said that with the earthquakes which he has seen, and the winds which naturally prevail, there would be no danger that the said work should fall or become decayed.

b) That the work of three naves lately commenced is not congruous, and does not deserve to be carried on; and in case it is continued, in the first place the vault of the second bay ought to be taken down from the springers to the capitals; in the second, also the other pillars [piers] which were made afterwards ought to be taken down, in order that they may be raised fifteen palms or thereabouts; and that with all this the work will not be completed well, but on the contrary will be *mesquin* [mean] and miserable. That the gallery, which would be lost, could not remain there; that it would not be possible to place the series of windows due to the work between the chapels higher than they would be in a single nave, owing to the thrust or pressure of the arches, which would be towards the gallery, corresponding to the new pillars [piers] of the enclosure of the choir, and would come against the void of the gallery, wherefore the work would not have the firmness it ought to have. The deponent concludes, saying, that for these and other reasons the said work of three naves would not be good or advantageous.

c) That the plan of one nave would be beyond comparison more

compatible and more proportioned to the chevet of the church already built, commenced, and completed, than would one of three naves; and he says it is the fact that the said choir of the church was made and completed with the intention that the remainder of the work should be made and carried out with a single nave.

11) John de Guinguamps, stonemason of the town of Narbonne:

a) That the work already commenced of one nave could very well be made and continued; and that when it is done it will be very good, firm, and secure, without any dispute; and that the foundations which are already made in the old work, and the others which will be made in the same way, are good, and have sufficient strength to maintain the work of a single nave.

b) That the plan of three naves latterly continued is not congruous or sufficient, and should not in any way be made or followed because it never will have reasonable conformity with the chevet.

c) That the plan of a single nave is beyond comparison more fit and proportioned to the choir of the said church, than would be that of three naves, for several reasons. 1st. That the deponent knows that the plan of a single nave with the said choir would be more reasonable, more brilliant, better proportioned, and less costly. 2nd. Because, if the work is carried on with one nave, there would not be the deformity or difference that disgusts. And though some may say that the plan of a single nave would make the choir look low and small, the more on that account would no deformity be produced, rather it would be more beautiful; and the reason is, that in the space which would be left between the top of the choir and the centre of the great vault, there would be so large a space that it would be possible to have there three rose windows: the first and principal in the middle, and another small one on each side: and these three roses would do away with all deformity, would give a grand light to the church, and would endow the work with great perfection.

Interrogatus. Whether, if the plan of three naves is adopted, it would be dangerous to open the pillars [piers] in order to join in them the springers corresponding to it? He said that he would not do it or consent to it on any account, because great danger, great wrong, and great damage would result, since in no part could the work be brought to perfection, and such a fissure could not be made without great risk. . . .

Then followed the minutes of the full meeting of September 1416 of the chapter and the bishop in which these answers were read by a notary. Also included were the minutes of the meeting of the following March 8, 1417, during which William Boffiy, master of the fabric of the cathedral, was interviewed by one of the canons and by a presbyter, delegated by the chapter in the presence of the chapter's notary, who recorded the meeting. William Boffiy had this to say:

a) That the work of the nave of the church of Gerona, already begun, could be made and continued very well; and that if it is continued it will be firm and secure without any doubt and that the foundations and others which may be made like them, are and will be good and firm enough to sustain the said work of one nave. And that it is true that the said foundations or abutments, even if they were not so strong, would be sufficient to maintain the said work of one nave since they have a third more of breadth than is required: wherefore they are very strong, and offer no kind of risk.

b) That the work of three naves for the said church does not merit to be continued when compared with that of one nave, because great deformity and great cost will follow from it, and it would never be so good as that of one nave.

c) That the work of one nave is, without comparison, the most conformable to the choir of the church already commenced and made, and that the plan of three naves would not be so. And that if the plan of one nave is carried out, it would have such grand advantages, and such grand lights, that it would be a most beautiful and notable work.[104]

And so, on March 15, 1417, the bishop and the chapter voted in plenary session to carry on the work as proposed, with a single nave.[105]

TUSCANY AT THE END OF THE FOURTEENTH CENTURY

The lively exchange of opinion and criticism among the experts at the cathedrals of Florence, Milan and Gerona reveal a freedom of expression and self-assertion among professional men unknown barely two gen-

[104] Street and Lavedan give the width of the nave as being greater than that of Albi or Chartres; it is 34m high, 23m wide and 55m long, only less spacious than St. Peter's in Rome. There are four bays, each bay having chapels opening into it on either side and filling up the space between the deep buttresses. Seen in elevation, the continuous arcade of chapels creates a base above which the wall rises severely. This is followed by a small triforium gallery above which, in each bay, there is a large window with tracery. Toward the east the nave ends in a wall opening into the choir and its aisles .The nave rises far above the choir. The end wall of the nave has three circular windows, the largest above the central part of the choir and the other two smaller ones over the sides. The light which comes in through these three circular windows illuminates the eastern part of the nave in such a way that the choir appears far away and mysterious (Lavedan, p. 203).

[105] Seven of the masters were in favor of a three-aisled nave, and only five, including Boffiy, were in favor of a single-aisled nave, yet the canons voted for a single nave. It seems they felt that since both methods of building appeared to be equally safe, a single nave would be more solemn and noble, would give more light—something which is pleasant and joyful—would cost much less to construct and would take less time to build (Lavedan, p. 202).

erations earlier, when they had responded to similar inquiries with grave and dignified restraint. Surely this does not mean that the architect's role regarding his responsibilities had changed, but rather that the social structure within which he was operating was making increasing allowance for his self-expression.

A similar change in attitudes is apparent if one compares, for example, the notebook of Villard de Honnecourt with the tractate on painting and workshop practices by the late fourteenth-century Italian painter Cennino di Drea Cennini. Villard avoided personal references wherever he could, forsaking this principle only in the most general terms when pointing to some excellent artistic or technical solution he had observed during one of his journeys. Cennino, on the other hand, established immediately who his father was, where he had been born, and that he had received his professional training in Florence in the workshop of Agnolo Gaddi, son of Taddeo, who in turn had been Giotto's greatest pupil and follower. We hear that he was born in Colle-di-Valdelsa (near Florence), the son of Andrea, who was also a painter; that he entered the workshop of Agnolo Gaddi, probably at the age of twelve in 1380, and that he was apprenticed for as many as twelve years. We know that his master died in 1396 and that, according to all evidence, Cennino did not linger in Florence, for his name does not appear among the registered members of the Florentine painters' guild. He was established in Padua by 1398, in the service of Duke Francesco da Carrara, and married a Paduan woman.[106]

Apart from his handbook, which probably was written during the last years of the fourteenth century, none of his work is known. His book consists of a collection of painters' receipts and careful prescriptions for the student on methods and techniques. It is divided into sections dealing with drawing; colors; fresco painting; oil painting and embellishments for walls; glues, sizes and cements; panel painting and gilding; mordant embellishments; varnishing; illuminating; work on cloth; operations with glass; mosaic; miscellaneous incidental operations; and casting. The whole gives splendid insight into the operations of a painter's workshop in that time.

True to medieval convention, the first chapter sketches for the

[106] Cennino's handbook has been edited several times and has been translated from the Italian into French, German and English. The most recent, excellent and probably definitive re-editing with a new English translation was done by Professor Daniel V. Thompson, Jr. The excerpts from the book which are quoted here come from Professor Thompson's book, *Cennino d'Andrea Cennini: The Craftsman's Handbook. The Italian "Il Libro dell' Arte"* (New York: Dover Publications, Inc., n.d.), reprinted through permission of the publisher. See also A. P. Laurie, *The Materials of the Painter's Craft in Europe and Egypt, from Earliest Times to the End of the XVIIth Century* (London and Edinburgh: T. N. Foulis, 1910), pp. 172–244; Albert Ilg, *Das Buch von der Kunst oder Tractat der Malerei des Cennino Cennini da Colle di Valdelsa* (Vienna: Wilhelm Braumüller, 1871).

reader an abbreviated history of the creation and fall of man. This is followed, however, by a very up-to-date brief polemic on the place of painting within the other arts, which is strong evidence that the Florentine painters had resumed the ancient debate on the relative merits and ranking of the various arts at the time of Cennino's writing. Cennino, their spokesman here, emphatically rejects the old medieval concept that painting is a craftsman's technique, producing objects mechanically. He tells his reader that a comparison between the painter's work and that of the poet is justified, because the painter too is gifted not only with the skill of his hands but with imagination and creativity when he represents things not seen and hidden under the shadow of natural objects. Cennino's wording, his very examples, go back to similar arguments raised in antiquity. One gets the impression not so much of his own erudition as of his being well acquainted with the debates of the artistic circles of Florence of the last quarter of the fourteenth century.[107]

Cennino's position in history at the turning point of an age is apparent also in his prescriptions. He advises that, when painting and drawing in chapels, he who wishes to learn correctly should bring the relief and shadow (modeling) to his figures from the windows and the natural light (Chap. viii); yet in Chapters xxxi and lxvii, for example, he describes various systems of shading and highlighting without any reference to natural light. He recommends drawing and composing from nature, but he offers mechanical help in measuring the proportions of a man's body (Chap. lxx) by recommending the classic proportions of Vitruvius. When he repeats the old superstition that man has on the left side one rib less than woman (Eve having supposedly been created from that rib), and declares that women have no set proportions, he is downright unscientific for his own time. Other recommendations, such as those for perspective drawing, for landscape and water, remain schematic and firmly tied to medieval conventions.

After saluting the reader he begins thus:

The first chapter of the first section of this book. In the beginning, when Almighty God created heaven and earth, above all animals and foods he created man and woman in his own image, endowing them with every virtue. Then, because of the misfortune which fell upon Adam, through envy, from Lucifer, who by his malice and cunning beguiled him —or rather, Eve, and then Eve, Adam—into sin against the Lord's command: because of this, therefore, God became angry with Adam, and had him driven, him and his companion, forth out of Paradise, saying to them: "Inasmuch as you have disobeyed the command which God gave you, by your struggles and exertions you shall carry on your lives." And so Adam, recognizing the error which he had committed, after being so royally endowed by God as the source, beginning, and father of us all,

107 Schlosser, "Materialien," pp. 94–102.

realized theoretically that some means of living by labor had to be found. And so he started with the spade, and Eve, with spinning. Man afterward pursued many useful occupations, differing from each other; and some were, and are, more theoretical than others; they could not all be alike, since theory is the most worthy. Close to that, man pursued some related to the one which calls for a basis of that, coupled with skill of hand: and this is an occupation known as painting, which calls for imagination, and skill of hand, in order to discover things not seen, hiding themselves under the shadow of natural objects, and to fix them with the hand, presenting to plain sight what does not actually exist. And it justly deserves to be enthroned next to theory, and to be crowned with poetry. The justice lies in this: that the poet, with his theory, though he have but one, it makes him worthy, is free to compose and bind together, or not, as he pleases, according to his inclination. In the same way, the painter is given freedom to compose a figure, standing, seated, half-man, half-horse, as he pleases, according to his imagination. So then, either as a labor of love for all those who feel within them a desire to understand; or as a means of embellishing these fundamental theories with some jewel, that they may be set forth royally, without reserve; offering to these theories whatever little understanding God has granted me, as an unimportant practicing member of the profession of painting: I, Cennino, the son of Andrea Cennini of Colle di Val d'Elsa,—(I was trained in this profession for twelve years by my master, Agnolo di Taddeo of Florence; he learned this profession from Taddeo, his father; and his father was christened under Giotto, and was his follower for four-and-twenty years; and that Giotto changed the profession of painting from Greek back into Latin, and brought it up to date; and he had more finished craftsmanship than anyone has had since),—to minister to all those who wish to enter the profession, I will make note of what was taught me by the aforesaid Agnolo, my master, and of what I have tried out with my own hand. . . .[108]

Chapter VIII. How you should start drawing with a style, and by what light. . . . Then, using a model, start to copy the easiest possible subjects, to get your hand in; and run the style over the little panel so lightly that you can hardly make out what you first start to do; strengthening your strokes little by little, going back many times to produce the shadows. And the darker you want to make the shadows in the accents, the more times you go back to them; and so, conversely, go back over the reliefs only a few times. And let the helm and steersman of this power to see be the light of the sun, the light of your eye, and your own hand: for without these three things nothing can be done systematically. But arrange to have the light diffused when you are drawing; and have the sun fall on your left side. . . .[109]

Chapter IX. How you should give the system of lighting, light or

[108] Thompson, pp. 1–2; Schlosser, "Materialien," gives the entire credit for the renewal of these ideas to Cennino himself.
[109] Thompson, *Cennino,* p. 5.

shade, to your figures, endowing them with a system of relief. If, by chance, when you are drawing or copying in chapels, or painting in other adverse situations, you happen not to be able to get the light off your hand, or the way you want it, proceed to give the relief to your figures, or rather, drawing, according to the arrangement of the windows which you find in these places, for they have to give you the lighting. And so, following the lighting, whichever side it comes from, apply your relief and shadow, according to this system. And if it happens that the light comes or shines through the center straight ahead, or in full glory, apply your relief in the same way, light and dark, by this system. And if the light shines from one window larger than the others in these places, always follow the dominant lighting; and make it your careful duty to analyze it, and follow it through, because, if it failed in this respect, your work would be lacking in relief, and would come out a shallow thing, of little mastery.[110]

Chapter XXVII. How you should endeavor to copy and draw after as few masters as possible.... Having first practiced drawing for a while as I have taught you above, that is, on a little panel, take pains and pleasure in constantly copying the best things which you can find done by the hand of great masters. And if you are in a place where many good masters have been, so much the better for you. But I give you this advice: take care to select the best one every time, and the one who has the greatest reputation. And, as you go on from day to day, it will be against nature if you do not get some grasp of his style and of his spirit. For if you undertake to copy after one master today and after another one tomorrow, you will not acquire the style of either one or the other, and you will inevitably, through enthusiasm, become capricious, because each style will be distracting your mind. You will try to work in this man's way today, and in the other's tomorrow, and so you will not get either of them right. If you follow the course of one man through constant practice, your intelligence would have to be crude indeed for you not to get some nourishment from it. Then you will find, if nature has granted you any imagination at all, that you will eventually acquire a style individual to yourself, and it cannot help being good; because your hand and your mind, being always accustomed to gather flowers, would ill know how to pluck thorns.[111]

Chapter XXVIII. How, beyond masters, you should constantly copy from nature with steady practice. Mind you, the most perfect steersman that you can have, and the best helm, lie in the triumphal gateway of copying from nature. And this outdoes all other models; and always rely on this with a stout heart, especially as you begin to gain some judgment in draftsmanship. Do not fail, as you go on, to draw something every day, for no matter how little it is it will be well worth while, and will do you a world of good.[112]

110 *Ibid.*, p. 6.
111 *Ibid.*, pp. 14–15.
112 *Ibid.*, p. 15.

Chapter XXX. How you should first start drawing on paper with charcoal, and take the measurement of the figure, and fix with a silver style. First take the charcoal, slender, and sharpened like a pen, or like your style; and, as the prime measurement which you adopt for drawing, adopt one of the three which the face has, for it has three of them altogether: the forehead, the nose, and the chin, including the mouth. And if you adopt one of these, it serves you as a standard for the whole figure, for the buildings and from one figure to another; and it is a perfect standard for you provided you use your judgment in estimating how to apply these measurements.[113] And the reason for doing this is that the scene or figure will be too high up for you to reach it with your hand to measure it off. You have to be guided by judgment; and if you are so guided, you will arrive at the truth. And if the proportion of your scene or figure does not come out right at the first go, take a feather, and rub. . . .

Chapter XXXI. How you should draw and shade with washes on tinted paper, and then put lights on with white lead. When you have mastered the shading, take a rather blunt brush; and with a wash of ink in a little dish proceed to mark out the course of the dominant folds with this brush; and then proceed to blend the dark part of the fold, following its course. . . . When you have gone as far as you can with this shading, take a drop or two of ink and put it into this wash, and mix it up well with this brush. And then in the same way pick out the very bottoms of those folds with this brush, picking out their foundations carefully; always remembering your [system of] shading, that is, to divide into three sections, shadow; the next, the color of your ground; the next, with light put on it. . . .[114]

Chapter XXXVI. This shows you the natural colors, and how you should grind black. Know that there are seven natural colors, or rather, four actually mineral in character, namely, black, red, yellow, and green; three are natural colors, but need to be helped artificially, as lime white, blues—ultramarine, azurite—giallorino. Let us go no farther, but return to the black color. . . .[115]

Chapter LI. On the character of a green called terre-verte. A

[113] *Ibid.*, p. 18. Information given in ensuing notes follows Thompson's notes. The literal translation of this sentence would be "and arrange your areas always even and equal."

[114] *Ibid.*, pp. 17–18.

[115] *Ibid.*, pp. 20–21. Thompson says that Cennino makes his bow to an old tradition in mentioning the number seven; as an example, he mentions Albertus Magnus' *Liber de sensu et sensato,* in which Albertus explains that colors are divided arbitrarily into seven in order to bring them into harmony with the classifications of "saporum et sonorum et aliorum sensibilium." The distinction between "natural" and "artificial" colors is also an ancient one. The term "azurite" stands for "German blue" or, as formerly in English, "asure of Almayne;" giallorino is yellow, a fairly bright, opaque material; Thompson has retained Cennino's name for it.

natural earth color which is called terre-verte is green. This color has several qualities: first, that it is a very fat color. It is good for use in faces, draperies, buildings, in fresco, in secco, on wall, on panel, and wherever you wish. Work it up with clear water, like the other colors mentioned above; and the more you work it up, the better it will be. And, if you temper it as I shall show you [for] the bole for gilding, you may gild with this terre-verte in the same way. And know that the ancients never used to gild on panel except with this green.[116]

Chapter LXII. On the character of ultramarine blue, and how to make it. Ultramarine blue is a color illustrious, beautiful, and most perfect, beyond all other colors; one could not say anything about it, or do anything with it, that its quality would not still surpass. And, because of its excellence, I want to discuss it at length, and to show you in detail how it is made. And pay close attention to this, for you will gain great honor and service from it. And let some of that color, combined with gold, which adorns all the works of our profession, whether on wall or on panel, shine forth in every object.

To begin with, get some lapis lazuli. And if you want to recognize the good stone, choose that which you see is richest in blue color, because it is all mixed like ashes. That which contains least of this ash color is the best. But see that it is not azurite stone, which looks very lovely to the eye, and resembles an enamel. Pound it in a bronze mortar, covered up, so that it may not go off in dust; then put it on your porphyry slab, and work it up without water. Then take a covered sieve such as the druggists use for sifting drugs; and sift it, and pound it over again as you find necessary. And bear in mind that the more finely you work it up, the finer the blue will come out, but not so beautifully violet in color. It is true that the fine kind is more useful to illuminators, and for making draperies with lights on them....[117]

Chapter LXX. The proportions which a perfectly formed man's body should possess. Take note that, before going any farther, I will give you the exact proportions of a man. Those of a woman I will disregard, for she does not have any set proportion. First, as I have said above, the face is divided into three parts, namely: the forehead, one; the nose, another; and from the nose to the chin, another. From the side of the nose through the whole length of the eye, one of these measures. From the end of the eye up to the ear, one of these measures. From one ear to the other, a face lengthwise, one face. From the chin under the jaw to the base of the throat, one of the three measures. The throat, one measure long. From

116 *Ibid.*, p. 30.

117 *Ibid.*, pp. 36–37. The Italian "non si bello violante" is here translated as "violet" or, better, "inclining toward violet"—in this connection justified by the context. The draperies here in question are *biancheggiati*, "modeled up" in contrast to the type of blue drapery in which the only modeling is darker than the ground of blue.

the pit of the throat to the top of the shoulder, one face; and so for the other shoulder. From the shoulder to the elbow, one face. From the elbow to the joint of the hand, one face and one of the three measures. The whole hand, lengthwise, one face. From the pit of the throat to that of the chest, or stomach, one face. From the stomach to the navel, one face. From the navel to the thigh joint, one face. From the thigh to the knee, two faces. From the knee to the heel of the leg, two faces. From the heel to the sole of the foot, one of the three measures. The foot, one face long.

A man is as long as his arms crosswise. The arms, including the hands, reach to the middle of the thigh. The whole man is eight faces and two of the three measures in length. A man has one breast rib less than a woman, on the left side. A man has ... bones in all. The handsome man must be swarthy, and the woman fair, etc. I will not tell you about the irrational animals, because you will never discover any system of proportion in them. Copy them and draw as much as you can from nature, and you will achieve a good style in this respect.[118]

Chapter LXXXVIII. The way to copy a mountain from nature. If you want to acquire a good style for mountains, and to have them look natural, get some large stones, rugged, and not cleaned up; and copy them from nature, applying the lights and the dark as your system requires.[119]

How to paint faces. When you have done the draperies, trees, buildings, and mountains, and got them painted, you must come to painting the faces; and those you should begin in this way. Take a little terreverte and a little white lead, well tempered; and lay two coats all over the face, over the hands, over the feet, and over the nudes. But for faces of young people with cool flesh color this couch should be tempered, the couch, and the flesh colors too, with yolk of a town hen's egg, because those are whiter yolks than the ones which country or farm hens produce; those are good, because of their redness, for tempering flesh colors for aged and swarthy persons. And whereas on a wall you make your pinks with cinabrese, bear in mind that on panel they should be made with vermilion. And when you are putting on the first pinks, do not have it straight vermilion—have a little white lead in it.... When you have got your flesh colors down so that the face is about right, make a flesh color a little bit lighter, and pick out the forms of the face, making it gradually lighter, in a careful way, until you finally come to touch in with pure white lead any little relief more pronounced than the rest, such as there would be over the eyebrow, or on the tip of the nose, etc....[120]

How to paint water. Whenever you want to do a stream, a river, or any body of water you please, either with fish or without, on wall or on panel; on a wall, take that same verdaccio which you used for shading the

118 *Ibid.*, pp. 48–49.
119 *Ibid.*, p. 57.
120 *Ibid.*, pp. 93–94.

faces on the mortar; do the fish, shading with this verdaccio the shadows always on their backs; bearing in mind that fish, and in general all irrational animals, ought to have the dark part on top and the light underneath. Then when you have shaded with verdaccio, put on lights underneath, with lime white on the wall; and with white lead on panel. And make a few shadows over the fish, and all over the background, with the same verdaccio. And if you care to make any outstanding fish, lace it with a few spines of gold....[121]

When Cennino drew attention to his training in the workshop which still bore the marks of the great tradition of Giotto, saying that Giotto had changed the profession of painting from Greek back into Latin and brought it up to date and that Giotto had more finished craftsmanship than anyone had had since, he was repeating what every Florentine had said about Giotto from the time he was appointed by the state of Florence to be its chief architect, with one important difference. When Giotto died, Giovanni Villani noted in his chronicle that "Giotto was the sovereign master of painting of his time and the one who more than anyone else drew every figure and action naturally" (see Chapter II, p. 75). Here there is as yet no evidence of the contempt contained in Cennino's remark against the earlier, Byzantine tradition of painting—only admiration for the artist's ability to depict reality.

Petrarch spoke of Giotto briefly; in his will of 1361, it will be remembered, he only says, "The panel I own, an image of the Virgin Mary ... whose beauty is not intelligible to the ignorant but whose beauty is a source of wonder to the masters of art." Boccaccio dedicated one of his novels in the Decameron *to the master, and here is the background, if not the source, for what Cennino said later. The novella itself is no more than an anecdote about Giotto—of which many made the rounds from the middle of the century on—emphasizing the painter's quick wit, his modesty, simplicity and distinction; he, Giotto, was not just an artist but also a great man. In the introduction to the novella Boccaccio says this:*

And the other, whose name was Giotto, had such a prodigious fancy, that there was nothing in Nature, the parent of all things, but he could imitate it with his pencil so well, and draw it so like, as to deceive our very senses, imagining that to be the very thing itself which was only his painting. Therefore, having brought that art again to light, which had lain buried for many ages, under the errors of such as aimed more to captivate the eyes of the ignorant, than to please the understandings of those who were really judges; he may be deservedly called one of the lights and glories of our city, and the rather as being master of his art, notwithstanding his modesty would never suffer himself to be so esteemed:

[121] *Ibid.,* pp. 95–96.

which honour, though rejected by him, displayed itself in him with the greater lustre, as it was so eagerly usurped by others less knowing than himself, and by many also who had all their knowledge from him.[122]

Boccaccio, admirer of Petrarch and humanist, creates here, in about 1353, the bridge between the "realism" of Giotto and that vaunted ancient art which had been able to deceive the senses of the onlooker. So far so good, but who were those real judges whom Boccaccio evokes in support of his judgment? Were these the humanists to whose circle he belonged? One would like to think that the art of Giotto, simple and logical in its compositions and forms and powerful in its impact, created in all observers a sense of rightness, and a feeling that his art was kindred in spirit to nature and to that which they admired in Greek and Roman literature. But did the humanists of the second half of the fourteenth century know Giotto's art? Petrarch, for instance, was a frequent guest in Padua. Did he know Giotto's fresco cycle in the Arena Chapel, or had he looked at Giotto's paintings elsewhere? He does not mention this; as has often been emphasized, he spoke of art in his letters from time to time, and one can judge the nature of his observations from a letter to Boccaccio from Pavia in about 1365.

. . . . you would see one of those works in which you have such an interest, and in which I, too, take the greatest delight, an equestrian statue in gilded bronze. It stands in the middle of the market-place, and seems to be just on the point of reaching, with a spirited bound, the summit of an eminence. The figure is said to have been carried off from your dear people of Ravenna. Those best trained in sculpture and painting declare it to be second to none.

Lastly, in order of time, though not of importance, you would see the huge palace, situated on the highest point of the city; an admirable building, which cost a vast amount. It was built by the princely Galeazzo, the younger of the Visconti, the rulers of Milan, Pavia and many neighbouring towns, a man who surpasses others in many ways, and in the magnificence of his buildings fairly excels himself. I am convinced, unless I be misled by my partiality for the founder, that with your good taste in such matters, you would declare this to be the most noble production of modern art.[123]

[122] *The Decameron, or Ten Days Entertainment of Boccaccio*, 2nd ed., 2 vols. (London: Printed by J. Wright, for Vernor and Hood, Longman and Rees; and Cuthell and Martin, 1804), Novel V of the VIth day.

[123] James Harvey Robinson with Henry W. Rolfe, *Petrarch: The First Modern Scholar and Man of Letters*, 2nd ed., rev. (New York and London: G. P. Putnam's Sons, 1914), p. 324. Copyright 1914 by G. P. Putnam's Sons. The Galeazzo of whom Petrarch speaks was the father of Gian Galeazzo, the builder of Milan cathedral.

Petrarch, as may be concluded from this sample, was not a connoisseur of art. Yet he was logical, penetrating and brilliant in his systematic attack on everything medieval throughout his lifetime—he disliked Thomas Aquinas, probably also Dante, and he avoided the use of Italian even in his letters—and he convinced others. Although a product of this late medieval civilization, he was literally blind to the task it had fulfilled in preserving the classic heritage with a great deal of love and respect, and he played a significant part in bringing it, intellectually speaking, to its end.

Florence did not produce great painters in the second half of the fourteenth century in spite of the presence of men with strong talents and gifts. This has been recently analyzed once more with great sensitivity by Millard Meiss, who attributes the tensions contained in the painting of the period to the conflicts and tensions of the time, caused by economic, political, social and spiritual upheavals which had begun with the Black Death.[124]

Uneasiness about the state of the art of painting is reflected in an anecdote by Franco Sacchetti which probably makes use of a real occurrence in 1358.[125] *Sacchetti tells of an assembly of painters and other artists at San Miniato al Monte. Orcagna was there and Taddeo Gaddi and some of the other well-known Florentine painters. After their meal they were talking about art, and Orcagna opened the debate by asking who they thought was the greatest master of painting that they had had, leaving out Giotto. They all offered names and agreed that there had been many a worthy master. Taddeo Gaddi then summed up the conversation when he said, "Yes, there have been many skillful painters . . . but this art has gone down from day to day."*

Here for the first time since antiquity the theme of what constitutes beauty and great art was reintroduced into art literature, significantly at a moment when the old was at the point of being discarded and the new had not yet been found.

The chronicler and historian Filippo Villani, nephew of Giovanni Villani and continuer of the Florentine chronicle after his uncle and his father Matteo Villani, summed up once more the sentiments of his home town at about 1405. In a booklet in praise of the illustrious men of Florence he included a brief review of painting in Florence in the thirteenth and fourteenth centuries, saying that previous to Cimabue Greek and Latin painting had almost been extinguished, corrupted by ignorance and coarse work, as could be seen from images and paintings in churches.

[124] Meiss, *Painting in Florence and Siena.*

[125] Schlosser, *Quellenbuch,* pp. 349–50, Novella 136. Professor Meiss (*Painting in Florence and Siena,* p. 4) gives this novella an interesting new interpretation, showing how it expresses a fading of the enthusiasm for the painting of Giotto by the painters of the generation of Orcagna, although Taddeo Gaddi, the old pupil of Giotto, still clung to the Giotto tradition.

This antiquated art had removed itself from observation of nature in a childish manner and had, in this way, sinned against the true calling of the artist as imitator of nature. Cimabue saved it from this fate. After Cimabue came Giotto, of great fame, who restored the art of painting to its former dignity, as might be seen in his work at the portal of the church of Saint Peter at Rome, an admirable mosaic with magnificent figures. His figures were so close to nature that they seemed to breathe, to speak, to cry and laugh, to move. He liberated art both in practice and in theory. Of Giotto's followers, Villani mentioned Maso di Banco, Stefano and Taddeo Gaddi. Maso, he said, painted with delicate beauty; Stefano painted true to nature and imitated it; and Taddeo Gaddi was able to develop space and architectural settings.[126]

We find here once more the old complaint, stereotype by now both in condemnation and in praise. As yet we find no trace of the formulation of new ideas, even though a new art was about to emerge. There was only the rejection of the old.

However, the picture becomes clearer when one understands what, at that very moment, antiquity had come to mean in Florence. The virile pagan world of Rome, which Petrarch and his followers and successors had been evoking in their effort to regenerate Italy intellectually, was far different from the image of an ancient world of wisdom which for instance Dante had created with the Divine Comedy *and elsewhere. The new posture was indispensable at this moment in history; it needed to prevail, for it aided immensely in permitting a new generation of artists to experiment with new ideas. But there should be no doubt that the older attitude, based on medieval man's assurance of an unbroken tie with his past, had provided the link to the present. In this sense Villard de Honnecourt's carefully drawn sketch of the tomb of a heathen was as significant as Dante's tender evocation of Virgil; and to the same tradition belong the comments on Aretine vases by the Franciscan monk Ristoro d'Arezzo, written at the end of his* Composizione del mondo, *around 1282. In a special chapter he described the finds which had recently been uncovered in the city of his birth. His observations may, without exaggeration, be considered one of the most moving surviving documents attesting to medieval man's admiration and awareness of the beauty of ancient art.*[127]

Now that we have spoken of the earth we want to mention the noble and miraculous object that was formed of it. Vases were made of it, a long time ago, subtle and noble objects in the city of Arezzo, where I was born, a city, I discovered from documents, which was originally called

[126] Filippo Villani, *Le Vite d'uomini illustri fiorentini,* ed. Conte Giammaria Mazzuchelli, 2nd ed. (Florence: Per Il Magheri, 1826), VI, 48–49; Schlosser, *Quellenbuch,* pp. 370–71.

[127] *La Prosa del duecento a cura di Cesare Segre e Mario Marti* (Milan: Riccardo Ricciardi Editore, 1959), III, 1038–40.

Orelia (Arretium). Of these [Etruscan] vases, admirable in their beauty, certain scholars made mention in their books, such as Isidore of Seville and Sedulius [Sedulius, a Christian Latin poet of ca. A.D. 435, mentions them in the prologue of his *Paschale carmen*, and Isidore, in turn, in his *Etymologiae*]. These vases were made of terra cotta, most subtly like wax and of the most subtle shapes in every variation. And on these vases were drawn and molded all kinds of plants and foliage and flowers and all sorts of animals one can think of in every imaginable pose, admirably and perfectly, so much so that they surpassed nature. And they were made of two colors, azure blue and red, more often, however, red. These colors were bright and subtle without being mixed [pure colors]. And these colors were so perfect that even though the vases had been underground, the earth had not been able to spoil them or destroy them. To show that all that I say is true, that is, of those which I have seen, whether they were excavated in my own time for whatever reason from inside the town or in its vicinity, nearly at a distance of two miles, many examples of these vases were found, in some places more and in others fewer; from which fact it has been assumed that they have been underground over 1000 years. And they were as colorful and fresh as if they had just been made. And the ground had had no power over them to destroy them. And these vases were carved and carried designs of all sorts of plants, foliage and flowers, and of all sorts of animals, admirably and perfectly done. There were, moreover, other things, so that the connoisseurs were beside themselves, and those who did not understand and who did not delight in them threw them away. For this reason, a great many came into my hands, which were decorated sometimes with slim figures and sometimes with fat ones, and sometimes they laughed and sometimes they cried; and some were dead and some were alive; and some were old and some were young; and some were naked and some were dressed; and some carried weapons and some were without weapons; and some were on foot and some on horseback—in every possible pose of that animal. One could find attacks and battles, excellently done in every possible pose. There could be found hunting, fowling and fishing scenes, admirable, representing all imaginable actions. And all this was molded and drawn so admirably that one recognized time (*li anni*), and whether it was light or dark, and whether the figures were near or far away. And there were forests and the animals which dwell there in every possible pose, admirably done. And one could see spirits flying in the air in the form of nude boys carrying garlands of every kind of fruit and others armed and fighting with each other and others still in chariots doing all sorts of things with horses in great number. And they could be seen flying in the air, beautifully, in every possible pose. And they could be seen in combat on foot and on horseback and doing things of all kinds.

Of such vases I have handled almost half a *scodella* (?), which were

modeled so naturally and subtly that those who knew them exclaimed aloud and were beside themselves when they saw them because of the pleasure they gave, while those who were ignorant wanted to throw them out. And when any of the pieces got into the hands of sculptors or painters or other experts, they held them dear as sacred things, marveling that human nature was able to rise so high in subtlety of objects that it created such shapes with such colors and such forms, and they said that the craftsmen were divine and that said vases had come from heaven, since they did not know who could have made said vases either in form or color or in other respects. And it was believed that that great, subtle nobility of the vases, which were carried all over the world, was granted by God to the temporal powers of the city because of grace toward the noble countryside and the beautiful land where said city lies. And for that reason these beautiful objects enjoyed being in the lovely countryside and the noble countryside required such beautiful objects.

Bibliography

Abbot Suger on the Abbey Church of Saint-Denis and Its Art Treasures. Translated and edited by Erwin Panofsky. Princeton: Princeton University Press, 1946.

Ackerman, James S. " 'Ars Sine Scientia Nihil Est.' Gothic Theory of Architecture at the Cathedral of Milan," *The Art Bulletin,* XXXI/2 (1949), 84–111.

Assunto, Rosario. *Die Theorie des Schönen im Mittelalter.* Edited by Ernesto Grassi and Walter Hess. Schauberg-Cologne: M. Du Mont, 1963.

Aubert, Marcel. *Notre-Dame de Paris: Sa place dans l'histoire de l'architecture du XIIᵉ au XIVᵉ siècle.* Paris: H. Laurens, 1920.

Bacci, Péleo. *La Ricostruzione del pergamo di Giovanni Pisano nel duomo di Pisa.* Milan and Rome: Casa Editrice d'Arte Bestetti e Tuminelli, 1926.

Borghesi, Scipione, and Luciano Banchi. *Nuovi documenti per la storia dell' arte senese.* Siena: Enrico Torrini, 1898.

Boutell, Charles. *Monumental Brasses and Slabs.* London: G. Bell, 1847.

Brach, Albert. *Nicola und Giovanni Pisano und die Plastik des XIV. Jahrhunderts in Siena.* Strasbourg: J. H. Ed. Heitz, 1904.

Branner, Robert. "Three Problems from the Villard de Honnecourt Manuscript," *The Art Bulletin,* XXXIX/1 (1957), 61–66.

Braunfels, Wolfgang. *Mittelalterliche Stadtbaukunst in der Toskana.* Berlin: Gebr. Mann, 1953.

Brayley, Edward Wedlake, and John Britton. *The History of the Ancient Palace and Late Houses of Parliament at Westminster.* London: John Weale, 1836.

Burchardi de Hallis Chronicon ecclesiae Collegiatae s. Petri Winpiensis. In J. F. Schannat, *Vindemiae litterariae Collectio Secunda,* Vol. II. Fulda and Leipzig, 1724.

Carpenter, Edward. *A House of Kings.* London: John Baker, 1966.

Cartellieri, Otto. *Am Hofe der Herzöge von Burgund.* Basel: B. Schwabe & Co., 1926.

Castelnuovo, Enrico. *Un Pittore italiano alla corte di Avignone: Matteo Giovannetti e la pittura in Provenza nel secolo XIV.* Turin: Giulio Einaudi, 1962.

Champollion-Figéac, Aimé (Louis). *Louis et Charles Ducs d'Orléans: Leur influence sur les arts, la littérature et l'esprit de leur siècle d'après les documents originaux et les peintures de manuscripts.* Paris: Comptoir des Imprimeurs-Unis, 1844.

Chastellain, Georges. *Chronique des Ducs de Bourgogne.* Published for the first time by Jean Alexandre Buchon. Paris: Verdière, Libraire, 1827.

Coulton, G. G. *Life in the Middle Ages,* Vol. I, 2nd ed., 4 vols. Cambridge, Eng.: At the University Press, 1928–1930.

Cronache senesi. Edited by Alessandro Lisini and Fabio Iacometti. Bologna: Nicola Zanichelli, 1931. A new edition of L. A. Muratori, *Rerum italicarum scriptores,* Vol. XV, Part VI.

Cronica di Giovanni Villani, coll' aiuto de' testi a penna. Florence: Il Magheri, 1823.

Crosby, Sumner McKnight. *L'Abbaye royale de Saint-Denis.* Paris: Paul Hartmann, 1953.

David, Henri. *Claus Sluter.* Paris: Editions Pierre Tisne, 1951.

Davidsohn, Robert. *Storia di Firenze.* Vol. IV, "I Primordi della civiltà fiorentina." Florence: G. C. Sansoni, 1965.

The Decameron, or Ten Days Entertainment of Boccaccio. 2nd ed., 2 vols. London: Printed by J. Wright, for Vernor and Hood, Longman and Rees; and Cuthell and Martin, 1804.

Dehaisnes, M. le Chanoine. *Documents et extraits divers concernant l'histoire de l'art dans la Flandre, l'Artois et le Hainaut avant le XVè siècle.* Lille: Imprimerie L. Danel, 1886.

Dehio, Georg, and G. von Betzold. *Die Kirchliche Baukunst des Abendlandes.* 2 vols. Stuttgart: Arnold Bergsträsser Verlagsbuchhandlung A. Kröner, 1884 and 1901.

Delisle, Léopold. *Recherches sur la librairie de Charles V.* 2 vols. Paris: H. Champion, 1907.

Depping, Georges Bernhard. "Réglemens sur les arts et métiers de Paris rédigés au XIIIè siècle et connus sous le nom du Livre des Métiers d'Etienne Boileau," *Collection de documents inédits sur l'histoire de France publiés par Ordre du Roi et par les soins du Ministère de l'Instruction.* Ser. 1, "Histoire politique." Paris, 1837.

The Dialogue on Miracles, Caesarius of Heisterbach (1220-1235). Translated by H. von E. Scott and C. C. Swinton Bland. 2 vols. London: George Routledge and Sons, Ltd., 1929.

The Divine Comedy of Dante Alighieri. With translation and comment by John D. Sinclair. 3 vols. New York: Oxford University Press, 1968.

Du Colombier, Pierre. *Les Chantiers des cathédrales.* Paris: A. et J. Picard, 1953.

Dvořak, Max. *Kunstgeschichte als Geistesgeschichte.* Munich: R. Piper & Co., 1928.

Eastlake, Sir Charles Lock. *Methods and Materials of Painting of the Great Schools and Masters.* 2 vols. New York: Dover Publications, Inc., 1960.

The English Works of John Gower. Edited by G. C. Macaulay. 2 vols. London: Kegan, Paul, Trench, Trübner & Co., Ltd., 1900 and 1901.

Falk, Ilse. *Studien zu Andrea Pisano.* Hamburg: Niemann and Moschinski, 1940.

Focillon, Henry. *Art d'Occident: Le Moyen Age romain et gothique.* Paris: Librairie Armand Colin, 1938.

Frankl, Paul. *The Gothic: Literary Sources and Interpretations through Eight Centuries.* Princeton: Princeton University Press, 1960.

Frey, Karl. *Scritte da M. Giorgio Vasari pittore e architetto aretino.* Vol. I/1. Munich: Georg Müller, 1911.

Gesta abbatum monasterii Sancti Albani (Cottonian MS. Claudius E. IV, British Museum). Edited by Henry Thomas Riley. 3 vols. London: Longmans, Green, Reader and Dyer, 1867–1869.

Giles, J. A., trans. *Matthew Paris's English History.* 3 vols. London: Henry G. Bohn, 1852–1854.

Grodecki, Louis, "De 1200 à 1260," in *Le Vitrail français, sous la haute direction du Musée des Arts Décoratifs de Paris,* pp. 115–44. Paris: Editions des Deux Mondes, 1958.

———. "The Transept Portals of Chartres Cathedral: The Date of Their Con-

struction according to Archaeological Data," *The Art Bulletin,* XXXIII/3 (1951), 156–73.

Guasti, Cesare. *Santa Maria del Fiore: La Costruzione della chiesa e del campanile secondo i documenti tratti dall' Archivio dell' opera secolare e da quello di Stato.* Florence: Tipografia di M. Ricci, 1887.

Guiffrey, Jules M. J. *Inventaires de Jean Duc de Berry (1401–1416).* 2 vols. Paris: E. Leroux, 1894 and 1896.

Harvey, John Hooper. *English Mediaeval Architects: A Biographical Dictionary down to 1550.* London: B. T. Batsford, Ltd., 1954.

———. *Gothic England: A Survey of National Culture, 1300–1550.* London: B. T. Batsford, Ltd., 1947.

———. *Henry Yevele, c.1320 to 1400: The Life of an English Architect.* London: B. T. Batsford, Ltd., 1944.

Haskins, Charles H., and Dean Putnam Lockwood. "The Sicilian Translators of the Twelfth Century and the First Latin Version of Ptolemy's *Almagest,*" *Harvard Studies in Classical Philology,* XXI (1910), 75–102.

Hastings, Maurice. *St. Stephen's Chapel and Its Place in the Development of Perpendicular Style in England.* Cambridge, Eng.: At the University Press, 1955.

Hoepffner, Ernst. *Eustache Deschamps: Leben und Werke.* Strasbourg: Verlag von Karl J. Trübner, 1904.

Huizinga, J. *The Waning of the Middle Ages.* Garden City: Doubleday Anchor Books, 1954.

Humbert, André. *La Sculpture sous les Ducs de Bourgogne.* Paris: Henri Laurens, 1913.

Ilg, Albert. *Das Buch von der Kunst oder Tractat der Malerei des Cennino Cennini da Colle di Valdelsa.* Vienna: Wilhelm Braumüller, 1871.

Keller, Harald. *Giovanni Pisano.* Vienna: Verlag Anton Schroll & Co., 1942.

Kleinclausz, Arthur. *Claus Sluter et la sculpture bourguignonne au XVᵉ siècle.* Paris: Librairie de l'Art Ancien et Moderne, 1905.

Knoop, Douglas, and G. P. Jones. *The Mediaeval Mason.* 3rd ed., revised and reset. Manchester: Manchester University Press, 1967.

Knowles, Dom David. *The Monastic Order in England: A History of Its Development from the Times of St. Dunstan to the Fourth Lateran Council, 943–1216.* Cambridge, Eng.: At the University Press, 1940.

Laurie, A. P. *The Materials of the Painter's Craft in Europe and Egypt, from Earliest Times to the End of the XVIIth Century.* London and Edinburgh: T. N. Foulis, 1910.

Lavedan, Pierre. *L'Architecture gothique religieuse en Catalogne, Valence et Baléares.* Paris: Henri Laurens, Editeur, 1935.

Ledru, A. *La Cathédrale du Mans Saint-Julien.* 2nd ed. Le Mans: Imprimerie E. Benderitter, 1923.

Lethaby, W. R. *Westminster Abbey and the Kings' Craftsmen: A Study of Mediaeval Building.* New York: E. P. Dutton & Co., 1906.

Lettenhove, M. Kervyn de. *Histoire de Flandre.* Vol. II, "1301–1383." Bruges: Beyaert-Defoort, 1874.

Liebreich, Aenne. *Claus Sluter.* Brussels: Dietrich & Cie., 1936.

Macklin, Herbert W. *The Brasses of England.* London: Methuen & Co., 1907.

Meiss, Millard. *French Painting in the Time of Jean de Berry.* London: Phaidon Press, Ltd., 1967.

———. "Fresques italiennes et autres à Béziers," *Gazette des Beaux Arts,* XVIII (1937), 275–86.

———. *Painting in Florence and Siena after the Black Death.* New York: Harper Torchbooks, 1964.

Milanesi, Gaetano. *Documenti per la storia dell' arte senese.* 3 vols. Siena: Onorato Porri, 1854–1856.

———. *Sulla storia dell' arte toscana: Scritti vari.* Siena: Tip. Sordo-Muti di L. Lazzeri, 1873.

Mommsen, Theodor E. "Petrarch and the Decoration of the Sala Virorum Illustrium in Padua," *The Art Bulletin,* XXXIV/2 (1952), 95–116.

Mortet, Victor. "L'Expertise de la cathédrale de Chartres en 1316," *Mélanges d'archéologie,* Ser. 2 (Paris, 1915), pp. 131–52.

———. "Hugue de Fouilloi, Pierre le Chantre, Alexander Neckam et les critiques dirigées au douzième siècle contre le luxe des constructions," in *Mélanges d'histoire offerts à M. Charles Bémont par ses amis et ses élèves à l'occasion de la XXVè année de son enseignement à l'Ecole Pratique des Hautes Etudes,* pp. 105–37. Paris: Librairie Félix Alcan, 1913.

———. *Recueil de textes relatifs à l'histoire de l'architecture et à la condition des architectes en France au moyen âge, XIè–XIIè siècles.* Paris: A. Picard et fils, 1911.

——— and Paul Deschamps. *Recueil de textes relatifs à l'histoire de l'architecture et à la condition des architectes en France au moyen âge.* Paris: Editions Auguste Picard, 1929.

Muratori, L. A. *Raccolta degli storici italiani dal cinquecento al millecinquecento,* Vol. XV. Bologna: Nicola Zanichelli, 1939.

Neale, John Mason, and Benjamin Webb. *The Symbolism of Churches and Church Ornaments.* Leeds, n.p., 1843.

Neckam, Alexander. *De naturis rerum, libro duo, with Neckam's Poem De laudibus divinae sapientiae.* Edited by Thomas Wright. London: Longman, Green, Longman, Roberts and Green, 1863.

Nott, John. *Petrarch Translated; in a Selection of His Sonnets and Odes Accompanied with Notes, and the Original Italian.* London: J. Miller, Chancery-Lane, 1808.

Oertel, Robert. *Die Frühzeit der italienischen Malerei.* Stuttgart: W. Kohlhammer, 1953.

Paatz, Walter. *Werden und Wesen der Trecento-Architektur in Toskana.* Burg b.M.: August Hopfer Verlag, 1937.

——— and Elisabeth. *Die Kirchen von Florenz.* 6 vols. Frankfurt a.M.: Vittorio Klostermann, 1940–1954.

Panofsky, Erwin. *Early Netherlandish Painting: Its Origins and Character.* Cambridge, Mass.: Harvard University Press, 1953.

———. "Postlogium Sugerianum," *The Art Bulletin,* XXIX/2 and 4 (1947), 19–21, 287.

Pevsner, Nikolaus. *The Buildings of England: Hertfordshire.* London: Penguin Books, 1953.

———. "The Term 'Architect' in the Middle Ages," *Speculum,* XVII (1942), 549–62.

Pollitt, J. F. *The Art of Greece, 1400–31 B.C.: Sources and Documents.* Englewood Cliffs, N.J.: Prentice-Hall, Inc., 1965.

Porter, Arthur Kingsley. *Medieval Architecture: Its Origins and Development.* 2 vols. New Haven: Yale University Press, 1912.

La Prosa del duecento a cura di Cesare Segre e Mario Marti. Milan: Riccardo Ricciardi Editore, 1959.

Reinhardt, Hans. "Le Jubé de la cathédrale de Strasbourg et ses origines rémoises," *Bulletin de la Société des Amis de la Cathédrale de Strasbourg.* Ser. 2, VI (Strasbourg, 1951), 18–28.

――. "Les Textes relatifs à l'histoire de la cathédrale de Strasbourg depuis les origines jusqu'à l'année 1522," *Bulletin de la Société des Amis de la Cathédrale de Strasbourg,* Ser. 2, VII (Strasbourg, 1960), 11–29.

Riley, Henry Thomas. *Memorials of London and London Life in the XIIIth, XIVth, and XVth Centuries, Being a Series of Extracts . . . from the Early Archives of the City of London, A.D. 1276–1419.* London: Longmans, Green, & Co., 1868.

Robinson, James Harvey, with Henry W. Rolfe. *Petrarch: The First Modern Scholar and Man of Letters.* 2nd ed., revised. New York and London: G. P. Putnam's Sons, 1914.

Royal Commission on Historical Monuments and Inventory of the Historical Monuments in Hertfordshire. London: Jas. Truscott and Son, Ltd., 1910.

Saalman, Howard. "Santa Maria del Fiore: 1294–1418," *The Art Bulletin,* XLVI/4 (1964), 471–500.

Salvini, Roberto. *Giotto: Bibliografia.* Rome: Fratelli Palombi, 1938.

Salzman, L. F. *Building in England down to 1540: A Documentary History.* Oxford: Clarendon Press, 1952.

――. *English Life in the Middle Ages.* London: H. Milford, Oxford University Press, 1926.

Scher, Stephen K. "André Beauneveu and Claus Sluter," *Gesta,* VII (1968), 3–14.

Schlosser, Julius von. "Die höfische Kunst des Abendlandes in byzantinischer Beleuchtung," in *Präludien, Vorträge und Aufsätze,* pp. 68–81. Berlin: Julius Bard Verlag, 1927.

――. "Materialien zur Quellenkunde der Kunstgeschichte," in *Sitzungsberichte der Kaiserlichen Akademie der Wissenschaften in Wien,* 177/I, "Mittelalter," pp. 3–102. Vienna: Alfred Hölder, 1914.

――. *Quellenbuch zur Kunstgeschichte des abendländischen Mittelalters.* N.F., VII. Vienna: Carl Graeser, 1896.

――. "Zur Geschichte der Kunsthistographie," in *Präludien, Vorträge und Aufsätze,* pp. 248–95. Berlin: Julius Bard Verlag, 1927.

Street, George Edmund. *Some Account of Gothic Architecture in Spain.* 2nd ed. London: John Murray, 1869.

Swarzenski, George. *Nicolo Pisano.* Frankfurt a.M.: Iris Verlag, 1926.

Thompson, Daniel V., Jr. *Cennino d'Andrea Cennini: The Craftsman's Handbook. The Italian "Il Libro dell' Arte."* New York: Dover Publications, Inc., n.d.

Thomson, W. G. *A History of Tapestry.* London: Hodder and Stoughton, 1906.

Toesca, Piero. *Storia dell' arte italiana.* 2 vols. Turin: Unione Tipografico Editrice Torinese, 1927 and 1951.

Urkundenbuch der Stadt Strassburg. Vol. I, "Urkunden und Stadtrechte bis zum Jahre 1266." Strasbourg: Wilhelm Wiegand, 1879.

Victoria History of the Counties of England. Vol. II, "Hertfordshire." Edited by William Page. London: Archibald Constable and Company, Ltd., 1908.

Villani, Filippo. *Le Vite d'uomini illustri fiorentini.* 2nd ed. Edited by Conte Giammaria Mazzuchelli. Florence: Per Il Magheri, 1826.

Villard de Honnecourt: Kritische Gesamtausgabe des Bauhüttenbuches MS. fr. 19093 der Pariser Nationalbibliothek. Edited by Hans R. Hahnloser. Vienna: Verlag von Anton Schroll & Co., 1953.

Le Vitrail français, sous la haute direction du Musée des Arts Décoratifs de Paris. Paris: Editions des Deux Mondes, 1958.

Vitruvius: The Ten Books of Architecture. Translated by Morris Hicky Morgan. Cambridge, Mass.: Harvard University Press, 1914.

Webb, Geoffrey. *Architecture in Britain: The Middle Ages.* 2nd ed. The Pelican History of Art, edited by Nikolaus Pevsner. London: Penguin Books, Ltd., 1965.

White, Lynn, Jr. *Medieval Technology and Social Change.* New York: Oxford University Press, 1966.

Willis, Robert. *The Architectural History of Canterbury Cathedral.* London: Longman and Co., W. Pickering, and G. Bell, 1845.

Wixom, William D. *Treasures from Medieval France.* Exhibition Catalogue, Cleveland Museum of Art. Cleveland, Ohio, 1967.

Wollaston, Susan. *One Hundred Sonnets Translated after the Italian of Petrarca.* London: Edward Bull, 1841.

Index